Waterline

Images from the Golden Age of Cruising

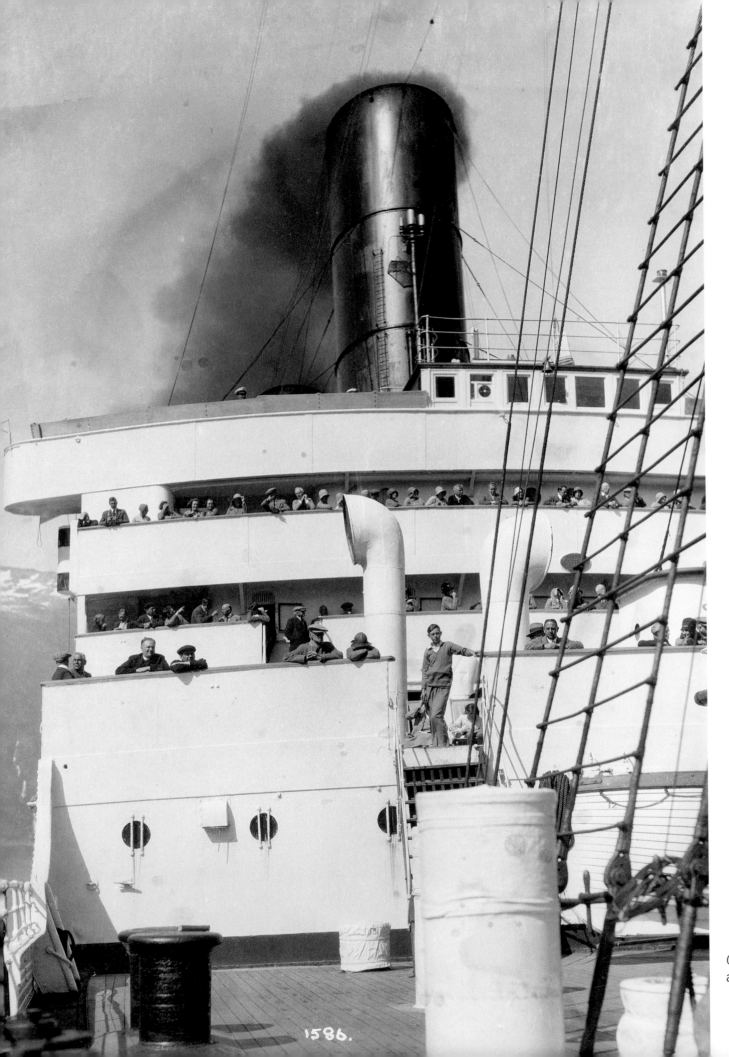

1586.

Caronia,
about 1925

Waterline

Images from the Golden Age of Cruising

John Graves

NATIONAL
MARITIME
MUSEUM

Contents

6 Author's note

7 Acknowledgements

10 Introduction

26 **Chapter 1: Destinations near and far**

28 The fjords of Norway

32 The Med

40 Southampton to South Africa with the Lavender Hull Mob

46 London to Sydney with the Ten Pound Poms

78 **Chapter 2: Running the ship**

80 Crews

86 Keeping the kids amused

92 Death at sea

118 **Chapter 3: Creature comforts**

122 Wining and dining

128 Sporting days

134 Entertainment at sea

156 **Chapter 4: Vessels large and small**

160 *Oriana* – the forty thousand ton greyhound

166 Cruising between the wars

174 The Old Cunarders

206 **Chapter 5: The lure of the sea**

208 Storm at sea

214 Souvenir hunting

238 'Getting there is half the fun'

250 Index

254 Picture credits

255 Text credits

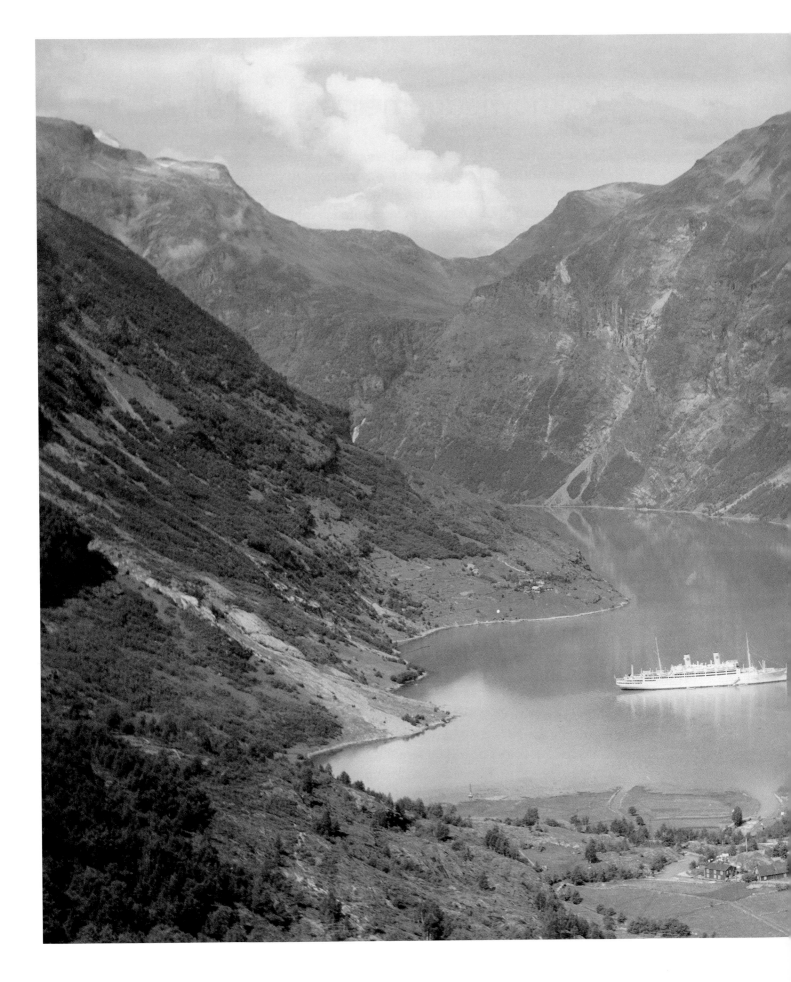

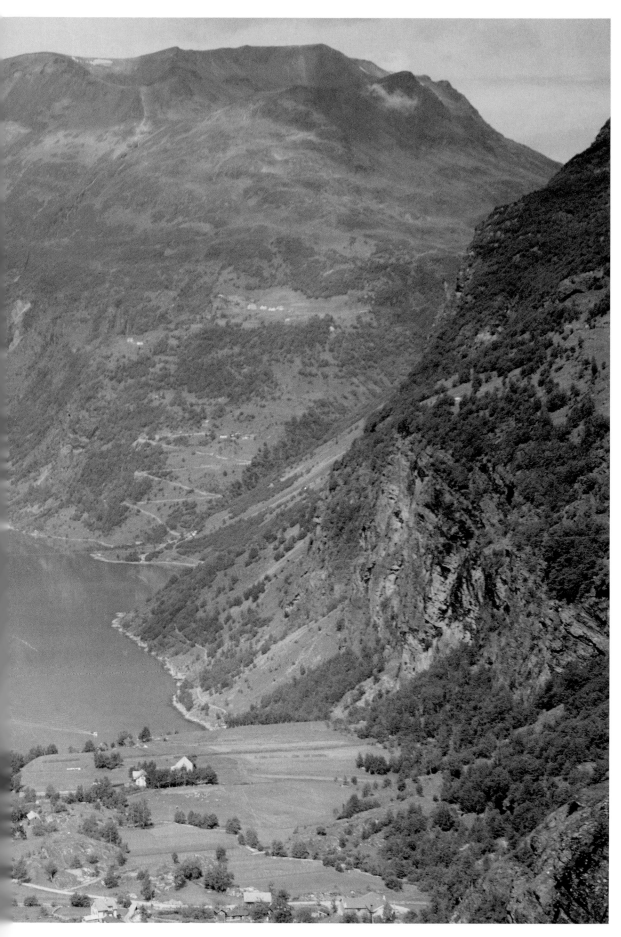

Geirangerfjord, Norway,
about 1935

The dramatic aerial view of
a ship at anchor, seemingly
land-locked in the very
centre of Geirangerfjord
with the village of Merok
nearby, was a favourite
composition and involved
a degree of strenuous
climbing on the part of the
photographer. The vantage
point from where this shot
was taken has now been
closed off for safety reasons.
The road zig-zagging in the
top right-hand corner is
Eagle Pass, which is closed
for most of the year. The
ship is the *Kungsholm* of
the Swedish America Line,
and would have come in
through the top left-hand
corner of this view of
the fjord.

country did not really get going again until 1950, for the priority was to re-establish the scheduled line voyages that for P&O, for example, didn't recommence until 1947. The last of P&O's requisitioned ships did not come back from the British government until 1950, so the company was in no position to run pleasure cruises until then. Other shipping lines were in much the same position. Global war brought about global changes. The freer movement of people and ideas helped to bring about a desire for egalitarianism, better living standards and higher consumer expectations. People were now beginning to expect air-conditioning on their ships and, indeed, to have the run of the whole ship. They wanted to spend more time enjoying themselves and they wanted to be seen to be enjoying themselves in glorious colour. MPS, along with everyone else, had to move quickly with the times and their photographic legacy is a record of these lifestyle changes. The development of photographic processes and equipment after the war gave photographers greater mobility and flexibility to capture more naturalistic and spontaneous shots. Their subjects were less inhibited, and more willing to look straight into the camera. Indeed passengers seem to have had no qualms about queuing up to have their picture taken, be it at the ship's helm or in front of the mermaid in Copenhagen. This part of the MPS collection, from 1950 to 1970, is a real child of its time – artless in comparison with the elegant pre-war material, but immediately engaging, dynamic and informative, and a valuable social and cultural record. These images speak to many of us in a direct way by jogging our memories of the styles and fashions of the age. They are on the cusp between 'dated' and 'historic'.

MPS was based in Colchester, in Essex. Although it remained a family concern throughout the whole of its life, the early days of the company are shrouded in the mists of time. No one knows when exactly it began business, but the consensus is about 1920. There are no early records of Marine Photo Service at Companies House, but we know that Gilbert Morgan Morris established his business at the glamorously named West End Studios in Colchester's Crouch Street. Things soon took off. Between the wars MPS had photographers on up to fifty ships around the world at any one time. Business was lucrative enough for a breakaway group of photographers to found the rival company Ocean Pictures, in Southampton, in the mid-1930s. As more and more shipping companies awarded contracts to MPS more space was needed so, in 1928, Morris purchased a large house at 173 Maldon Road. His family lived here, and the darkrooms, offices and stores were set up in newly erected outbuildings, employing around thirty people. It might have been a family firm and a cottage industry, at least to

the casual observer, but its business was truly international. Many of the staff though, including some of the photographers themselves, were local people from Colchester and the surrounding area, a tradition that continued for many years. The all-important negatives were kept in a shed at the bottom of the garden. It is a minor miracle that the earliest ones have survived to this day.

Morris had twin sons – Gilbert Ernest, or 'Bunce' as he was known, and Kenneth. A new company, Morris Photo Service, was established by Bunce in 1945 when he was 'demobbed' from his reserve occupation in the Fire Service Police. He offered a developing and printing service using ex-shipboard MPS equipment which was still at 173 Maldon Road. Meanwhile Kenneth (Ken) ran West End Studios, reopening MPS in 1947. Bunce often helped out with MPS, sharing the problems and some of the profits, but Ken was the main driving force. It also became a limited company at this time. Coincidentally, both twins had married Swedish girls before the war. Ken married Anna-Britta Lamm in 1935. They met on the Swedish America Line ship, *Kungsholm,* where Anna-Britta worked in the Ferdinand Lundquist gift shop. Three years later Bunce married Irine Setterberg, also from *Kungsholm's* gift shop. In those days only young ladies of some 'breeding' were employed on Swedish America Line ships.

Following the war, business was sluggish to begin with, but picked up rapidly in the early 1950s with the introduction of new ships to the world's fleets. In 1968 Tony Morris, Bunce's son, took over MPS as chairman and managing director, at the age of twenty-four, and remained there until the company closed twenty-three years later. He made it a rule that he would go out on one cruise a year to remind himself what it was like to work as a junior. At the start of his chairmanship the company had contracts with four ships on a full-time basis and part-time agreements with three others, with an annual turnover of £40,000. By 1982 MPS had photographers on thirty-five ships with a turnover of over a million pounds. MPS had become one of a group of seven specialist photographic companies, together employing around 250 people. The group was severely hit by the recession of the early 1980s. At that time MPS had contracts with seventeen of the twenty cruise ships operating out of Sydney, many of which were Russian. With the invasion of Afghanistan by the Soviet Union on Christmas Eve in 1979, this business virtually disappeared overnight. By the end of the 1980s, Tony Morris decided that he had had enough. The company ceased trading in 1991 before being wound up three years later.

Tony Morris at the foot of *Gripsholm*'s gangway, around 1962.
The camera is a Rolleiflex attached to a Clive Courtney flashpack.

technique in which all MPS photographers were trained would be to walk up to a passenger, in a relaxed manner, without upsetting them, and to give them the option of refusing to have their picture taken. They would say something along the lines of 'Good evening. Would you like to turn this way for a picture please?' and then take a step back. They were not allowed to invade a passenger's personal space. The photograph would then be taken unless there was active resistance. There was absolutely no pressure for the passenger to purchase anything. On most cruises passengers would be routinely photographed as they were coming on board, and there were other popular scenarios – engine room and bridge visits, deck games, dinner dances and the like. The passengers would usually comprise a number of nationalities. New photographers soon realized that they would achieve higher sales if they spoke to them in their native tongue. Bob Cook recalls: 'If you were doing table shots in the restaurant it was always a challenge to go up to any table and try and guess if it was a German, French or Spanish table. If you got it wrong it was not a good start'. Those new to the job were often nervous and self-conscious of stopping passengers in their tracks or midway through dinner, feeling that they might be imposing.

Until the 1950s the majority of passengers would not have owned cameras, so the idea of being able to purchase professionally shot pictures of themselves on their travels was naturally appealing. MPS photographers would record the passengers, crews, the ports of call and the peoples who lived there, shipboard life and activities and, of course, the ships themselves. Once the photographs were taken and the films developed, contact prints would be made and posted up the following morning in one of the ship's public areas. Passengers could then place an order with one of the photographers, using the negative number for reference, which, on cruises out of England, would then be brought back to Colchester for processing. On cruises starting elsewhere, orders were completed on board the ship. Sometimes passengers would order a whole album of photographs as a complete record of their holiday.

From the 1930s onwards, several thousand photographs would be taken every week by MPS photographers. The negatives would be returned to Colchester from across the world for sorting, cataloguing and storing. Brasso polish was used to clean them from time to time, as the cold, damp conditions in which they were kept frequently caused mildew to form on them. Generally speaking though, the negatives were kept in as good a condition as possible, as they were vital to the company's profitability (their

level of fare, or class, where money determined the quality of space and comfort. Creature comforts, though important, were secondary to providing a prompt and reliable service, and liners evolved to meet these very specific requirements. A cruise, on the other hand, is a leisurely journey, conducted for pleasure and often taking a circular tour, calling at a number of ports and usually returning passengers to the place of embarkation. Because cruise ships are not required to maintain high speeds in all weathers and conditions, they are geared more to passenger comfort, the aim being to ensure that passengers enjoy their time at sea in much the same way as they would on a land-based holiday. Liners and cruise ships, therefore, evolved to be quite different from one another. The distinction only became blurred in the 1960s and 1970s when line voyages lost custom to cheaper air travel, and consequently shipping companies turned to cruising and the holiday market to help to fill vacant berths.

For over thirty-five years MPS photographers recorded passengers enjoying themselves on cruises, and were spared the trials and tribulations of the functional end of the passenger market. However this all changed on a

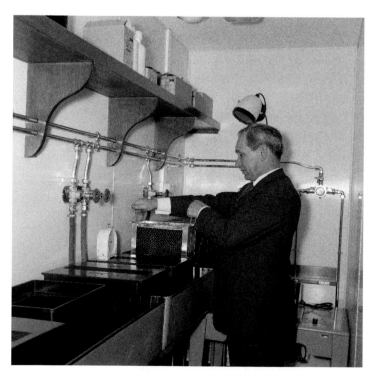

MPS director Kenneth Morris posing for a press picture in the darkroom he designed for the *Oriana*, taken when the ship first entered service in late 1960.

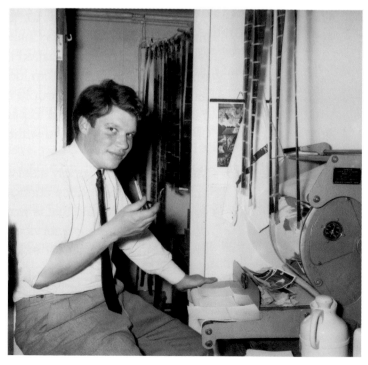

MPS photographer, and later director, Tony Morris, using a Johnson's glazer in the *Iberia*'s darkroom, around 1962.

wet thundery August in 1958, when MPS joined the *Orcades* for a three-and-a-half-month line voyage to Australia – the first time a photographic company had provided such a service on a liner. The photographers had to become members of the crew and to sign the ships articles, meaning that they were now subject to maritime law. They were billeted on 'H' deck, along with passengers on assisted passages (the so-called 'Ten Pound Poms'). Considering that these made up half the passengers, who in total numbered some 1400, the takings were not too bad. The photographers also developed films for the minority of passengers who owned their own cameras. It was to set a trend during the remaining years of line voyages, until cheap air travel deprived shipping lines of their core business. Servicing line voyages was profitable, but trying to get the Ten Pound Poms to spend money could be a challenge. The emigrants were required to have £100 with them on arriving at their destination which, in the case of *Orcades,* was Sydney. If they spent too much on the voyage, they were reduced to selling some of their possessions to make up the shortfall.

From the 1950s, with the change to Rolleiflexes using twelve-exposure, 120 square-format film, many more photographs were taken and consequently the compositions were less formal. Half-plate cameras with sheet film were still used for taking large groups, panoramic vistas and so on, and pre-war stock negatives of the destinations on the itinerary were on board so that passengers could be offered as comprehensive a range as possible. Five-inch square prints were printed up overnight, mounted and displayed the following morning for passengers to make their selection. There used to be twice as much work for photographers on ships with first-class and tourist-class areas, as everything taken ashore had to be printed up twice. Two photographic shops would be required, and sometimes two events would need to be photographed simultaneously as the classes were strictly segregated at that time.

One of the biggest changes in the history of MPS came in the early 1960s, with the transition from black-and-white to colour photography. MPS had a contract to service the new P&O-Orient Lines's vessel *Oriana*, from the first day of her maiden voyage, on 3 December 1960. She was an important commission. At 41,000 tons and carrying 600 first-class and over 1400 tourist-class passengers, she required four photographers. She and the *Canberra*, delivered the following year, were the first British passenger ships to have dedicated darkrooms, and Ken Morris had been commissioned to design them both. P&O split the concession for the two ships, with the *Canberra* contract going to another company, to avoid a monopoly.

It was certainly not all doom and gloom, however. Working for MPS had its many compensations, not least of which was the great spirit of adventure that came with the job. For many, particularly the young recruits, the experience of being on a ship and travelling to far-flung destinations was like a dream come true. After his first visit to New York, photographer Geoff Pettit remembers that returning to Colchester 'felt very strange and flat. I had had the most exciting time of my life, even though we had worked very hard with long hours … I had nevertheless had a most wonderful experience. I wore my American clothes, I would say "sure" a lot'. Bob Cook remembers that 'it was always so exciting to get the call from Colchester when you were home. The call would say something like, "Hey, have you ever been to Hong Kong?" and before you knew it you would be half way around the world. Quite amazing'.

There was always time to go ashore as, partly due to longer turnaround time, ships invariably spent longer in port than today. Whether it was seeing Ella Fitzgerald at the Top of the Mark Hotel in San Francisco, wandering around the Indian market in Durban, or attending the 1964 Olympic Games in Tokyo, there was always something to do. The passengers themselves were often a good source of entertainment too, though the photographers were sometimes laughing at them rather than with them. One recalls a passenger on the North Cape cruise up to the Land of the Midnight Sun, who asked, 'Can I photograph the regular sun and the Midnight Sun together with my Instamatic?' Differences in time zones always led to confusion, and the photographers would enjoy telling passengers that their order would be ready on the second Tuesday of the following week. There were always amusing stories to tell. Photographer Paul Savage was once out on deck with a box of 2000 waste prints to tip overboard. The wind picked up at just the wrong moment and the whole ship was covered in old photographs, like spent confetti. It took two days to get rid of them.

The Marine Photo Service archive enables us to witness, through the photographers' own eyes, a golden age of travelling aboard majestic and superlative ships, to beguiling destinations across five continents and seven seas. A selection of MPS negatives was purchased by the National Maritime Museum in 1996. They join a collection of historic maritime-related photographs at the Museum. Comprising some 270,000 negatives and many more prints, this is a collection unrivalled anywhere else in the world. Selecting the best 200 or so images from the 16,500 in the MPS collection was an immensely pleasurable, not to say enviable, task, but was at times frustrating as one tried to think of more and more creative

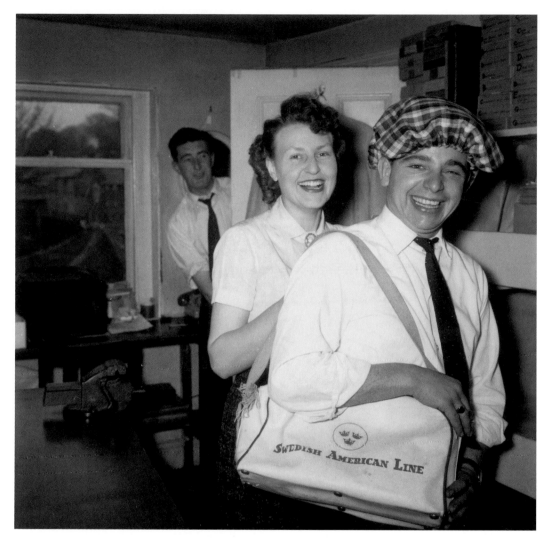

MPS photographers John Saunder (with bag) and Doug Hunt
(looking around the door to see whether or not coffee was
ready) with secretary Jean Freeman, taken about 1960.

ways to include additional material without the project becoming hopelessly
unwieldy. Hopefully the following selection has achieved a balance of
period, genre and subject matter. It represents a rich and diverse collection,
which is now in the public domain for everyone to enjoy. We are very
lucky to have it.

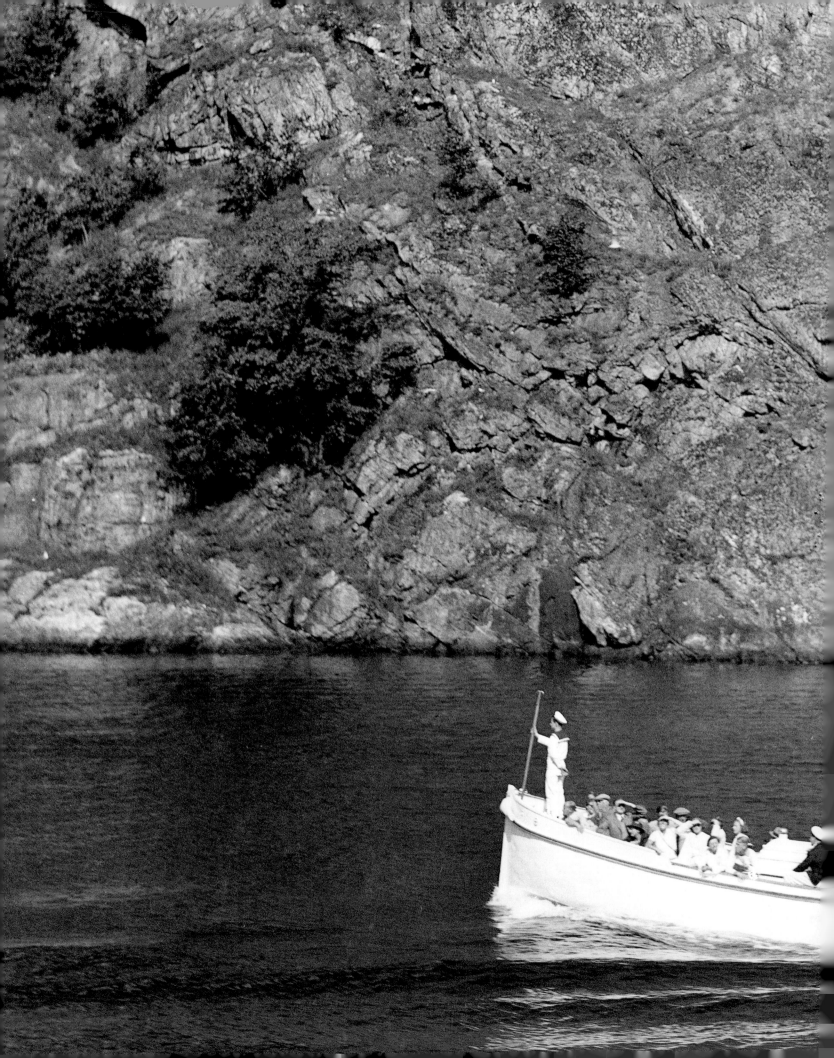

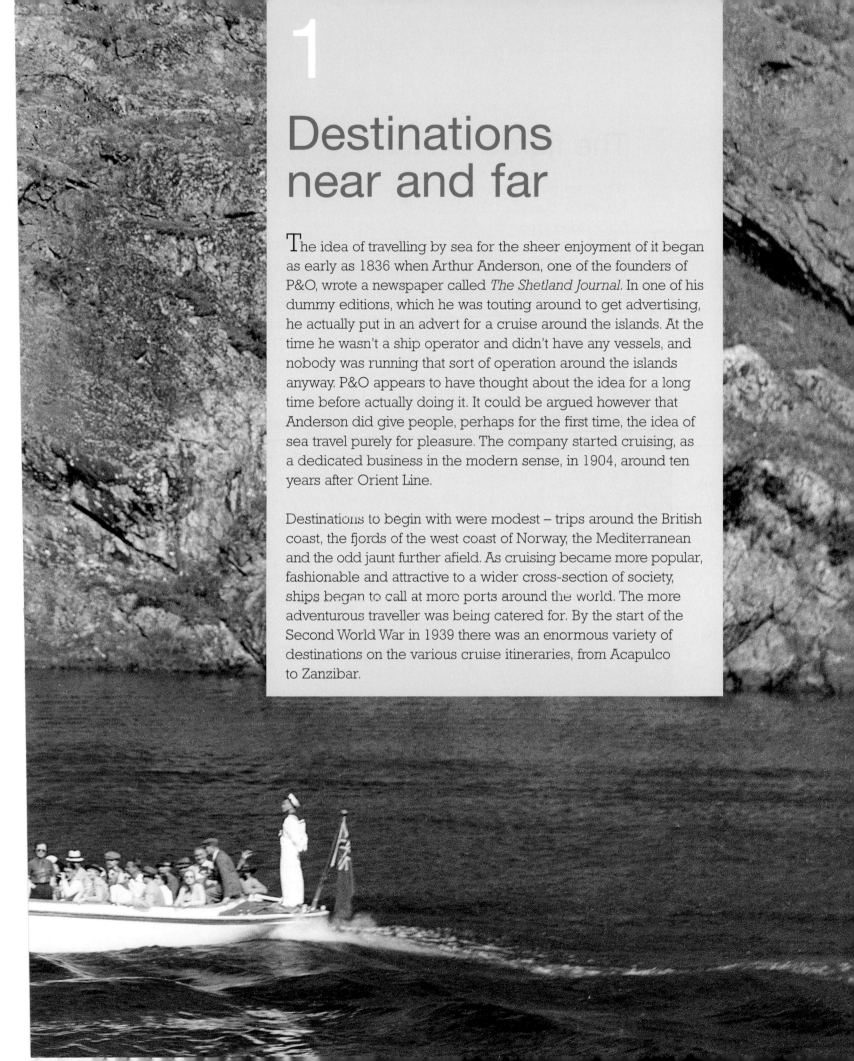

1

Destinations near and far

The idea of travelling by sea for the sheer enjoyment of it began as early as 1836 when Arthur Anderson, one of the founders of P&O, wrote a newspaper called *The Shetland Journal*. In one of his dummy editions, which he was touting around to get advertising, he actually put in an advert for a cruise around the islands. At the time he wasn't a ship operator and didn't have any vessels, and nobody was running that sort of operation around the islands anyway. P&O appears to have thought about the idea for a long time before actually doing it. It could be argued however that Anderson did give people, perhaps for the first time, the idea of sea travel purely for pleasure. The company started cruising, as a dedicated business in the modern sense, in 1904, around ten years after Orient Line.

Destinations to begin with were modest – trips around the British coast, the fjords of the west coast of Norway, the Mediterranean and the odd jaunt further afield. As cruising became more popular, fashionable and attractive to a wider cross-section of society, ships began to call at more ports around the world. The more adventurous traveller was being catered for. By the start of the Second World War in 1939 there was an enormous variety of destinations on the various cruise itineraries, from Acapulco to Zanzibar.

The Med

Cruising began in the Mediterranean Sea in 1844. P&O had been in existence for just seven years, and had by then a number of branch lines connecting with their regular service to Alexandria. The company started selling round tickets which took in Malta, Athens, Smyrna (Izmir), Constantinople (Istanbul), Rhodes, Jaffa and Egypt, before returning passengers to England. It used ships running on their normal commercial lines, so it was not a cruise in the modern sense. Shore excursions were offered at each port of call and passengers would be required to change ship several times. P&O cannily offered a free ticket to the novelist William Makepeace Thackeray, and he wrote a book about his trip under the pseudonym Michael Angelo Titmarsh. He showed his appreciation by describing the cruise in an upbeat way despite the fact that he, and everyone else, was seasick both in the Bay of Biscay and crossing the Mediterranean itself. The book proved to be good publicity, inspiring people to strike out and go on a sea voyage just for the sheer experience of it.

Before the end of the century, other companies such as Orient Line were getting in on the act. The Med was the perfect area for cruising. It was near to the ports around the south and south-east coast of England, and once the choppy Bay of Biscay was out of the way, the Mediterranean Sea was mostly calm. It was also strategically placed at the crossroads of the cruising world. It lapped at many of the principal cities of southern Europe – Barcelona, Marseilles, Naples – but North Africa could be visited too – Tunis, Tripoli, Algiers. Some of the great cities of Western Europe could be enjoyed – Venice, Rome, Athens – and the East began here as well, not to mention the Holy Land – Port Said, Beirut, Istanbul. Passengers could immerse themselves in some of the great cultures that encircle the Mediterranean Sea – Slav, Syrian or Egyptian – or visit the myriad islands, large and small – Corsica, Sicily and Crete. Then there were the idiosyncratic ports of call – Monaco, Trieste, Ceuta. The Med catered for all tastes. An interest in archaeology and ancient civilizations, generated in no small part by the discovery of the tomb of Tutankhamun, led to an influx of tourism by ship in areas across the region. The Med was small enough for a circular tour within a couple of weeks, but large enough not to become swamped with shipping or tourists.

Cruising in the Med in the 1920s and 1930s appealed to patriotic holiday-makers. The *Arandora Star*'s Christmas cruise, which left Southampton on

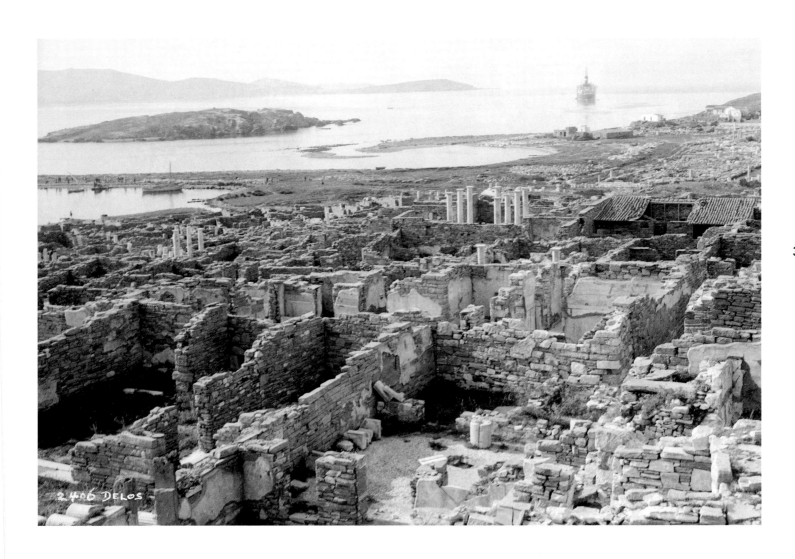

Delos, Greece, about 1930

This uninhabited island is full of ancient ruins, including the famous Temple of Apollo, who was born here according to Greek legend. Interest in the archaeology of Delos began at the end of the nineteenth century with the French Archaeological School of Athens. The site continues to be considered one of the most important in Greece. Visitors have to leave the island by sunset.

Southampton to South Africa with the Lavender Hull Mob

The Union-Castle Line was formed on 8 March 1900, a result of the merger of The Union Steam Ship Company and the Castle Mail Packets Company. For seventy-seven years it was one of the greatest names in British shipping, carrying cargo and passengers from London and Southampton to ports in South and East Africa. During that time Union-Castle ships were a familiar sight, distinctive with their unconventional lavender-grey hulls. The reliability and punctuality of the fleet was legendary. Its business of carrying mail, cargo and people was extremely efficient. Union-Castle also cruised to many destinations over the years, including the Baltic, the Mediterranean, South America and Mauritius. In 1922 the line established its famous 'Round Africa' service. It was on a homeward-bound Union-Castle ship at about this time that Gilbert Morgan Morris had the idea for setting up Marine Photo Service. The line ceased to operate in 1977, with the introduction of containerization.

South Africa itself was new too, formed on 31 May 1910 as a union of a number of provinces. The country began its life racially segregated. Of the new union's estimated six million inhabitants in 1910, 67 percent were black African, 21.5 percent white, 9 percent mixed race and 2.5 percent Asian. Black South Africans were barred from being members of parliament. The South African Party, a union of the former Afrikaner parties, held power under the premiership of General Louis Botha. They passed the Masters and Servants Act (the reservation of skilled work for whites), the Pass Laws, the Native Poll Tax and the 1913 Land Act which reserved ninety percent of the country for white ownership. The 1920s and 1930s saw much discontent in the country, with strikes and widespread protests. In 1937 laws were passed to force municipalities to segregate black African and white residents. The United Nations' condemnation of South Africa's racial inequality after the war did not prevent The Nationalist Party gaining power in the 1948 election, and not relinquishing it until 1994. Apartheid became official government ideology. The 1950s were to bring increasingly repressive legislation against black South Africans. Laws passed included The Separate Amenities Act of 1953 that introduced 'petty apartheid' segregation. South Africa's isolation increased in 1961 when, following a white referendum, South Africa became a republic and Prime Minister Verwoerd took it out of the Commonwealth.

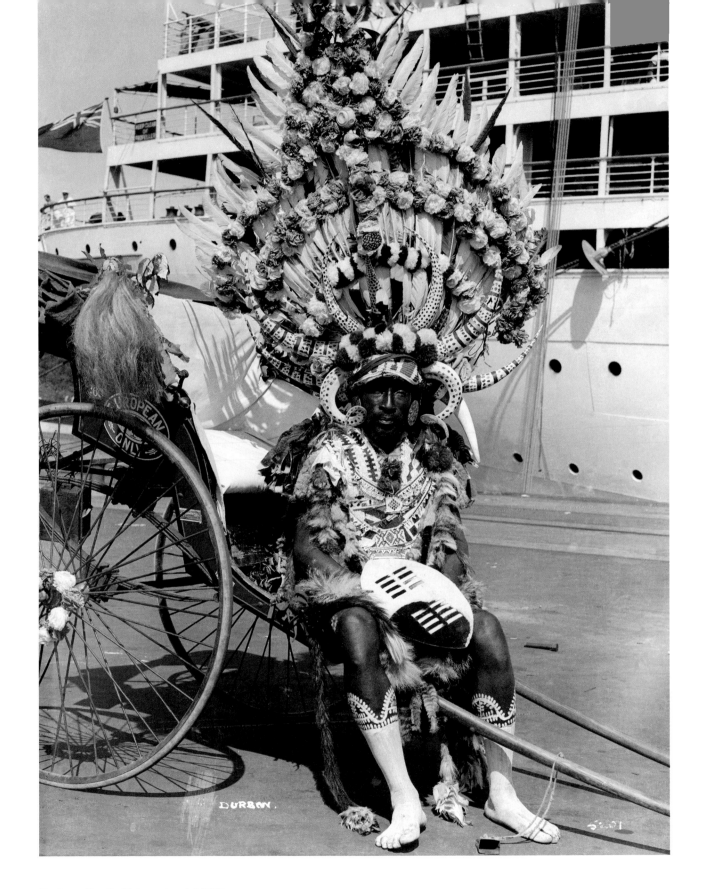

Durban, South Africa, about 1935

The traditional dress (at least in the tourist sense) of this rickshaw puller, the 'European only' notice on the side of his carriage, and the immaculately uniformed white officer at the stern of the liner alongside the red ensign together comprise a complex visual story. How much of all this was picked up by those who eventually went for a ride to see the local sights is uncertain.

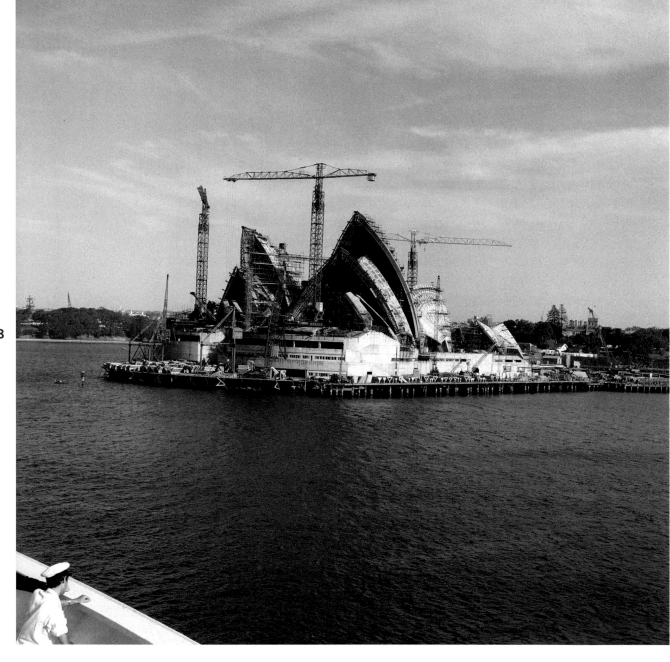

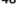

Sydney, Australia, about 1968

The Sydney Opera House was completed on Bennelong Point in 1973, almost twenty years after the international competition for a design. The project was beset with controversy, and Danish architect Jørn Utzon – whose dramatic 'sails' design with its roof of white ceramic tiles won the competition – was eventually forced to resign in 1966 after working on the project for nine years. After this the unexciting interior of the building was built by Sydney City Council. The final cost of the project was 102 million Australian dollars, some ten times the original estimate. It remains one of the world's most important, and recognized, modern buildings and an exemplar of how a structure can add to the environmental experience rather than detract from it. It is all the more remarkable in that its design makes no reference to history or to classical forms. Passengers passing Bennelong Point prior to 1957 would have seen the site being used as the city's tram depot. MPS were of course prevented from selling the same photograph over a number of seasons when an unfortunate thing happened like the building of an opera house. Photographers did get complaints from passengers from time to time that some of the prints on offer looked nothing like the place to which they had just been on excursion.

Orcades leaving port, about 1962

The first new liner to reach Australia after the end of the Second World War, Orient's *Orcades* left Tilbury (east of London) on her maiden voyage on 14 December 1948. She arrived first at Fremantle which at that time, according to Orient Line social hostess Rosalia Chesterman, had 'almost nothing …but a jetty'. Then it was on to Melbourne and finally Sydney, where the ship would remain for four days. It was possibly there that this picture was taken, leaving Circular Quay on a homeward-bound trip. *Orcades* carried 773 first-class passengers and 772 in tourist-class. During the 1956 Olympic Games in Melbourne she was berthed at the port for two weeks and served as a floating hotel. In 1964 she was modernized and converted to a one-class ship.

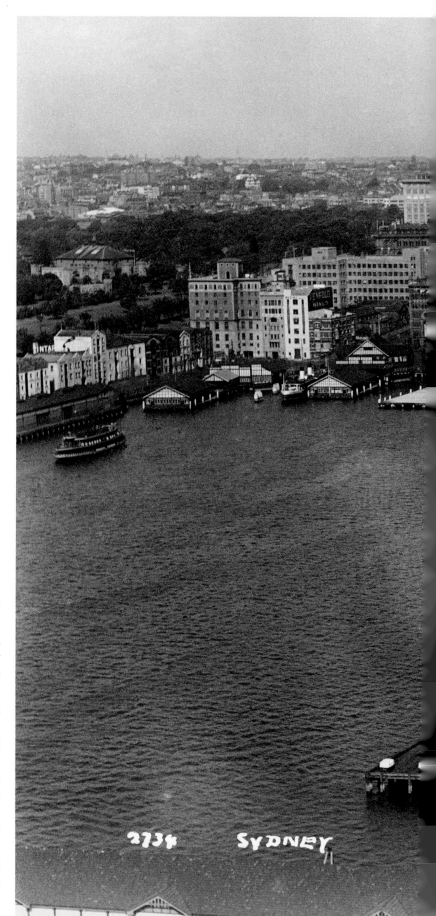

52

Sydney, Australia, about 1935

Taken from the Sydney Harbour Bridge, completed in 1932, this view shows Circular Quay with the city centre beyond. The delightfully rustic passenger terminal in the foreground, together with the half-timbered ferry piers beyond, have long gone, though some of the foreground warehouses survive today as tourist shops and restaurants. Sydney is built round one of the world's largest and finest natural harbours. It has always been a spectacular sight for migrants seeking new lives in Australia. Circular Quay has also always been a popular port of call for cruise ships.

The vessel at the quayside here is Cunard's *Franconia*, which had entered service on the North Atlantic route in 1923. Throughout the 1920s and 1930s though she was used for cruising, and loyal passengers included Cole Porter, Noël Coward, Richard Rodgers and Oscar Hammerstein.

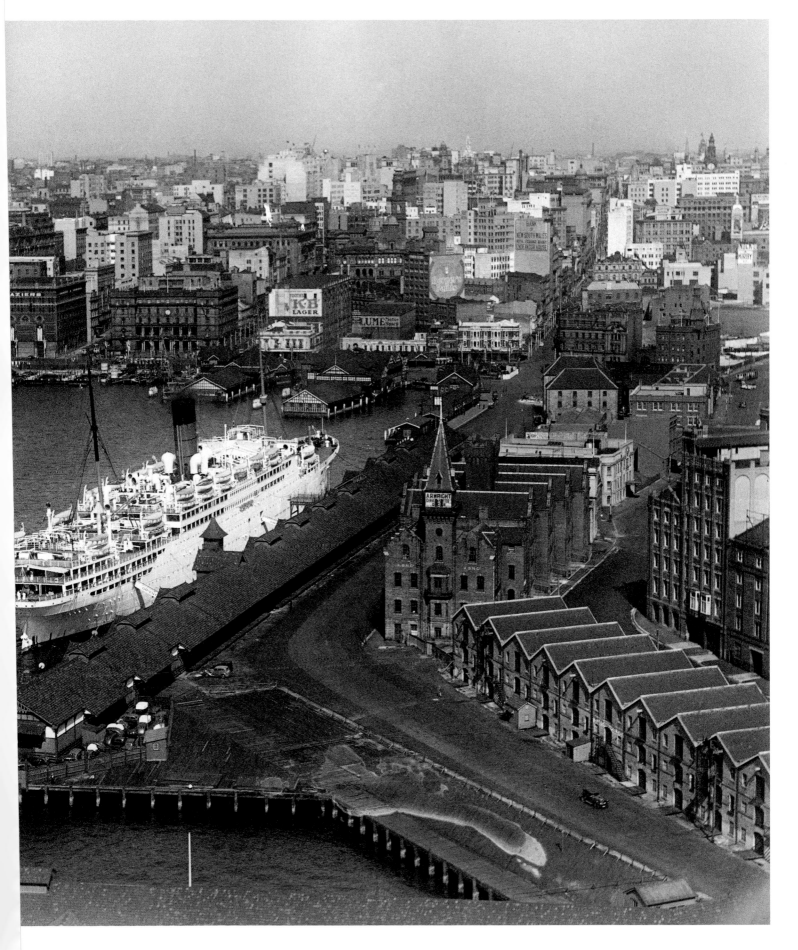

Dubrovnik, Croatia, about 1930

Dubrovnik has had a chequered history since its foundation in the seventh century. Once part of the Austro-Hungarian Empire, it was occupied during the Second World War by the Italian army and then Germany. In 1945 it became part of the Federative People's Republic of Yugoslavia and then, in 1990, the Republic of Croatia came into being. Just a year later the Serbo-Montenegrin army laid siege to Dubrovnik, a situation that was to last intermittently for a further four years. There have been periods of peace however and it was, in the inter-war years, a favourite stopping-off point for cruises around the Adriatic.

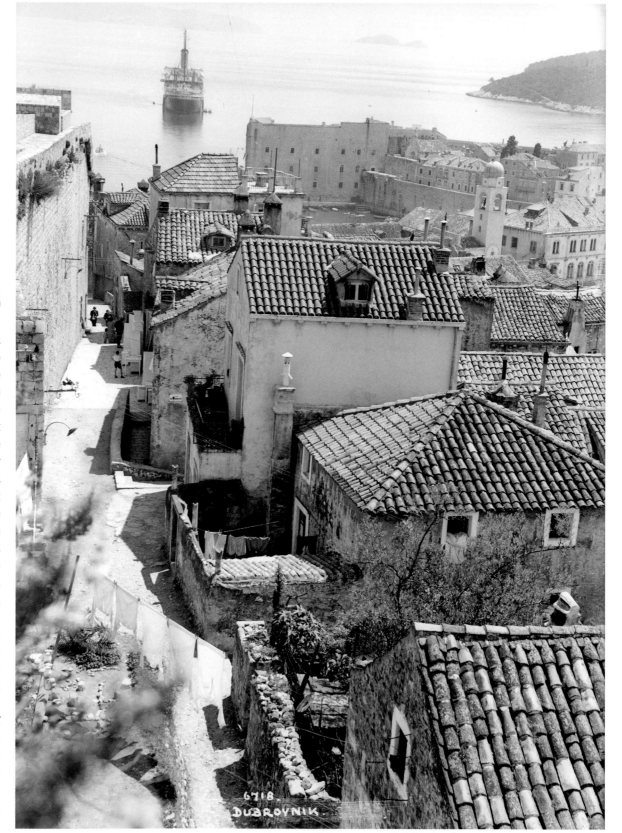

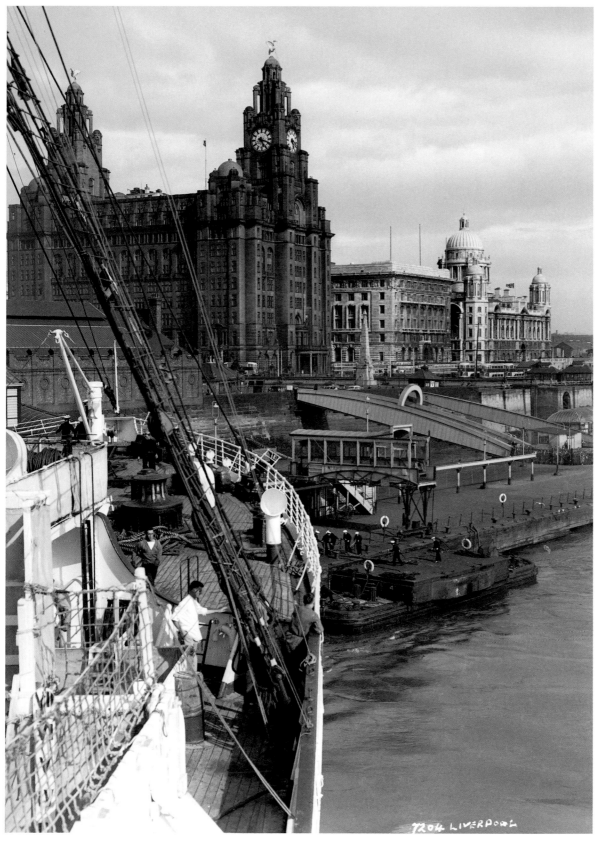

7204 LIVERPOOL

Liverpool, England, about 1930

This is an unusual destination subject for MPS photographers. The port of Liverpool was never a popular one from which to cruise, because it is on the wrong side of the country for Europe, the Baltic and Scandinavia, although Canadian Pacific used it for its westbound routes. The Royal Liver Building is dead ahead. Built from 1908 to 1911 it is architect W. Aubrey Thomas's main work. This massive building is one of the world's earliest examples of multi-storey reinforced concrete construction. This, together with the development of steel framing, made possible the development of skyscrapers. The sculptural domed clock towers are topped with the mythical Liver Birds.

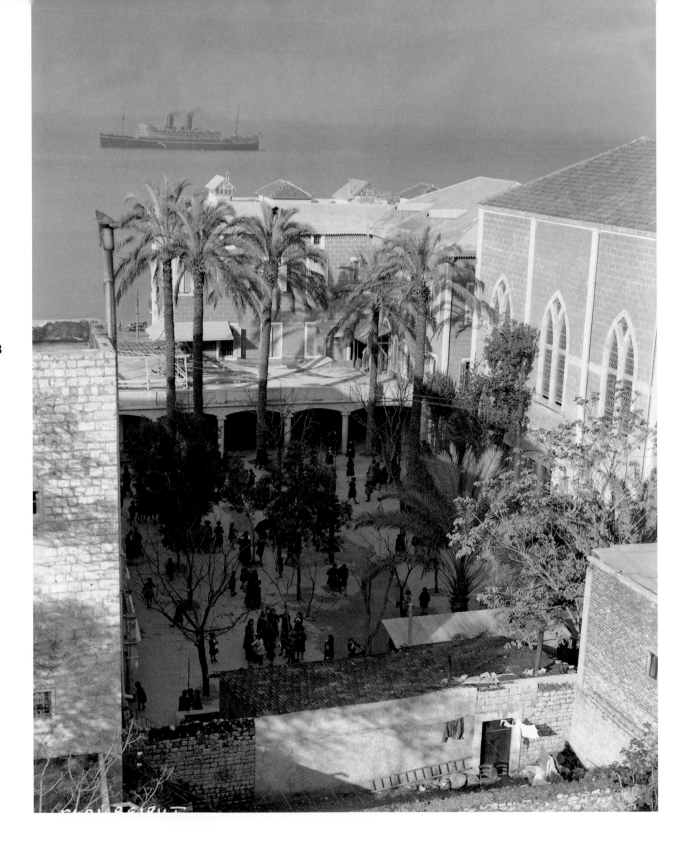

Beirut, Lebanon, about 1935

Beirut was on the Mediterranean cruise circuit, the vessel here being
P&O's *Viceroy of India*. Partly due to its mix of Christians and Muslims,
Beirut has been a melting-pot for Western and Eastern influences and
has suffered divisions over the centuries, both ideological and physical.
Union-Castle Line officer, Peter Laister, remembers visiting in 1980: 'You
couldn't phone from one side of Beirut to the other but you could phone
the UK. If I wanted to go to the port I used to take a taxi from the hotel to
the divide, walk across the divide, then take another taxi to the port'.

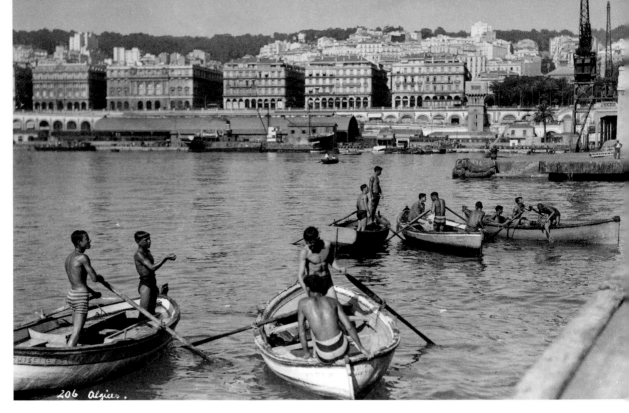

Algiers, Algeria, about 1935

The political problems in Algeria in the 1950s and 1960s caused it to lose its attraction as a cruise destination. Between the wars, however, Algiers was popular for those who considered it a stimulating, Bohemian type of place. The country had been under French rule since 1830 and the Ottomans before that, and so the city was an eclectic mix of Eastern and Western cultures.

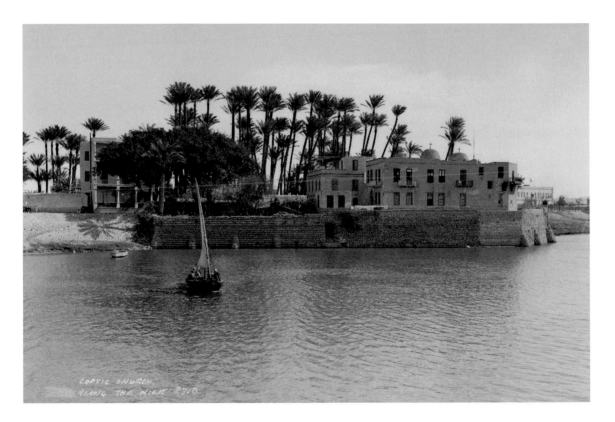

Cairo, Egypt, about 1930

Excursions that took in the antiquarian sites of Egypt were a specialist operation, invariably organized by companies independent of sea-going shipping lines. The drawback was that a Nile-based excursion, starting either from Alexandria on the Egyptian north coast, or from Suez in the east, took time and usually entailed retracing one's steps since the antiquities on the river tended to be south of Cairo. Tours usually combined Nile passenger boats and coaches. Edith Starling, sailing home in the *Rawalpindi* wrote, in 1938: 'Some people are making the Cairo trip while we pass through the [Suez] canal. The minimum price is £3.7s.6d (£3.37) and lasts for only one day. One sees the pyramids, sphinx, etc., but I think it is a lot to pay for only one day's sightseeing'.

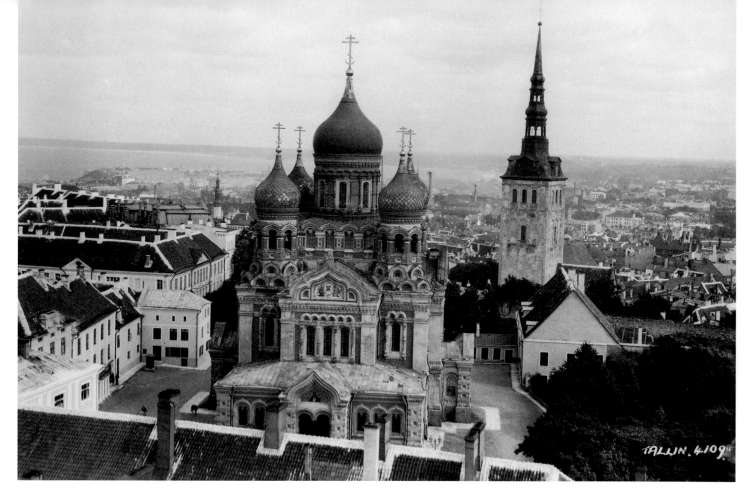

Tallinn, Estonia, about 1930

The Alexander Nevsky Cathedral dominates Tallinn's medieval centre. Tsar Alexander III commissioned the cathedral in 1894 from the architect Mikhail Preobrzhensky, and it was completed in 1900. Much older is the adjacent St Nicholas Church whose origins date back to around 1230. This is a rare photograph of the two buildings before the devastation of the Second World War. The heaviest bombardment of the conflict, the so-called Märtsirünnak, by Soviet long-range bombers on 9–10 March 1944, set the tiny church ablaze and gutted the interior. The tower continued to smoulder for a month. It teetered for almost a decade, on the verge of being demolished, but was given a reprieve and restoration commenced in 1954.

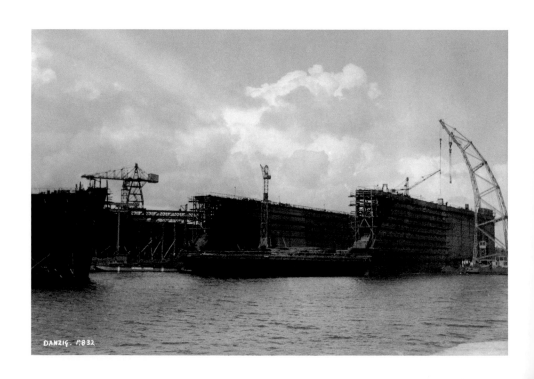

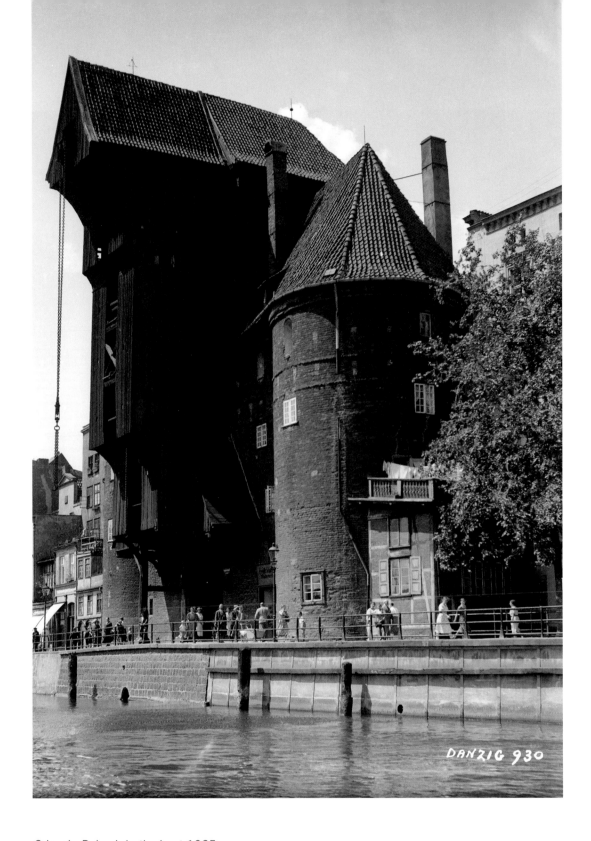

DANZIG 930

Gdansk, Poland, both about 1935

Gdansk is on the Baltic coast and, before 1945, the British knew it only by its German name –
Danzig. For much of its existence it has had a sizeable German-speaking community of traders.
Visitors during the inter-war period would have found a free port and city that had been wrested
from Germany under the Treaty of Versailles. But citizens of Gdansk, opposed to their independent
status, elected a Nazi government in May 1933. The city had been a major port since the
fourteenth century, and subsequently a principal centre for shipbuilding and engineering. The
two photographs show industrial Danzig, old and new. The port crane on the river Motlawa is
medieval, while the floating dock, at the International Ship Building & Engineering Co. Ltd.
shipyard, is decidedly twentieth century.

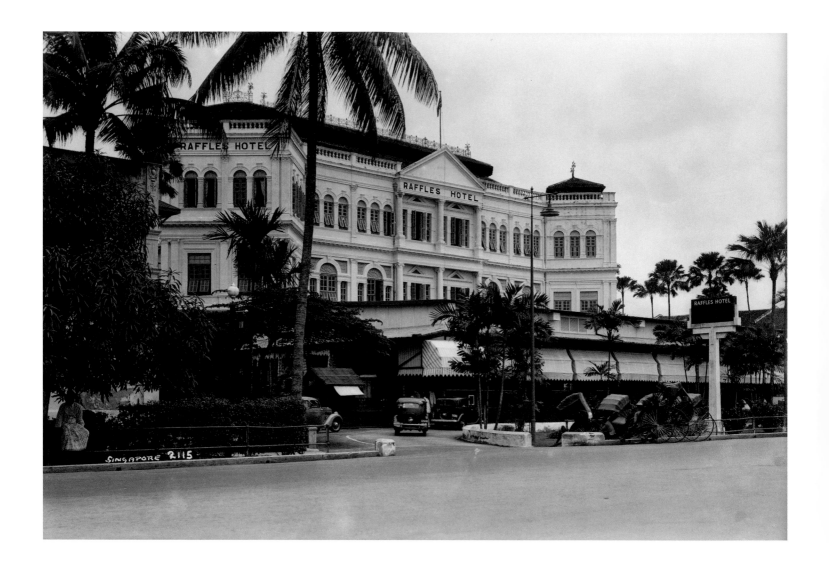

Raffles Hotel, Singapore, about 1937

The famous Raffles Hotel started as a modest bungalow on the sea front, the main building being completed in 1889. Prior to this, in 1885, the existing hotel was purchased by the Armenian Sarkies brothers and, ironically, became the very essence of imperial Britishness. Visiting characters of all kinds have stayed here, including Somerset Maugham, Rudyard Kipling and Noël Coward. It is named after Sir Stamford Raffles, who founded the original British East India Company trading post in Singapore in 1819. In 1987, by now rather tired, the hotel was in danger of demolition but was declared a national monument. Most of old Singapore had already been demolished, including the neighbouring Raffles Institution, set up by Raffles himself in 1823. Today, after a complete renovation not to everyone's taste, the hotel is a solitary low-rise island of green among the skyscrapers of modern Singapore.

Singapore, about 1930

Singapore today prides itself on modernity and efficiency, but this picture of Boat Quay, across the Singapore River, features rows of traditional Indian shophouses. These early buildings have nearly all been lost. Built mostly by migrants from southern India, and with varying plaster decoration, they span the period from 1840 right through to the 1960s. Those pictured here are mostly from 1900 to 1930. They comprised attractive modest terraces of shops with covered walkways beneath, well suited to Singapore's hot, and occasionally very wet, climate. Another feature of Singapore was the *sampans* – small working boats on which families would also live. Most of these were cleared away (sometimes destroyed) by the Housing Development Board in the 1960s and 1970s. Cavanagh Bridge in the foreground, which still stands, was built in 1869 from steel shipped out from Glasgow; it was the last convict labour project in Singapore. In style it would not be out of place across the Thames at Chelsea, and shows how British architecture was replicated throughout the empire.

Bombay (Mumb

The 'Gateway
was erected to
had first set fo
by Scotsman (
architecture th
decorative cha
as a ceremoni
Constructed c
formally to lea
the gateway h
to ships like th
Taj-Mahal Hot
twenty-storey
Viceroy of Ind
confusion hav

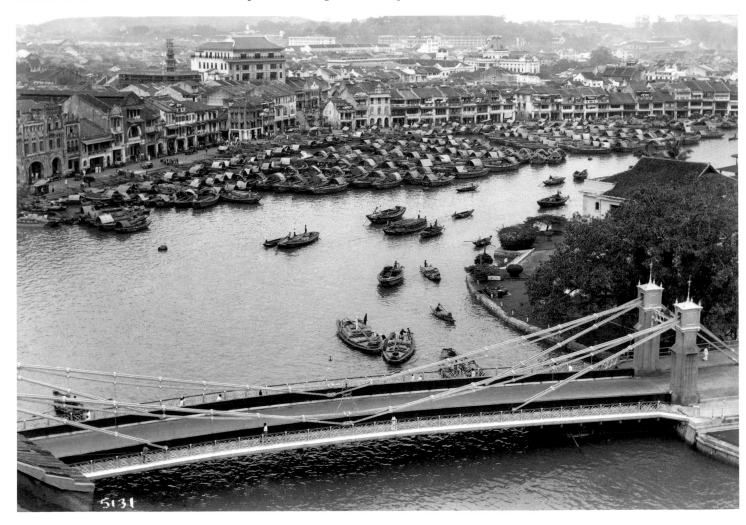

Lisbon

The *Pa*
at the
domin
to the
of Por
monu
sculpt
from l

Åndalsnes, Norway,
about 1935

The ship is at anchor in
Romsdalsfjorden, just
below the Arctic Circle.
The city of Molde is at its
western end while the
town of Åndalsnes, a
popular resort, is at the
extreme eastern end.

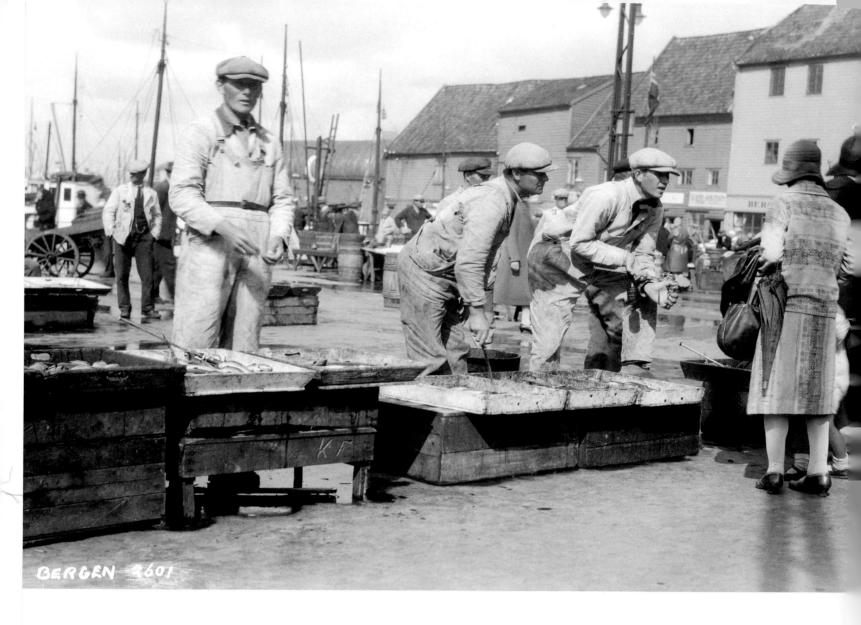

BERGEN 2601

Bergen, Norway, about 1925

The fish market in Bergen has changed little since this shot was taken. Although it is Norway's second largest city, it nevertheless has a small-scale human quality. The passenger is wearing sensible shoes and a warm, knitted jersey suit that has been influenced by Chanel. In the late 1920s the designer was famous for her simple, comfortable, straight-line suits, which were ideal for taking on cruises.

Nordkapp, Norway, about 1935

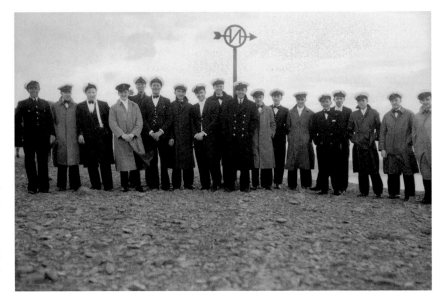

Judging by the various uniforms, this is an assembly of officers from several ships. The bow ties indicate that a special occasion has been celebrated. It has long been a tradition for ships to arrive at North Cape around midnight during the summer season to give passengers the full benefit of the curious half-light. Acknowledged as the most northerly point of Europe it is, in a sense, the ultimate European destination.

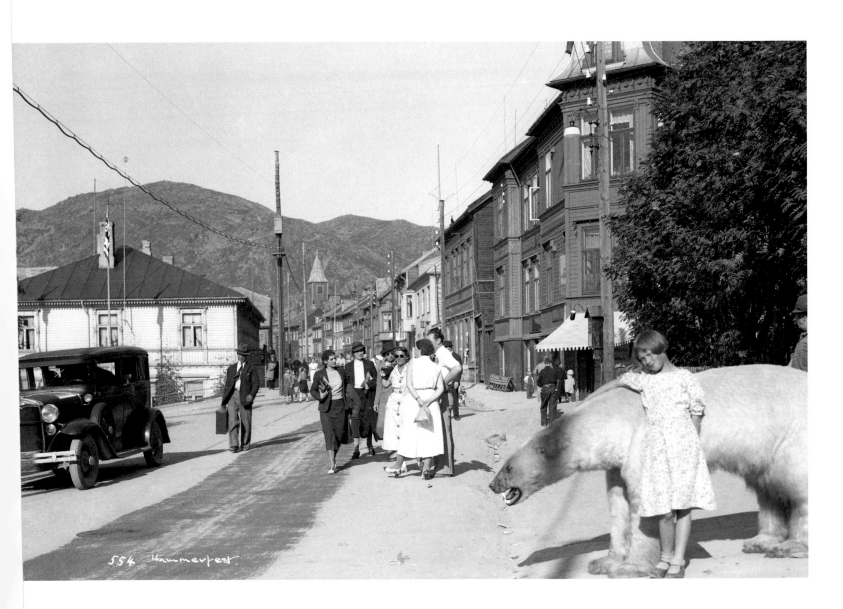

Hammerfest, Norway, about 1935

This is the world's most northerly city. Bernard Radford remembers: 'I've seen a couple of stuffed polar bears outside shops. Hammerfest is a bleak sort of place.

Orcades at Hong Kong, about 1962

In 1960 P&O and Orient Line integrated their fleets completely and became known as P&O-Orient Lines. By October 1966 the name was dropped in favour of 'P&O Line', and all Orient's ships were painted in P&O's all-white scheme from 1962 to 1964. The photograph is how MPS photographers would have known the *Orcades*, still sporting Orient's distinctive corn-coloured hull. She was repainted early in 1964.

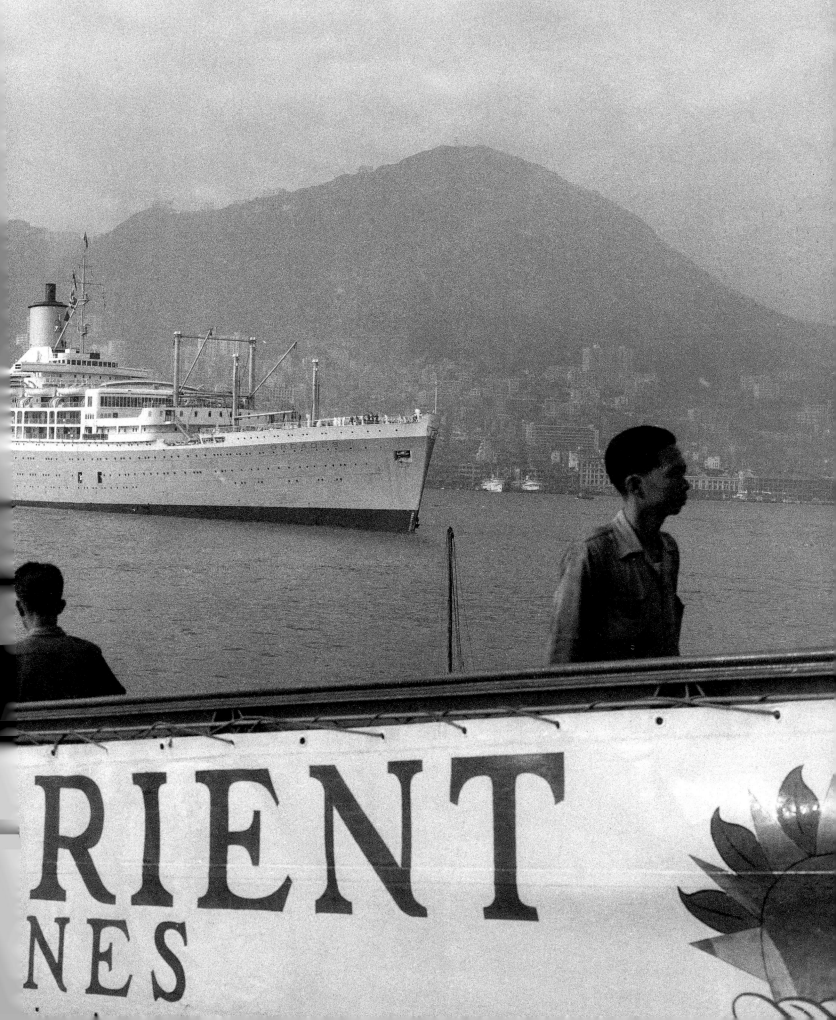

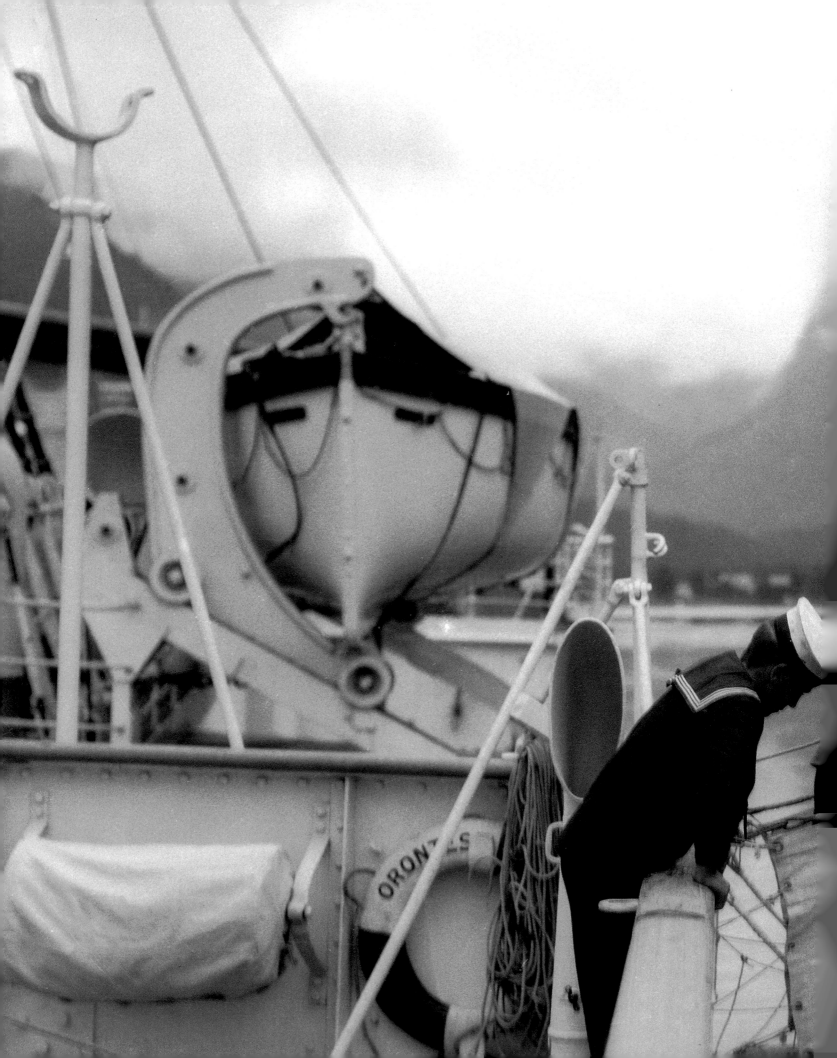

2

Running the ship

Today there are still some parts of the world that can only be visited by ship. In the period from 1920 to 1970 it was almost the only way of travelling any distance overseas, and for seeing the wonders of the world. There were vastly more shipping companies going to many more destinations than there are today, and competition was fierce irrespective of whether markets were expanding or contracting. Many of the world's shipping lines turned to cruising during the boom and bust inter-war period to help to fill empty cabins, and again in the 1960s following the competition from air travel. Good, well-disciplined crews were essential in ensuring that their ships were maintained and operated to exacting timetables and itineraries, and in meeting ever higher customer expectations.

Keeping passengers happy on cruises was, if anything, more of a challenge than on the lines that simply transported people from point to point. Some timetables would be complicated and involve dovetailing with the planned shore-based excursions. Cruising during this period tended to include fewer ports of call and more days at sea, so holidaymakers required more in the way of entertainment and being kept amused. Nowadays cruise ships spend far fewer days at sea.

Crews

Large ships are self-contained microcosms of society. The old class structure segregating passengers from one another was a reflection of Britain itself before the First World War, and its gradual erosion on ships similarly mirrored changes in society ashore. The crew structures on liners and cruise ships have hierarchies comparable to the Royal Navy and, prior to the 1970s, these may have appeared to passengers as autocratic and even archaic. Obviously though, maintaining a ship and serving the needs of passengers and fellow crewmembers has always involved a high level of teamwork on the part of the crews themselves. Some of these teams are highly visible, while others remain very much behind the scenes. Uniforms help both in terms of the command structure of a ship and the interface with passengers. British shipping lines have always adopted the Royal Naval approach of navy blue uniforms as a general rule and switching to all-white uniforms in the Tropics. While the change is entirely practical, to many passengers it was proof, if proof were needed, that they had sailed into warm, sunny climes. 'Stewards are dressed in white. Very nice they look too', wrote one passenger in the *Rawalpindi*, in 1936. It would depend on the captain as to when the officers changed from blues to whites. Kitting themselves out was an expensive business for officers. Union-Castle purserette Ann Haynes remembers: 'We were always in uniform on deck on the ship, which we had to buy ourselves, it wasn't supplied. Nor was our eveningwear. I still have the bill from Bourne & Hollingsworth for all my dresses. I remember one cost £4.19s.6d (£4.98)'.

A purserette on Union-Castle Line was basically the ship's secretary, and required good social, organizational and secretarial skills. There were usually two purserettes on each of their ships, one for first-class and one for tourist-class, and they helped to run the ship's entertainment. There would usually be five female officers on board and each had their own table in the first-class dining room. Eating with and entertaining passengers were important parts of their respective jobs. This was similar to the social hostess on P&O-Orient Lines' ships in the 1960s. Rosalia Chesterman was one of the first:

> I was the social hostess on the *Oriana*. I had been deemed acceptable by that stage to be a first-class hostess. There were only about five-hundred first-class passengers on *Oriana* but occupying easily half the ship. He [Captain Clifford Edgecombe] was a hard taskmaster. Now

Previous page

Taking a sounding aboard the *Orontes*, about 1930

The photograph was taken at Vadheim. It was particularly important to take soundings to establish the depth of water beneath the ship when in the fjords of Norway. The geological composition of the whole region is such that the depths of water inland are hardly ever constant.

Evening tote on the
Orcades, about 1955

Considering that
horseracing and
frog-racing games were
harmless and naive
pursuits, designed to
while away the
evenings, they could
attract large sums in
bets. An officer would
normally take
responsibility for the
monies and ensure
fair play.

and again he would appear after dinner and say 'Come for a walkabout
with me'. We would go through all the public rooms and he would want
to know the names of all the different people and what they did and if
there was anything particularly interesting about them. He expected
me to know everybody. Sometimes the word would come down 'The
Captain wants you to arrange a cocktail party for this evening', and
I would get this message maybe three o'clock in the afternoon. So I
would have to go around and find people who would mix well and who
would keep the Old Man amused. I used to have to introduce people.
Fortunately I had a good memory for names.

Pam Laister occupied the same position on the *Oronsay:*

Although we were junior officers we had privileges. A junior officer had
to be off the decks by ten o'clock, there were no exceptions. That was it.
The female junior officers were allowed to stay up until eleven or twelve
o'clock at night. You were expected to be around for the entertainment.
We used to have to carry around with us five or six evening dresses. We
used to have a mess kit for eveningwear. With Union-Castle it was a black
dress, and a white one when in whites with epaulettes on. With Orient
Line it was a duck-egg blue dress with the Orient insignia on the pocket
and braiding round the neck and arms. If you were missing from the
dance for maybe three nights or more you would have a letter along the
lines of 'The Captain requests the pleasure of Miss Moody at his table this
evening'. And you would know that this was a reprimand for not having
been up for a few nights. You had to be seen to be there, to be circulating.

In a sense we were always on duty, we were always on the job. I was a children's hostess but on some ships where there was Scottish dancing and the children's hostess would be expected to turn up at six o'clock in the evening to join in, you would have to attend an officers' class to show you how it was done. And only then would you get into eights with passengers, with little Chinese gentlemen and so on, trying your best to keep your eight in order. A lot of fun but it meant you had to be there. You had to be at the race evenings and to cut the tape. You couldn't let your hair down. You could have the odd dance with one of the other officers but you couldn't make a habit of it. And if you were seen to be dancing with any of the young passengers too much, you were taken to task.

Another important member of the crew was the nursing sister. There were usually two on each vessel, to assist the two surgeons. They would treat everything from broken bones to appendicitis and, no matter how many or how few children there were aboard a line voyage, there always seemed to be an outbreak of chicken-pox. Apart from their day-to-day tasks women officers had to learn and be proficient in things like heliographing – signalling with reflecting flashes of sunlight – and semaphore. Working for a shipping line, or even a particular ship, evoked tremendous loyalty. Competition was fierce and officers would be keen to show that their company had the edge. Union-Castle was famed for its punctuality. One of the duties of a Union-Castle deck officer was to establish exactly what time sunset was. A bridge boy or a quartermaster stood at each flag throughout the ship, a whistle would blow at exactly sunset, the flags would be lowered simultaneously and 'Sunset' would be played. At eight o'clock in the morning the whole exercise was reversed. If there were two Union-Castle ships in port, the flags would come down or be raised simultaneously on both the southbound ship and the northbound ship.

The merger between P&O and Orient in 1960 brought together two long-standing rivals, even though the former had effectively owned the latter company since the end of 1918 but had continued to let it operate independently. Rosalia Chesterman remembers that period well: 'When P&O merged with the Orient Line we weren't very well received because there was this animosity that one was better than the other. P&O were always superior to the Orient Line. But in regards to the job that I did, entertainment and social welfare, Orient were much better'.

P&O used Asian crews since its earliest days, Orient Line did not.

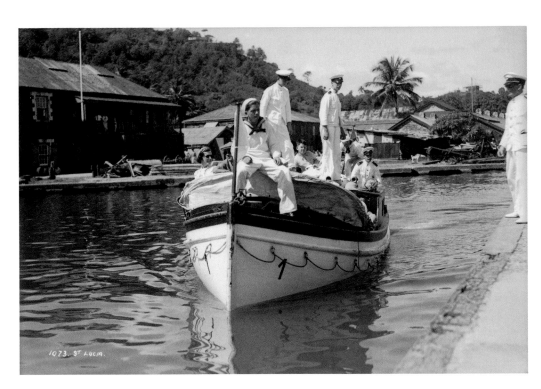

Tender arriving at St Lucia, Windward Isles, West Indies, about 1930

If a ship could berth alongside at a port of call it would do. At ports where this was not possible tenders were necessary, but billed as part of the fun and adventure of cruising. The procedure would involve any number of crew, as can be seen here.

Officers of the *Oronsay*, 1961

This photograph was taken during a round-the-world voyage that departed on 15 August 1961 from London for the Pacific, Australia and Hong Kong, and arrived back home on 14 January 1962. *Oronsay* was under the command of Captain R. W. Roberts, OBE (bottom row, fourth from right). The female officers were, from the left of the picture, Jennifer Campbell Davys (nursing sister), H. Saffery (junior assistant purser), Patsy Fraser (assistant purser), Yvonne Hammond (tourist-class hostess), Wendy Hoare (first-class hostess), Pat Faulkner (first-class children's hostess), Pam Laister (tourist-class children's hostess), Elizabeth Timothy (junior assistant purser) and Clair Yates (assistant purser). There can be an enormous amount of camaraderie amongst a crew over the course of a long voyage, and relief, tinged with sadness, when it is over.

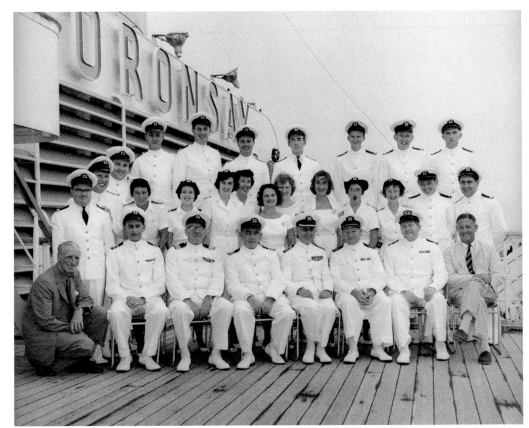

Passengers felt happy in their presence because they knew it was a part of the company's long tradition. Some families served the company for three or four generations. They were the very embodiment of P&O's long and reliable heritage of servicing the empire's routes and the people who travelled on its ships. When P&O first started operating in the Indian Ocean, in the 1840s, they found that European crews didn't like the conditions and didn't work well so they employed Asians, East Africans and Chinese for laundry duties. They quickly established a tradition of reliable service. Asian seamen tended to work in groups rather than as individuals, and because they were shorter and lighter than the average European, sometimes more of them would be required for specific tasks. The Indian government always had strict regulations on how their people were employed. P&O were not allowed to pay an Indian waiter the same salary as a European waiter as it would have been grossly disproportionate to what Indians at home would be earning. Typically they would be on the ship for between nine and twelve months at a time. The deck crews were Hindus, and a *serang* (a sort of Asian deck petty officer) would be in charge of them. Under the *serang* were *tindals* (the equivalent of boatswains' mates). The purser's department crew – cabin stewards and waiters – tended to be Roman Catholics from Goa, while the engine room crews were invariably what would now be Pakistani. These were Muslims and they also had a *serang* responsible for them. European officers would normally give their orders to the *serangs* in charge of the deck and engine room crews. It was considered poor form to order an individual Asian seaman to do something, because one would be undermining the authority of his Asian petty officer. In an emergency, however, that would not apply and European officers were expected to know the basics of Hindustani. Because of issues of possible contamination by pork and beef elsewhere on the ship, Hindus and Muslims had their own cooking and eating facilities. Passengers would virtually never see the engine room crews, but would frequently see the deck crews in their highly distinctive uniform and, of course, would come into contact with the stewards all the time. The popularity of these seamen is borne out by the sheer quantity of photographs taken of them by MPS.

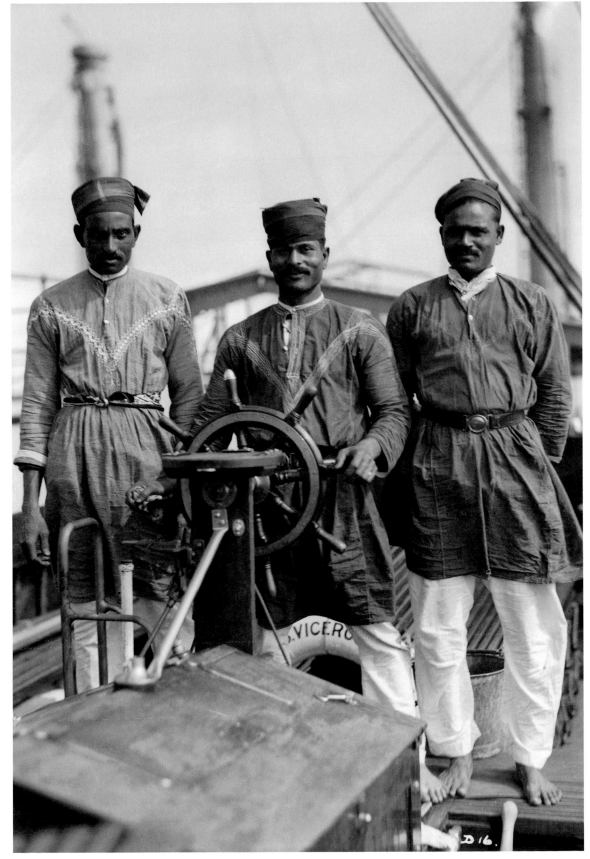

Lascars from the *Viceroy of India* in a tender, about 1935

Lascars (Asian seamen) were often used to help to ferry passengers from ship to shore on their excursions. With their colourful and exotic uniform, they were popular and highly visible members of the crew. Their uniform consisted of dark blue, knee-length, embroidered tunics (*lalchi*) over white trousers, red cords (*rhumal*) around their waists, and brimless caps of the same red. The *serang* and his *tindals* were distinguished by richer embroidery on the tunic, tartan *rhumals* and usually a silver boatswain's pipe hanging from a chain.

It was my very first trip with Captain Edgecombe, who eventually became Commodore. Very charismatic, *very* strict. And there was I, a very new person. There were two children's hostesses. It was a one-class ship, the *Otranto*. And you always began your life as a 'chilly-ho' on a one-class ship. You then graduated to the tourist end of a two-class ship. It was only then you were deemed sufficiently grounded in sea life, and how to behave, that you then worked in first-class. This was 1957 and we were at Tilbury to be told that embarkation in a couple of days' time would include 500 children. Even with the Ten Pound passages, that was a record. But the Old Man, the Captain, he was so 'with it'. He ordered all these exercise books, pencils, rubbers and rulers and then he told us that we were to organize any teachers who were among the passengers and anybody else who would like to help, because no way could you have 500 children running loose all day around the ship if there was nothing to do. He just laid down the law, he said to everyone, 'this is my ship and I will say what you will do'. And it was absolutely fantastic. Sufficient people came forward. We divided all these children into groups of about fifteen or twenty. A register was produced. At nine o'clock all these children went to their classes that were held all over the ship – part of the dining room, part of the smoke room, anywhere. And if a child didn't attend then the parents were hauled up in front of the Old Man. Between nine and twelve every morning every child under eleven had to attend lessons. This was school as we called it. It was a terrific challenge as it was in the days when schoolwork was a lot more formal. I used to do things like mental arithmetic and dictation. They were used to being seated and facing a teacher. Goodness knows what would have happened otherwise – they would have been running wild.

At twelve o'clock that was it, you couldn't keep them there all day. In the afternoon they could do swimming. I used to teach PE before I went to sea, so was keen on teaching them to swim and I had heard that if you lowered the water in a pool to eighteen inches [forty-five centimetres] and you got the children to walk on their hands and knees along the bottom of the pool, before they knew where they were they were dog-paddling. I must have made the deck hands' lives a misery as I had the pool lowered to eighteen inches every afternoon.

After the *Otranto* I graduated to the two-class ship, the *Orcades*. The tourist-class area was at the back-end and I was the tourist-class children's hostess. On the after-end of the deck was my playroom, right over the propeller, and the vibration, oh dear. And the heat was unbearable as we sailed further south because there was no air-conditioning.

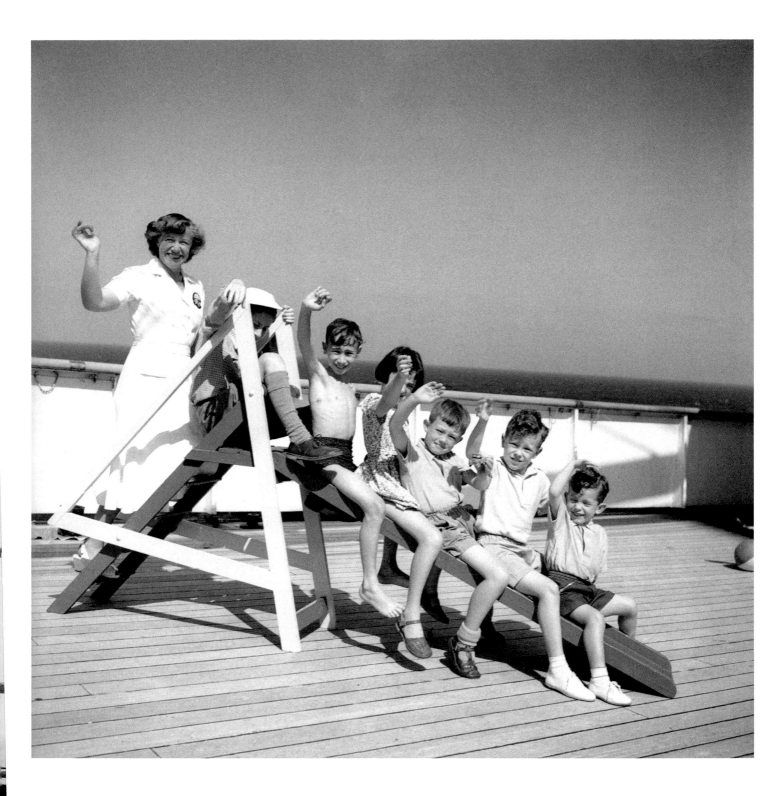

Children's hostess and junior passengers aboard *Chusan*, about 1960

The *Chusan* was built for P&O's Far Eastern service. From 1950 she plied regularly for most of the year to Hong Kong, Japan and also to Bombay (Mumbai). From 1963 she served Australia as well. They were long voyages. The first London–Sydney run took thirty-four days, and keeping kids of all ages entertained, educated and under control was a challenge. This image though is one of optimism. Perhaps the children are heading for a new life 'Down Under'.

Death at sea

The prospect of going on a cruise and not to return is to think the unthinkable, but sadly it has never been a particularly rare phenomenon. Given that all passengers, even in the days of second-class or tourist-class cruises, are cosseted from the off, this may seem surprising. Reasons may well include the temptation to over-do it and to over-indulge, the popularity of cruises with older people, and the number of people who have chosen to cruise for reasons of poor health.

Perhaps the most sombre event that MPS photographers were required to record was the occasional memorial service at sea. Under international maritime law ashes can be cast into the sea, and many ex-mariners stipulate this. Burial at sea can also happen when the person has died at sea with no suspicious circumstances surrounding the death. Post-mortems must be carried out, either on board or at the nearest port of call, by a pathologist. Next of kin should be consulted where possible. Once a member of the deck crew of the *Otranto* died at sea by falling into an empty swimming pool. The officers suspected foul play and London's Scotland Yard instructed them to keep the body. The ship's purser at the time recalls that the body was stored down in the ice room: 'Somebody pointed out that the body would freeze to the deck so the captain told us to turn it around every twelve hours. The captain and I did this. The surgeon did a post-mortem and was delighted to discover that the body was frozen, which made his job a damn sight easier'. Sometimes a body was kept at the request of relatives who preferred to have the deceased brought home for burial. More modern cruise ships have mortuaries, but before the 1960s, and particularly on smaller vessels, corpses were stored in the ice room, as in the account above, or anywhere cold. On at least one occasion a body was apparently kept in a freezer that had been emptied of food.

Very occasionally there will be a suicide on board, usually a member of the crew. Naturally it was distressing for colleagues, who would have to keep the news from passengers. Photographer Bob Cook remembers that it seemed to occur more frequently on Russian-owned cruise ships. Nearer to home, purserette Ann Haynes recalls that there was a suicide on her very first trip with Union-Castle Line, on the *Transvaal Castle*:

> We had just left Las Palmas bound for Cape Town when there was emergency drill in the middle of the night. The Klaxon siren went off

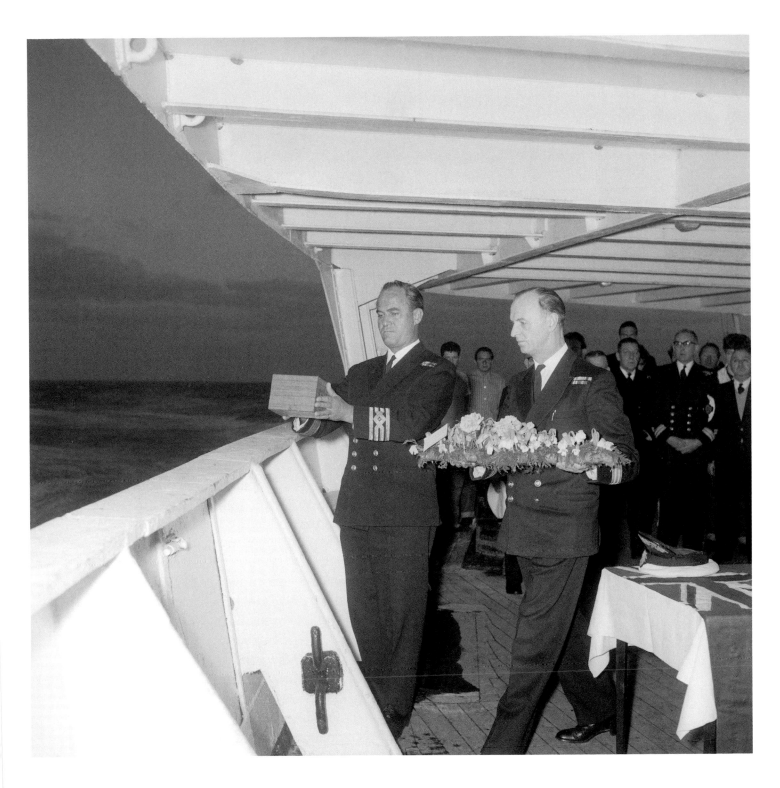

Committing ashes to the deep on the *Empress of England*, about 1960

Services such as these were normally conducted early in the morning, away from the attention of the travelling public. The purser is holding the wreath and the captain is dropping the ashes. Orient Line purser Nelson French recalls: 'Very often we would commit to the deep a mariner's or ex-seaman's ashes. We would bore little holes in the box so that it sank. I had a captain who opened the box thinking he was going to scatter the ashes and they all blew back inboard'.

PANAMA. 1704.

97

Crew aboard the
Kungsholm transiting
the Panama Canal,
about 1935

Photographers
remember that the
Panama Canal was easy
to photograph because
transit would take all
day. It was also a period
of relative inactivity for
the crew, interspersed
only by routine duties
and paperwork.

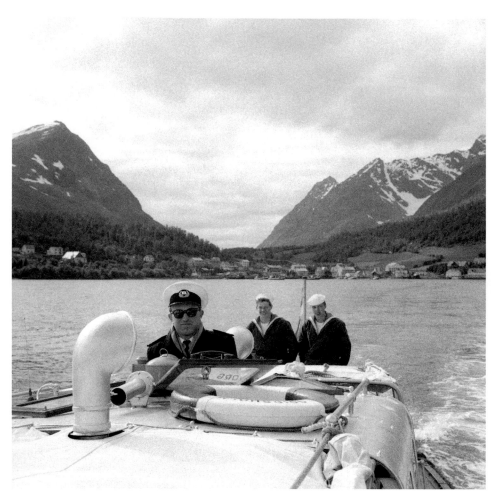

Lyngseidet, Norway, about 1970

An enclosed tender belonging to the Swedish America Line ship *Gripsholm*.

Alexandretta (Iskenderun), Turkey, 1937

The steps leading ashore are, in effect, an international frontier, and a member of the harbour police stands guard. Reassuring in the distance, but not too far away, is the second *Orcades*, then a new ship. Her maiden voyage was a Mediterranean cruise, departing Southampton on 21 August 1937. Orient Line then put her on the Australia run where she made several cruises out of its ports. She was in service for just two years before war was declared. She was torpedoed by *U-172* in 1942.

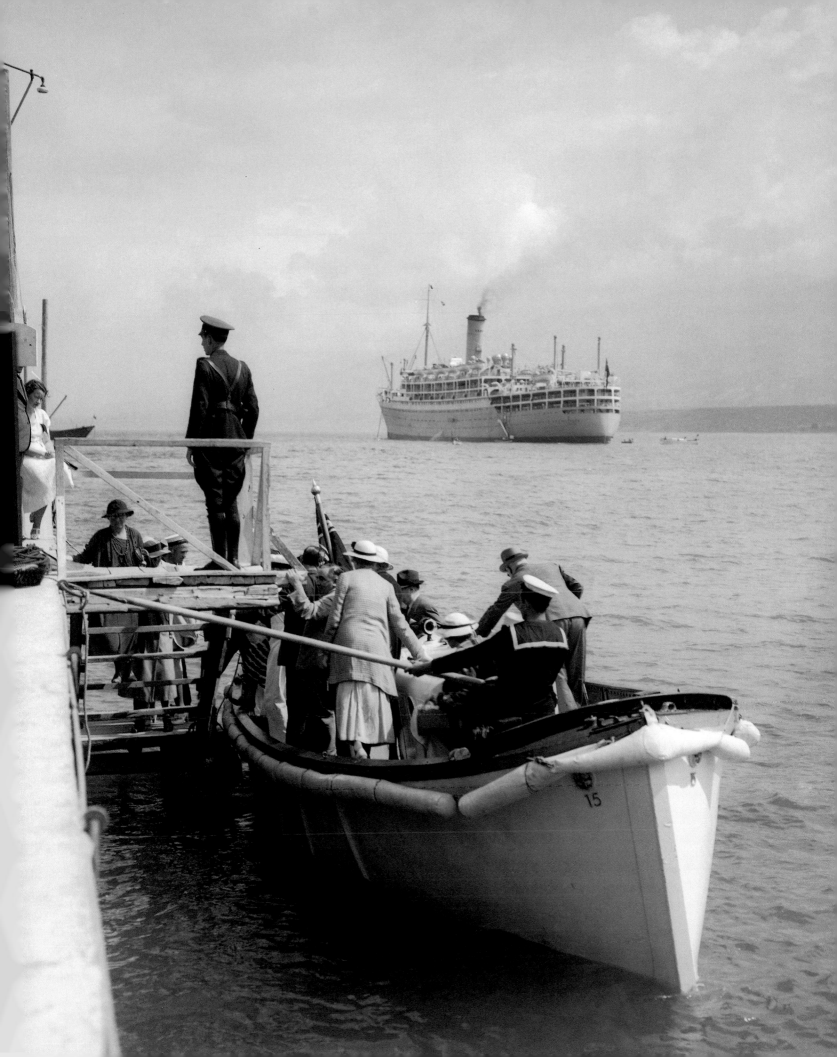

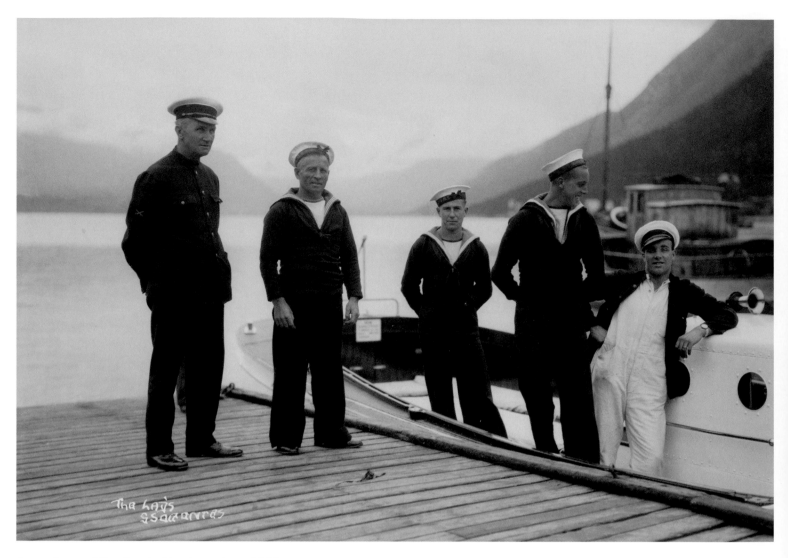

Crew of one of the *Orontes'* tenders, about 1930

When a ship is in port there is a limit as to what the crew can do, and
there are inevitably periods of idleness. Here seamen are probably
waiting for a shore excursion to return to the tender.

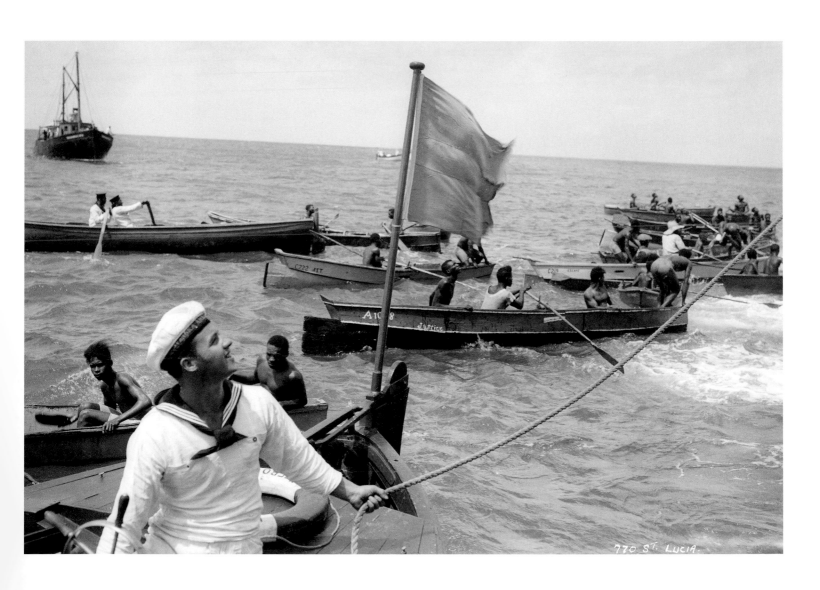

St Lucia, Windward Isles, West Indies, about 1935

In this scene of chaotic abandon, a sailor navigates his tender through the flotilla
of small local vessels and back to his ship, probably the *Kungsholm* of 1928.

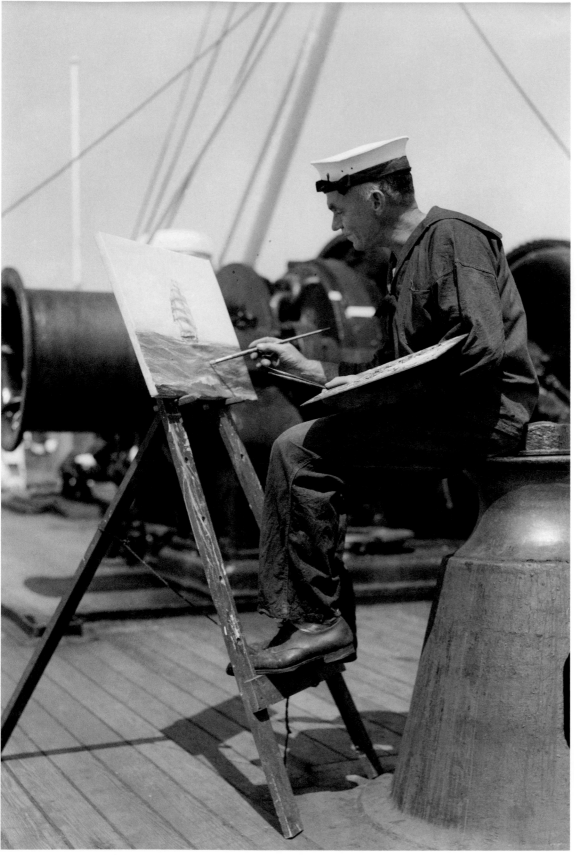

Seaman at recreation, about 1930

This carefully, even uncomfortably, posed picture provides an intriguing perspective on Britain's maritime history and its relevance now. There is a long tradition of seafarers creating artefacts whilst at sea, originally as a way of whiling away the time on long sailing voyages, but it declined over the first half of the twentieth century, partly as a result of improved recreational facilities for crews. The seaman here then, obviously proficient, talented, well equipped and even well shod, would appear to be an exception, turning his back on the mess room and the dartboard in favour of a more tranquil pastime. Even the subject of his painting belongs to a bygone age.

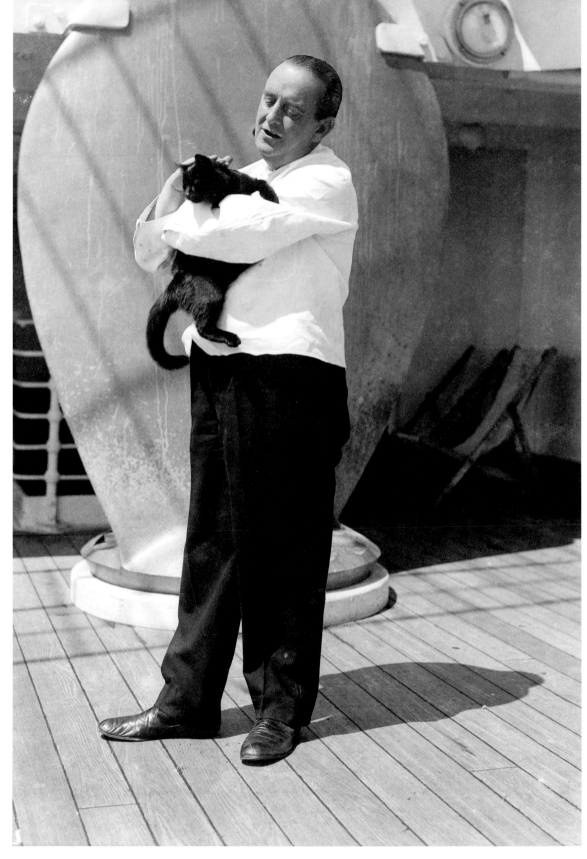

103

Steward with the ship's cat, about 1930

Ships are notorious for having rodents on board, therefore ships' cats have always been necessary. Resident on the *Queen Mary* for many years was perhaps the most famous maritime cat, Minnie. The new *Queen Mary 2* also has a cat, Minnie 2. The steward here is posing in front of the ship's spare propeller blade.

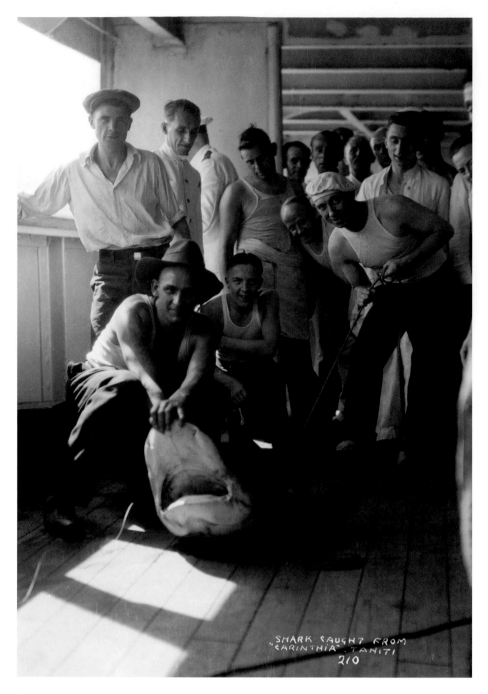

Shark caught from *Carinthia*, Tahiti, about 1925

Almost certainly these are members of the crew, given their
dark-coloured working trousers and singlets. The two men on
the right are each wearing part of a chef's uniform. Cunard Line,
to which this ship belonged, was an early client and the
photograph is one of the oldest in the MPS archive. A favourite
with holidaymakers, *Carinthia* had sailed over 270,000 miles
(435,000 kilometres) on her cruises by 1932.

Officers of the *Viceroy of India*,
about 1930

The carefully structured and artful
composition suggests that this was a
promotional photograph. Some
shipping lines to which MPS was
contracted stipulated that negatives
could be used by them, if wished, for
publicity purposes.

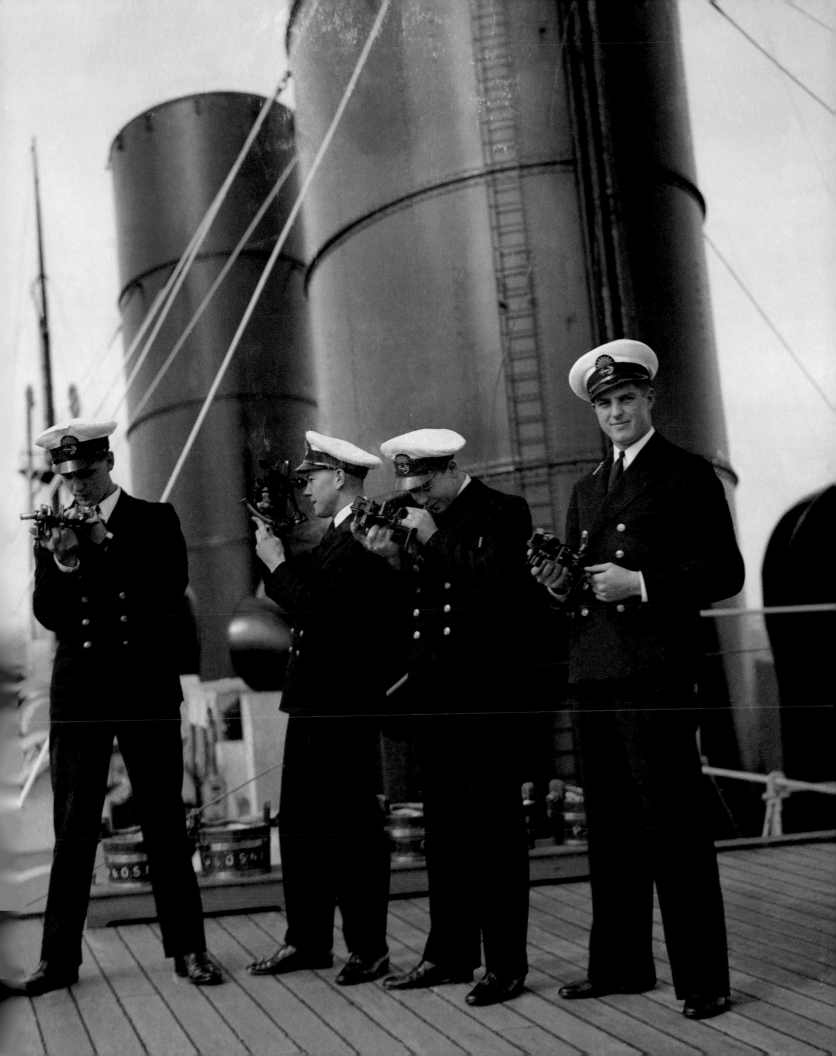

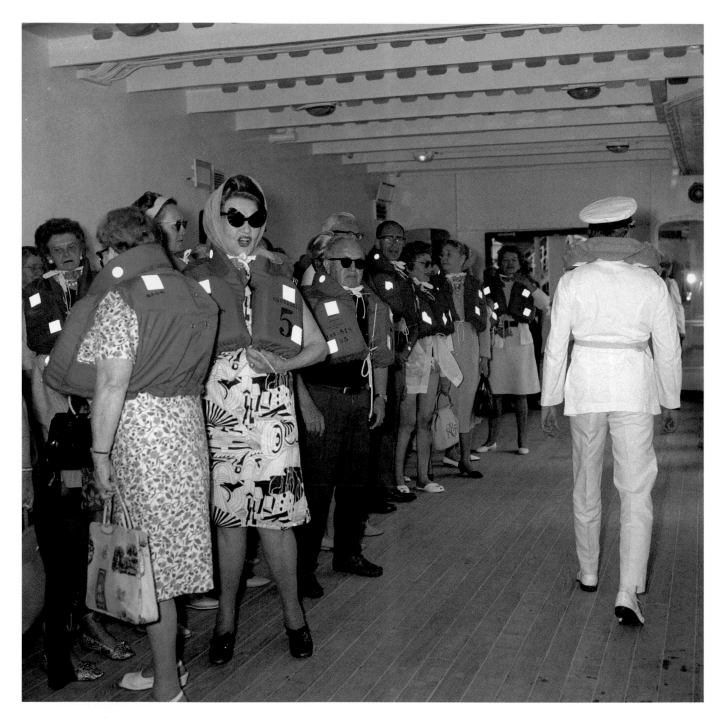

Lifeboat drills aboard the *Kungsholm*, about 1967

Passengers are required to carry out lifeboat drill early on the day
of embarkation. It is compulsory under international maritime law, so
the shipping companies attempt to play it for its entertainment value
or else turn it into a 'let's make the best of it' exercise.

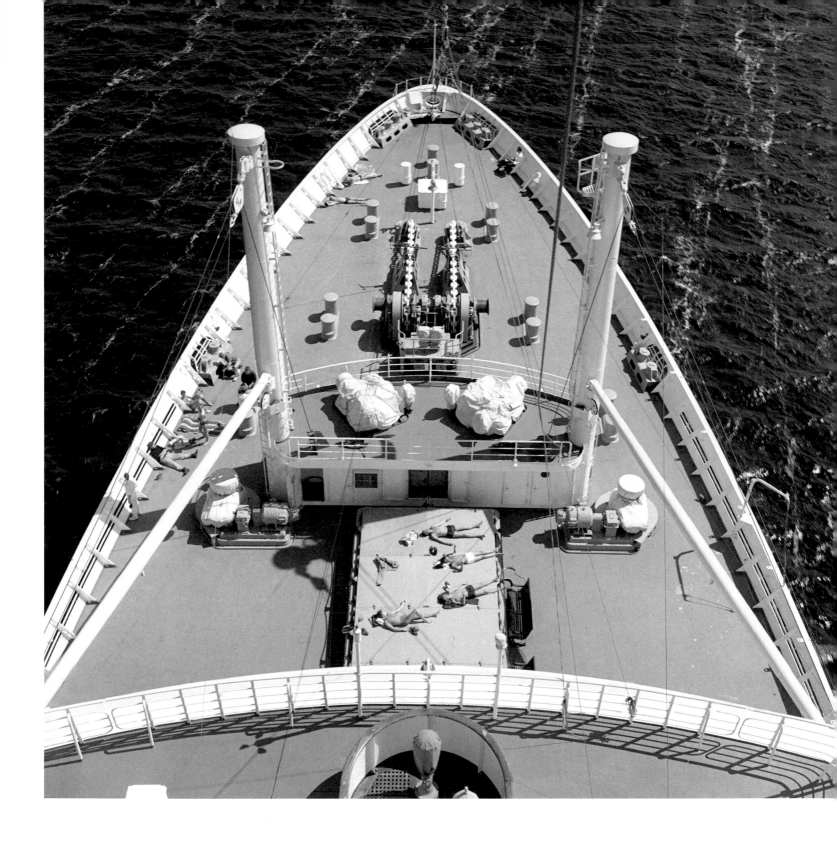

Crew sunbathing on the *Gripsholm*, about 1965

The forecastle (the deck situated at the bow of a ship) has only been very recently given over entirely to passengers. In the past this prime area would have been off-limits, and was therefore the ideal place for crews to relax, away from the gaze of passengers. A number of them here are sunbathing on the cargo hatch, aft of the two derricks (ship's cranes). The photograph was taken on the St Lawrence River, Canada.

Bizerte, Tunisia, about 1935

This image, like several others in the Collection, provides a striking contrast between the towering, orderly and self-contained bulk of the visiting ship and the rather more untidy ('exotic' or 'picturesque' would be the description in the travel brochure) environs of the port itself. This posing Tunisian is nicely positioned between the two worlds, his printed sign directing passengers from the *Viceroy of India* towards the local guides who will direct the shore visit. He may even be one himself.

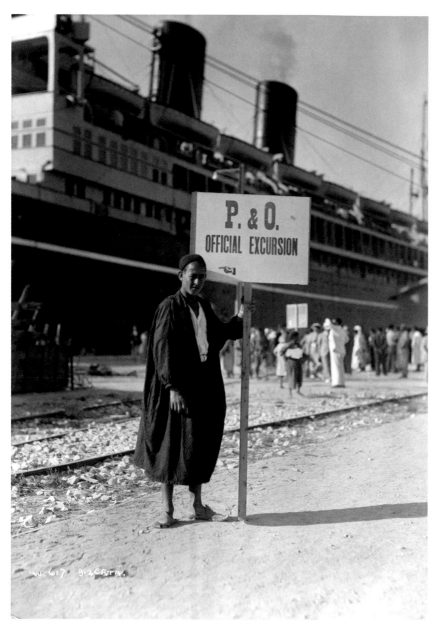

Santoríni (Thira), Greece, about 1935

A sailor takes a sounding as the ship approaches the Greek island. The photograph is interesting as we examine, through the photographer's lens, the passengers who are engrossed in the demonstration of seamanship. There may be a class division here with the lower promenade at the top of the picture being a tourist-class area. There are crew here too, including a nurse. The passengers on the upper, possibly first-class, deck are certainly well kitted out. Several of the men are wearing linen lounge suits and Panama hats, while others have binoculars and even their own cameras.

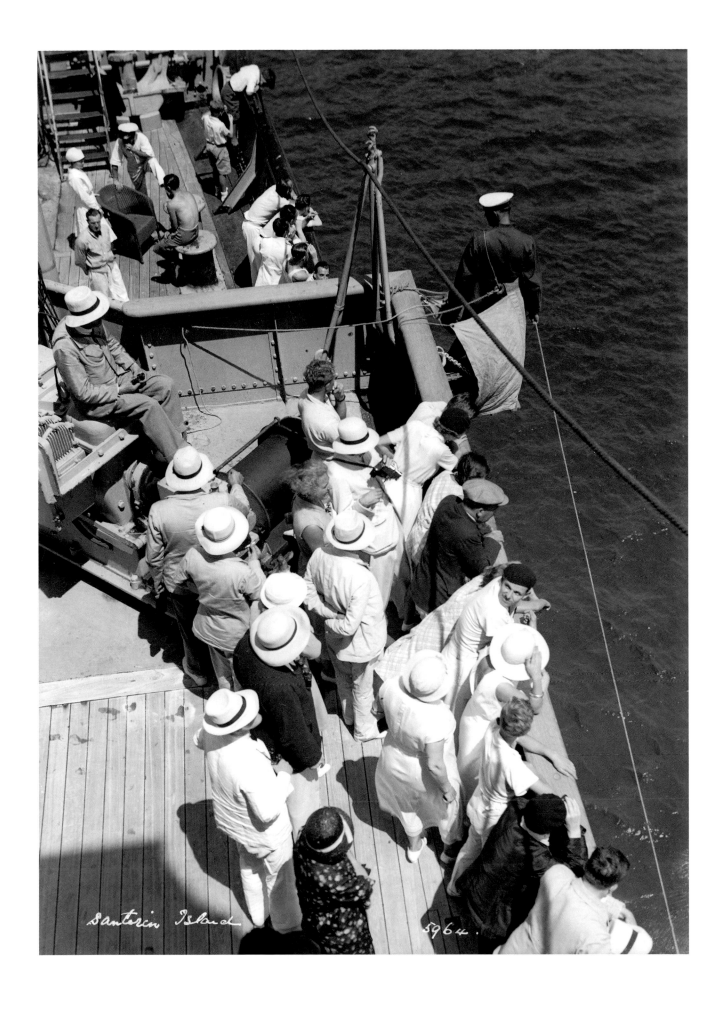

Santorin Island 5964.

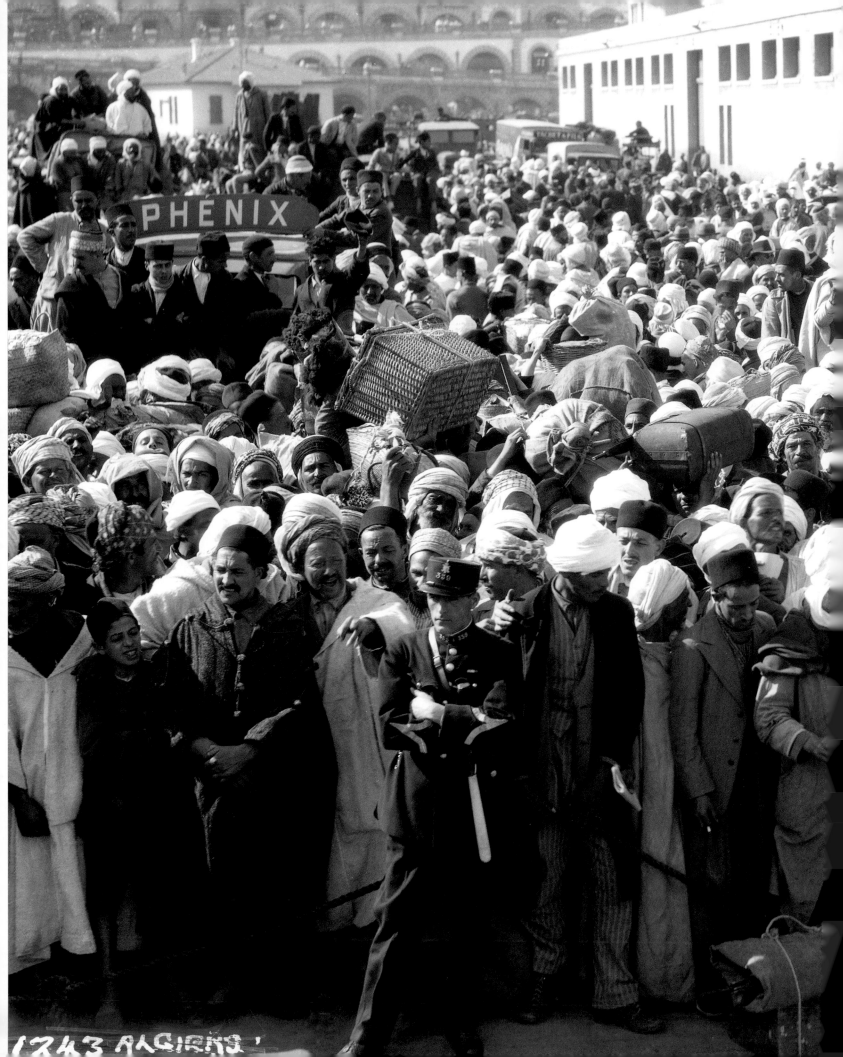

PHENIX

1243 ALGIERS

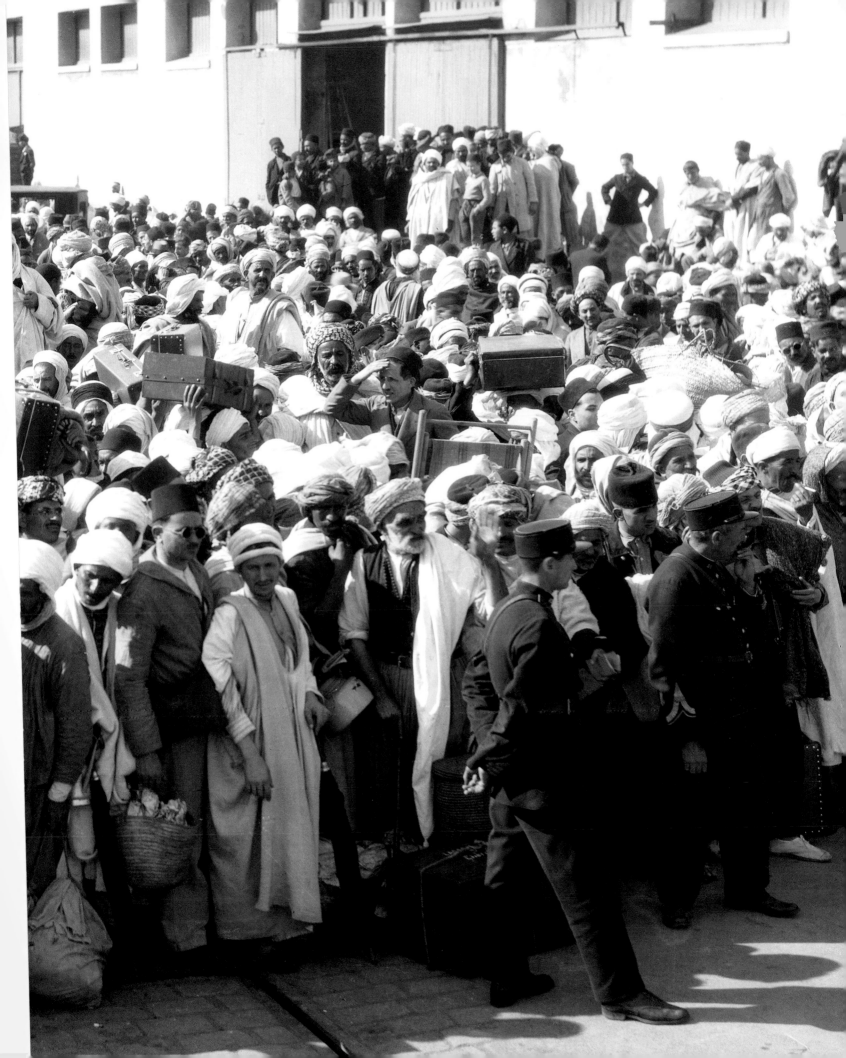

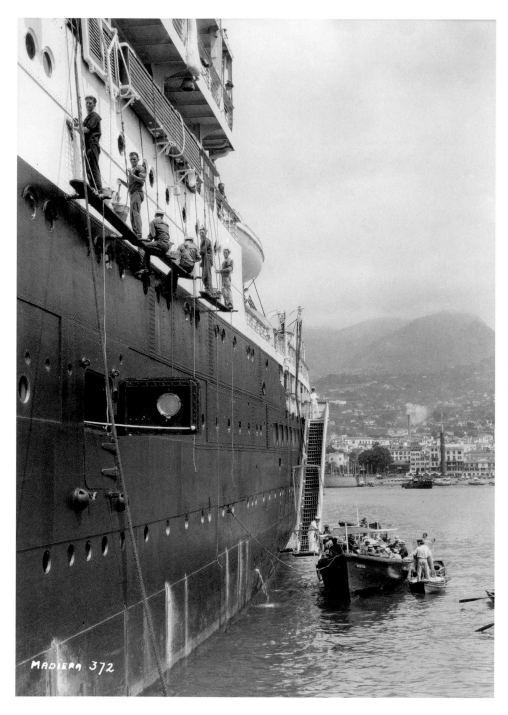

MADIERA 372

Crews painting the *Orontes* at Madeira, about 1930, and the *Strathnaver*, about 1935

'Immediately you were berthed there was somebody over the side painting. Painting was going on all the time. It was constant maintenance – a bit like painting the Forth Bridge', recalls Union-Castle Line officer, Peter Laister. As soon as passengers were ashore and out of sight, the crew would set to touching up. It happens less frequently now, as modern paint is more hard-wearing. One of the problems with an all-white hull, which in the 1930s became the preferred livery of cruising ships, was that the slightest bit of discoloration showed up, although the switch from coal to oil helped greatly to keep ships generally cleaner. White hulls were apparently not just for effect. P&O claimed that the change to white from their traditional black and stone-coloured livery made cabins four degrees cooler in hot weather.

Following page

Swimming pool aboard the *Montcalm*, about 1925

In the 1920s only the largest vessels had bespoke swimming pools. The extemporized pools of timber and canvas were the norm. Because swimming costumes were made from wool, they became saturated with water. The shoulder straps prevented an embarrassing situation from occurring when the wearer left the pool.

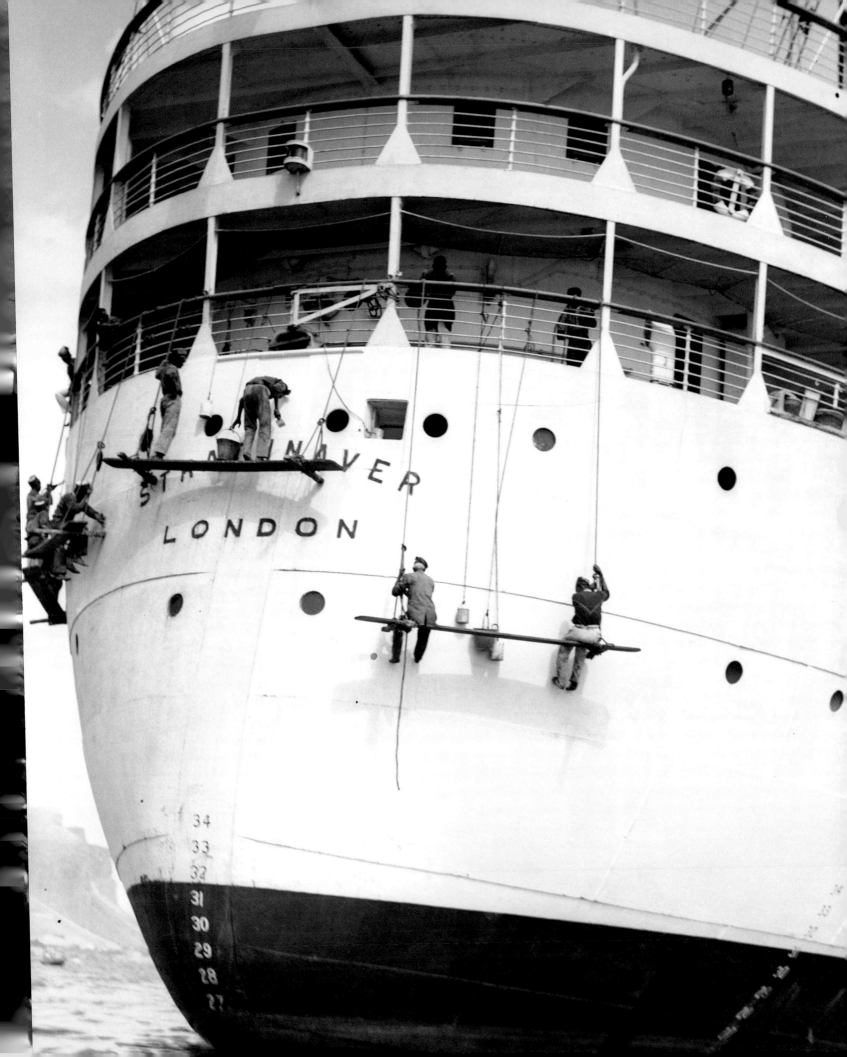

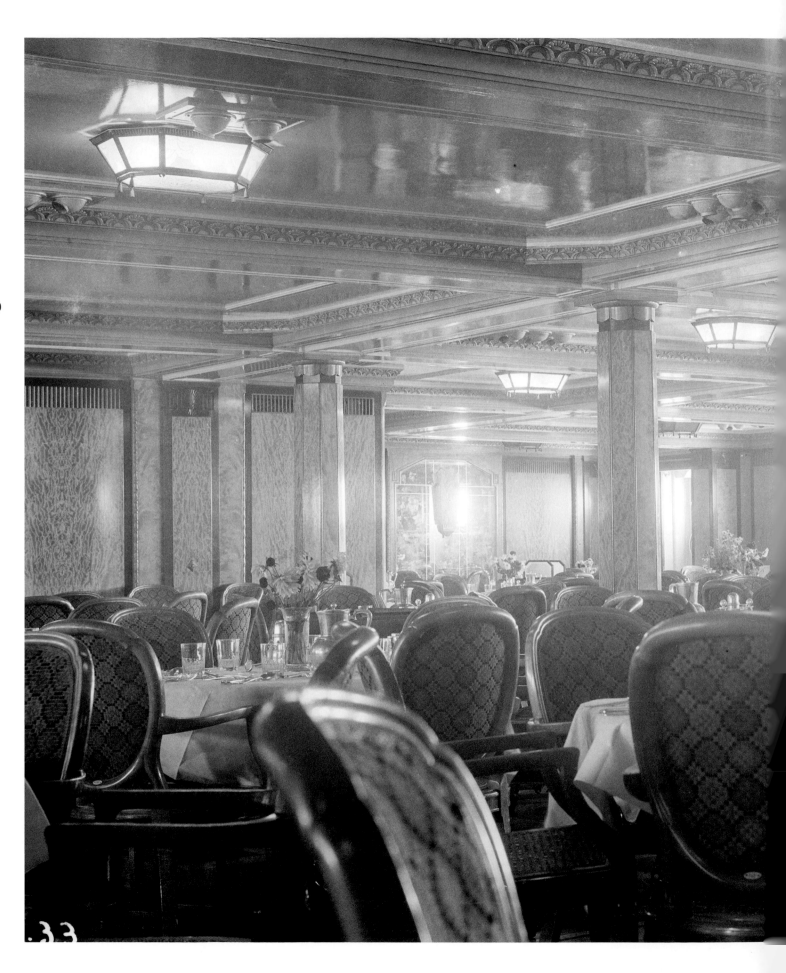

33

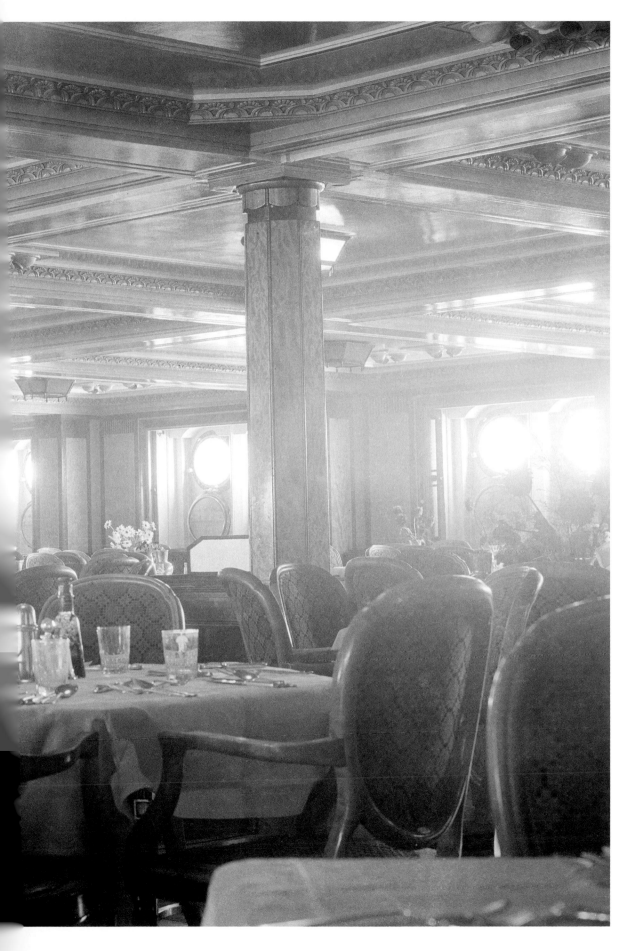

First-class dining saloon aboard the *Viceroy of India*, about 1930

The *Viceroy of India* entered service in 1929 and caused a sensation among the travelling fraternity. She was a one-off. Externally she was a distinctive lump, but inside the magnificence of her public rooms was the last word in luxury. They were designed by the Honourable Elsie Mackay, the daughter of Lord Inchcape, who was chairman of P&O at the time. She had already been responsible for the public interiors of five earlier P&O ships, but those of the *Viceroy* were the most memorable. Each room was in a different style. The dining saloon here, for example, was in the eighteenth-century English neo-classical taste, complete with blue marble pillars. The upholstery material for the seats was copied from examples of the period in the collection of the Victoria and Albert Museum in London. It was all intended to make passengers feel as though they were dining in a comfortable and expensive restaurant in England. The photograph itself is a rarity. There are only a handful of other pre-war shipboard interior shots in the Collection.

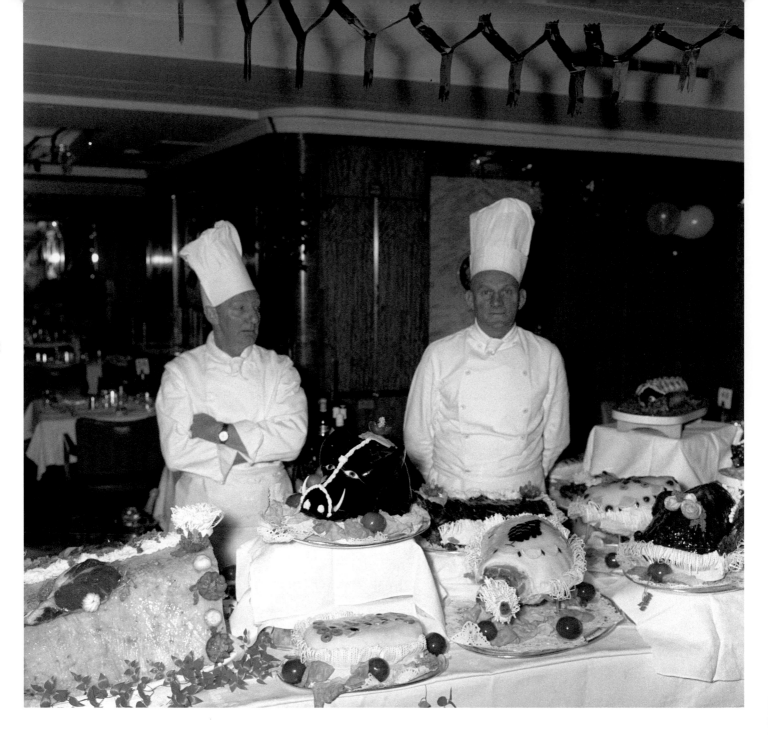

Christmas buffet aboard the *Empress of England*, about 1965

It is Christmas on the *Empress of England* and the chefs are looking decidedly fed up.
For most passengers though, Christmas at sea is a novelty and no less pleasurable
than spending it at home. A passenger aboard the *Chusan* recorded in her diary, on
25 December 1955, that at breakfast a menu and Christmas card was placed for each
person, and that there was a church service at 10.30am. After lunch, her diary notes,
she had a 'walk around the dining room to see the Christmas spread, the amount of
work the chef had done, there was a boar's head, two sucking pigs, a large ham, turkey,
Christmas cake, a cake made into a clock and the decorations were wonderfully done...
Then we heard the Queen's speech'.

Wining and dining

The Times reported, on 26 May 1932, that one of the advantages of cruising was 'to have good food (or at any rate good English hotel food) and plenty of it'. This is not quite the underwhelming remark it may seem, as liners and cruise ships are, after all, floating hotels. Shipping lines have always gone to great lengths to maintain high levels of quality and service where meals are concerned, and as meals are included in the cost of the holiday they have always been an important component in the overall experience. Meals regulated the day for passengers (at least in the days before twenty-four hour dining), which was particularly useful if the voyage was traversing different time zones. During this period the day would frequently begin with beef tea for passengers or, if the ship was in the Tropics, fruit or ice-cream.

As passengers spent a degree of their time in the ships' dining rooms, these areas would be homely and reassuring, while the china, glassware, cutlery and linen would be attractive and often bear the insignia of the line. Menu cards included illustrations on the covers; some would follow themes and be relevant to the places being visited, so that passengers could collect the set over the duration of a cruise. Special menus commemorated events such as traversing the Equator (the 'Crossing-the-Line ceremony'), or occasions such as the special 'Caledonian dinners' held periodically on the *Oronsay*, itself named after a Scottish island, which included 'A Muckle Sirloin o' Beef', 'Biled Tatties' and 'Russet Tairt'. Shipping lines have always boasted about the sheer quantities of provisions required for a voyage or cruise, and would often publicize statistics for the amusement and amazement of their passengers. At Auckland, during her first ten-day cruise, the *Oriana* took on board over seventy tons of meat.

Until the Second World War all meals on cruises tended to be formal occasions, irrespective of the shipping line or the class. The venerable old Edwardian liner *Mauretania* had a first-class dining room that rivalled any shore-based restaurant. Designed by Harold Peto, who had won acclaim for his English country house interiors, it had a two-storey galleria, was panelled in straw-coloured oak, and featured a domed ceiling decorated with signs of the zodiac which 'sparkled like the stars in the sky'. P&O's *Viceroy of India* had a dining room with blue marbled pillars, continuing the tradition into the 1930s for ships with interiors that were traditional, elegant and comfortable, and which made passengers feel as though they

were not on a ship at all. And standards had to be maintained. Ruth Harwood, a passenger on a one-class cruise in 1936 to the Mediterranean with her husband and son, on board the *Moldavia*, wrote to her daughter at home that younger people on board 'wear shorts and jumpers of all colours, also walk about in bathing dresses, but are not allowed in [the] dining saloon like it'.

P&O had an ace up its sleeve when it came to quality of service at mealtimes. Their stewards have traditionally been Goan. Young men would be recruited from their home towns in the province where, in 1498, Vasco da Gama claimed a part of what is now India for his country – thus bringing Catholicism and the Portuguese language to the Indian subcontinent. These young men would be brought to P&O's ships without passports on a special crew manifest, and would be attached to the purser's department as cabin and restaurant stewards. They would learn the job as they travelled around the world and, if they had any problems, would usually seek the advice of fellow Goans aboard. It was likely there would be somebody from their own home town or village, or even a member of the family. Often there were several generations of stewards coming from a single family. Because they were Christians rather than Hindus or Muslims, they had no difficulty in handling and serving beef or pork. Everyone seems to have fond memories of them. Orient Line social hostess Rosalia Chesterman remembers thinking that P&O had the edge on food and service because of the Goans, particularly at a time when British stewards, who belonged to trade unions, were becoming more militant: 'The Goans were always polite, and looked after their passengers better than the British did. When I went on the *Iberia* every steward was a Goan. Always so kind, never got annoyed. They were perfect'. Following the merger between P&O and Orient in 1960 the latter also adopted the policy of employing Goan stewards. At the end of *Strathnaver's* final voyage her Goan crew transferred *en masse* to the *Orion* at Naples, the first to serve in an Orient Line vessel. Dining room stewards, whatever their nationality, had a busy time of it. On a large vessel like the *Oriana* they would have to serve six full sittings a day, as well as the children's meals or afternoon tea.

After the war formal menu-led meals continued to take place on cruises, though informal buffets became increasingly popular. They were often served on deck, weather permitting, though this petered out in the late 1960s for reasons of hygiene. Presentation was important, and chefs would appear proudly alongside their increasingly elaborate spreads. Ship's purser Nelson French recalls:

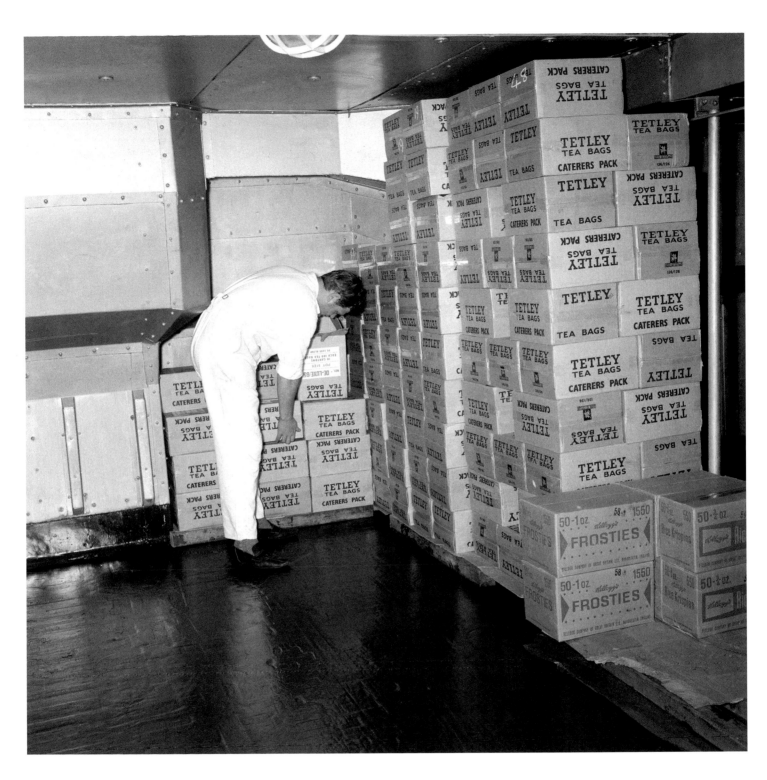

Storage area aboard the *Iberia*, about 1955

It would be revealing to know whether this picture was taken simply to record stores coming aboard or, more impishly, by an MPS photographer amused at this bulk stacking of items essential for any truly British breakfast – Kellogg's Frosties and Tetley tea bags. No matter how remote or exciting the places visited, most cruise passengers preferred to eat 'their own' food rather than local fare.

I once went ashore with the chef and chief steward at Honolulu. We stayed at the Royal Hawaiian Hotel because its buffet was supposed to be absolutely superb. Our chef asked the hotel chef who was standing next to the buffet, 'Can you eat that?' and pointed to a wedding cake supported by pillars, which we noticed used to appear every day at lunchtime. The hotel chef replied that it was made from plaster of Paris and our chef blew his top and said, 'I never put anything on display that cannot be eaten!'

Buffets might be themed. A spread laid out on the eve of arriving in Australia would include produce from that country, and something like a cake in the shape of Sydney Harbour Bridge. No buffet was complete, though, without a centrepiece carved from ice. These ephemeral works of art would be eagerly awaited and admired by all. According to one photographer: 'The ice sculptors used to work in the cold room where we kept our photographic paper. You would open the door and there would be this chap, a member of the crew, dressed like an Eskimo, chip, chip, chipping away'. The result could be anything from a Viking longboat to an Easter bunny.

However, there was also ample opportunity after the war for formal dining. Restaurants were now chic and contemporary, and no longer harked back to the stuffy architectural styles of the past. Tables would be meticulously laid to set guidelines, even for children's meals at their own breakfast, lunch and high tea. Dress codes were common and strictly adhered to – and still are. Officers would be required to socialize with passengers at their designated tables at dinner. The social hostess was pivotal in this respect, having her own table in the dining room and eating with the passengers. She would be given a generous entertainment allowance to buy wine for the passengers, and was responsible for ensuring that everyone had a good evening.

Though the food was free, alcohol was not. On the *Oronsay* in 1961 the cost of a bottle of gin at sea was 8/- (40p), whisky was 12/8d (63p) and Amontillado sherry was 10/6d (52p). Alcohol was far cheaper on the open sea. For instance the same bottle of gin in an Australian port was 32/6d (£1.62). Wine was supplied from ports visited, and the produce from the vineyards of Chile, California, Australia, New Zealand and South Africa were enjoyed on voyages decades before they were 'discovered' and enjoyed in Britain.

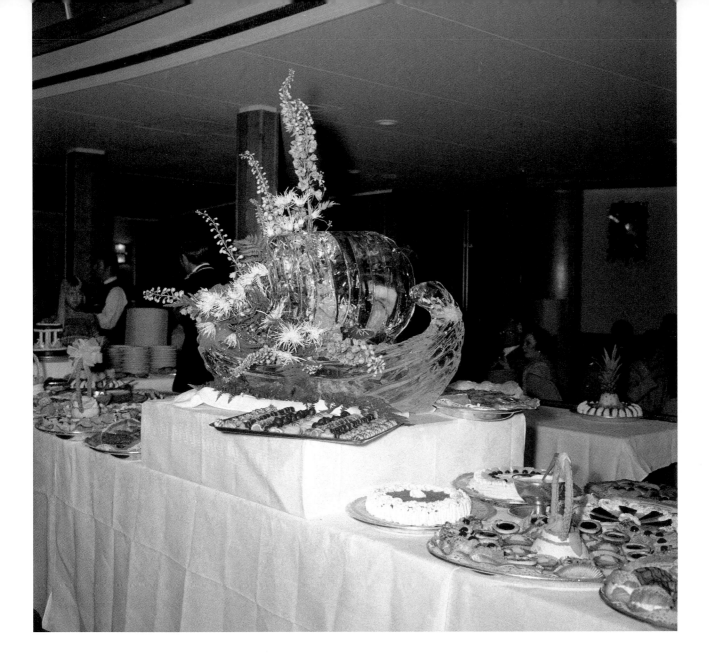

Smorgasbord aboard the *Kungsholm*, about 1970

The ice sculpture centrepiece here, appropriately for a Scandinavian vessel, is a Viking longboat. Such sculptures can be as entertaining in the making as they are enjoyed as ephemeral works of art. Passenger Bernard Radford recalls that:

> Filipinos are very good at ice carving. On every cruise I have been on a big block of ice weighing a couple of hundred pounds [one hundred kilos] is delivered to the ship and they put it by the poolside, on the tiles, and one of these talented lads will come along with what looks like a long wooden broom handle sharpened at one end like a chisel. It doesn't look much at all and he will have a bash at the block of ice. And the chap on the Tannoy will be saying 'What do you think it's going to be? Well? Have a guess!' Sometimes it turns out to be a flying fish, sometimes it's a salmon. They can sculpt these things in no time at all. And of course everybody crowds round to take photographs and it becomes an entertainment in its own right. Whatever it is they carve will be on display in the dining room that evening. Some cruise ships cheat – they have moulds that they fill with water and then freeze, like a big ice cube. And you get elaborate vegetable carvings done by chefs in front of the passengers. You get an itinerary every day and you might see 'Vegetable carving at three o'clock'. Well, if you are at sea and you're not drunk, it's a nice entertaining thing to go along and see. They make flowers or a whale out of an aubergine, things like that.

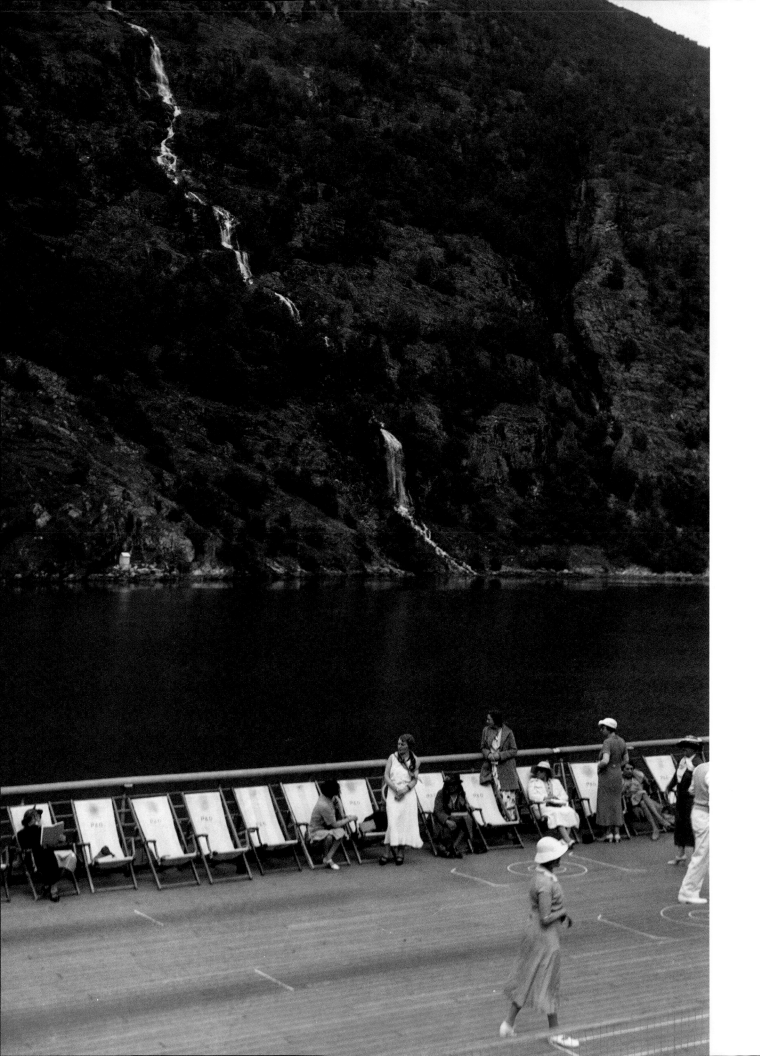

Sporting days

Life on a liner is a joyous experience for anyone, and the ship's games are not the least of the pleasures and benefits of an ocean voyage. Games for the athlete and games for the ladies, games for the veteran, and games for the young – all are to be found on board ship.

Deck tennis, as fast a game as you could wish; quoits, involving perfect poise and judgement; shuffle boards, needing a useful shoulder and push of the leg; and, on many of the *Royal Mail* liners, well equipped gymnasiums – above all, the bracing salt sea air to fill your expanded lungs. No wonder everyone gets fit and keeps fit at sea.

Then there are the ship's sports with jolly potato races, egg and spoon races, riding the spar, eating the treacly bun for the children, and a dozen other amusing and strenuous events to create fun and competition and laughter. The tug-of-war, possibly married men versus single, is good enough training for an Olympic athlete.

Introduction to Royal Mail Line publicity brochure,
Royal Mail Sports On Board, about 1930.

Getting passengers to participate in sports and games has always been one of the simplest ways to encourage social interaction and to relieve boredom. Until the outbreak of the Second World War, shipping companies made much of the health reasons for cruising, though available space tended to dictate the level of facilities. Only the larger, more prestigious vessels had gymnasiums. Pools were more common, though if they were sited on deck they were often temporary wood and canvas structures for easy dismantling. The *Viceroy of India*, which entered service in 1929 and was a benchmark for luxury at sea, was the first P&O ship to have an indoor pool, though it was salt water. Table tennis was played more frequently than the court version because there simply wasn't the room on many ships. The types of sports practised were restricted to areas of the decks that could be netted-off without interrupting the normal life of the ship. Tug-of-war, wheelbarrow races, tossing a medicine ball over a net and 'physical drill' were all popular, as they could be played on long narrow promenades. Perhaps one reason why passengers feel the need to participate in strenuous activities owes much to that other great distraction at sea – food.

Deck of a P&O ship, possibly the *Viceroy of India*, about 1930

The markings for playing quoits can be seen on the deck. *Blue Peter*, a contemporary ships and travel journal owned by P&O, described the *Viceroy of India* thus: 'Her promenade decks, with cunningly devised nooks, are long, wide and sheltered; the sports deck aft is a smoothly timbered floor of royal and inviting dimensions'.

One of the most popular of all deck games was deck quoits, and it is still played today. A target is marked out on deck and passengers take turns to throw their quoits of rope rings to land as closely as possible to the target centre and, if possible, knock opponents' quoits out of it. It was reckoned to be particularly suitable for women for, as the Royal Mail Line brochure points out, ladies were not expected to be athletic. However the more relaxed and less frenetic social games were enjoyed by all, such as miniature golf, bull-board and shuffle-board. Another sport that was played on ships until at least the 1970s was spar-boxing, or 'riding the spar'. This is where two passengers would straddle a bar placed across the pool and, armed with balloons in pillowcases, would set about trying to dislodge one another. The game became more dastardly after the war, when the bar was made greasy with soap or Vaseline, making it almost impossible to sit on. Social hostess Pam Laister recalls: 'There were also pyjama relay races where people would swim across the pool and their partners would then get into the wet pyjamas and swim back again. And there were cigarette races where people had to swim across the pool while keeping a lighted cigarette in their mouths'.

Perhaps the most enduring and endearing spectator sport at sea was 'horseracing'. There were two basic types, and they were key events in ships' itineraries, made all the more popular as there would be totes. The first type involved up to six wooden horses on a course that had been drawn onto the deck and divided into squares. Two dice would be thrown by passengers to determine which horse would move and by how many squares. Sometimes those crewmembers enrolled to move their designated horse would dress up as jockeys. Usually four or five races would be deemed sufficient for one 'meeting'. The second type of horserace game involved passengers (for some reason they were usually women) taking direct control of the horses, which were tied to a long length of cord or string. The other end was wrapped around a two-handled winder, like a ship's windlass. After the bets had been placed, the starter's orders would be followed by vigorous winding which would pull the horses down the 'course'. Photographer Keith Winterbourne recalls: 'They would take all the money in from the bets and a certain percentage would go to the ship or the operator and the rest of it would be divided up among the winners. A contribution would sometimes go to the various seamen's charities'.

Photographs of such events from the 1920s and 1930s show passengers dressed as though they were attending a race meeting at Ascot or Epsom.

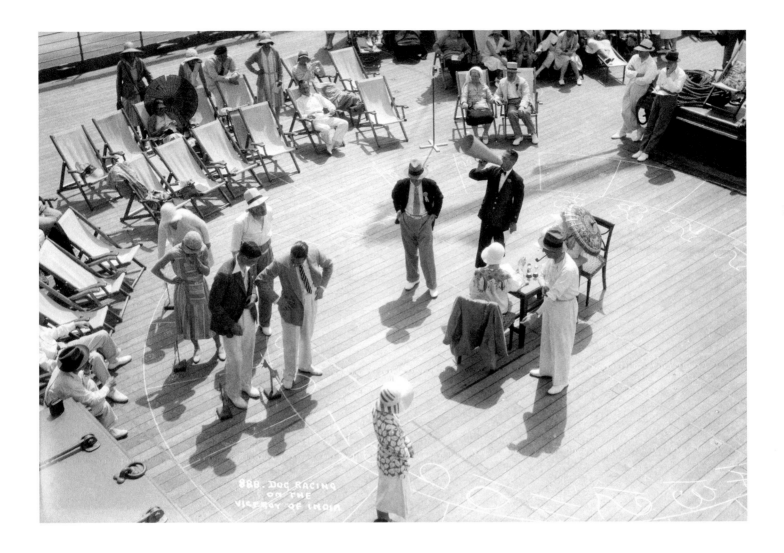

Dog racing aboard the *Viceroy of India*, about 1930

In the 1920s there was a subtle shift in sporting pleasures away from the DIY games, such as sack races, towards more organized fun. By the end of the decade school sports-type pursuits were being relegated to the children's parties. In their place, dog-, horse- and frog-racing grew in popularity. The passengers are dressed very elegantly for this fixture – the seated woman throwing the dice and several of the other women are wearing cloche hats. They were certainly practical, especially here as the sun is almost immediately overhead, but they were also associated during the 1920s with the freer lifestyle of women. Hair had to be bobbed or shingled, cut neat and moulded to the head in order to wear this hat successfully. Edna Woolman Chase, Editor-in-Chief of *Vogue* during the 1920s, stated that 'chic started at the eyebrows and Loelia, Duchess of Westminster, was almost reduced to recognizing her friends by their teeth'. The man next to the steward with the megaphone is wearing flannel trousers and traditional blazer, both associated with a sporty lifestyle. Turn-ups had recently come into vogue, made famous (some say invented) by the Prince of Wales. Everyone is wearing sports shoes, as stipulated in Thomas Cook's packing list, *Have We Got Everything?*

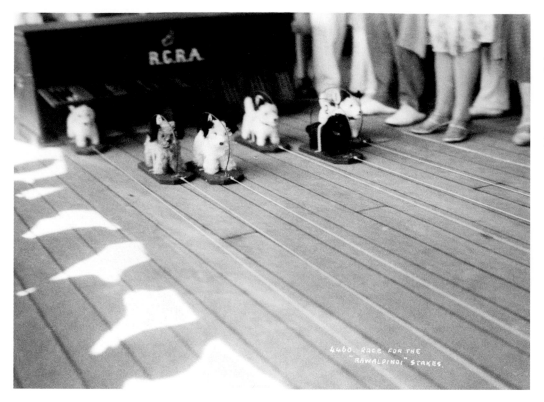

'Race for the *"Rawalpindi"* stakes', about 1930

An eighteen-year-old nanny, Edith Starling, travelling home from China in the *Rawalpindi* in the spring of 1938 wrote a series of letters home to her mother. She describes the event depicted in the photograph:

There was dog racing last night, which is far more exciting than frog racing. The 'dogs' were toy ones and the competitors sat with their backs to them and had to wind a handle at top speed at the word go and the dog that got home first won. The men said the women should be good at it as they were used to turning a sewing machine handle and a mangle. You couldn't spend more than a shilling [five pence] a race so nobody lost much or won much, but it was very exciting all the same.

Racing night aboard the *Orcades*, about 1955

It is perhaps surprising for us to see so many dinner-jacketed people at an event such as this. Occasionally, first-class and tourist-class passengers would be allowed to get together for sports and games evenings. Edith Starling remembers one such instance for a game of 'housey-housey' (bingo), and it amused her 'to see how the Classes refused to mix but kept to their own sides of the barrier'.

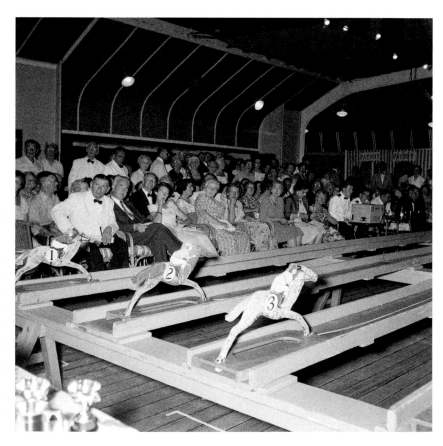

'Frog-racing' was just as popular. The wooden frogs were about a foot high, painted green. They had a very long string attached to them, one end of which was held by the competing passenger. Union-Castle purserette Ann Haynes recalls that there might be six or so passengers, each with a frog secured on the end of its string at the opposite end of the course, 'and at the signal to go the passengers would pull their string and the frogs would go flap, flap, flap and make their way gradually along the string and the first frog to cross the line was the winner'. Yet another variation of this winning participatory formula was the ribbon-cutting race, as remembered by Pam Laister:

> Passengers would race one another by cutting lengthways up the centre a long length of inch-wide tape and everyone would bet heavily on the outcome. The women used to attract the biggest bets. There would be both a passengers' and an officers' race and in every officers' race there would be a female, and the women passengers would always put their money on her. You would have to cut this ribbon with curved scissors and a lot of money was resting on your head if you went off the edge. We usually beat the men. Happy days – it was so simple.

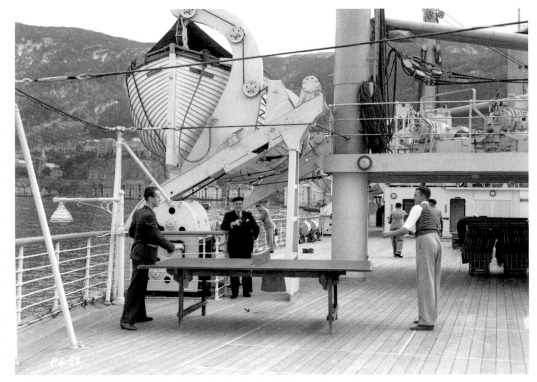

Table tennis aboard the *Orion*, 1935

The advantage of a game like table tennis was that it could be packed away afterwards, freeing up valuable deck space. The photograph shows the ship at, or almost at, the start of her long career. Her inaugural voyage in August 1935 was a cruise to Norway. Apparently the only significant problem encountered was smuts from her funnel falling back onto the after decks. It was later rectified with a taller funnel.

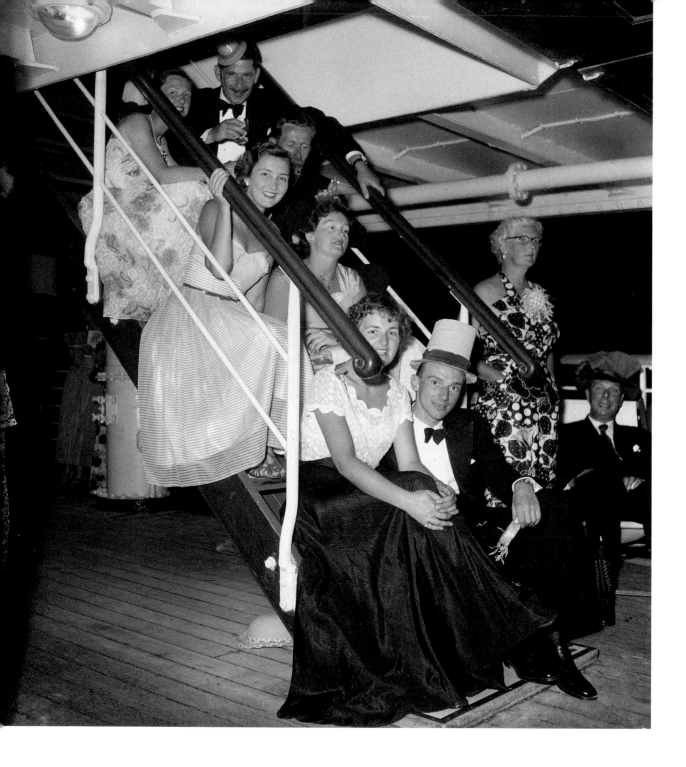

Cocktail party aboard the *Chusan*, about 1960

Cocktail parties usually began about six o'clock in the evening. After the Second World War eveningwear for men was modified, and they no longer had to don stiff collars and starched-fronted evening shirts, although the dark suit and bow tie remained the same. Women's styles were also more relaxed. The pale, striped organza, strapless cocktail dress with a patent leather belt was typical of this period. It would have had a nylon net petticoat underneath to hold out the top skirts, and a boned bodice. The skirt is gathered into the waistline. Christian Dior created this style in 1947 with his 'New Look' collection. Similarly the lace blouse and circular skirt were very much products of this age. The latter was extremely popular due to the emergence of rock and roll, and would have been an ideal skirt for dancing. Nylon was invented by the Americans and became the wonder fabric after the Second World War. A synthetic polymer, it was tough, lightweight, washable, and ideal for taking on a cruise. It didn't shrink and could be drip-dried. The woman standing, and obviously not part of the merry group, is dressed entirely differently, wearing a very colourful, flowery dress with a halter neck and large chrysanthemum corsage.

Entertainment at sea

Anyone who has been on a modern cruise and enjoyed the sophisticated and spectacular entertainment on offer might be surprised to know that, prior to the early 1970s, dedicated professional entertainers on ships were rare, if not non-existent, and special acts would be booked on a one-by-one basis. In the early 1970s P&O and other lines began to feel the effects of air travel encroaching on their services, so one of the ways to make sea travel more attractive was to employ permanent singers, dancers, cabaret artists and the like. Before that it was largely down to passengers and crews to entertain themselves and each other, though on most lines there would at least be a resident troupe of musicians, usually a quintet. On Union-Castle ships these were always known as the 'Struggling Five' because they would have to appear at all times of the day and night from the Sunday morning worship to Crossing-the-Line ceremonies. On two-class ships they would have to allocate their time accordingly. There would always be a cocktail party at the start of a cruise (or if it was a two-class ship, two cocktail parties), where the captain and his officers would be present to welcome passengers aboard.

On long line voyages, and some cruises, an entertainment committee would be formed from the ships' officers and invited passengers. They would organize things like fancy dress parties, and there would be a daily programme. On Friday 22 December 1961 the *Oronsay*'s first-class programme included:

> 11:00 ship's daily tote, also light music in 'C' deck lounge
> 17:00 Scottish dancing 'D' deck
> 17:55 choir practice (meet outside purser's office)
> 21:00 dancing 'B' deck, also bingo 'C' deck

There was 'housey-housey' for an hour nearly every evening on the *Oronsay*, and sedate pursuits such as whist drives and bridge evenings were organized as well. It goes without saying that some of the homespun entertainment could be ropey, if not decidedly risqué. Keith Winterbourne was once on duty and saw:

> one chap at a fancy dress doing the dance of the seven veils. He started stripping off and the audience were counting him down, seven, six, five, four, three, two, one and he ended up with this little loin cloth. The

ship's master on this P&O vessel was becoming really edgy, but we all encouraged this guy. Little did we know that he had had his head shaved and had put a wig on, and he suddenly pulled it off as the seventh veil and left the loin cloth where it was.

Fancy dress parties have always been popular on P&O ships, ever since the company's formation in 1837. Calling at ports *en route* to a destination gave passengers the opportunity of buying exotic costumes and accessories. On occasions, however, things did move with the times. For instance one area that disappeared with the introduction of the *Strathnaver*, in 1931, was the music room, a facility that had been a feature on all P&O vessels since the *Clyde* of 1881. Its demise suggests that home-produced music had finally given way to professional troupes and the gramophone.

Sometimes passengers would entertain one another in more sedate style at privately organized functions on board ship. They could be lavish affairs, particularly those on long, up-market cruises. Swedish America Line specialized in such holidays on their ships *Kungsholm* and *Gripsholm*. On one three-month cruise on the *Kungsholm*, in 1957, which had more than its share of American millionaires, passengers seemed to be competing with one another as to who could organize and host the most extravagant cocktail party. MPS photographer Geoff Pettit recalls:

> I think the prize went to a couple who bought a rickshaw off the street trader in Hong Kong, and kimonos for all the lady guests, and silk smoking jackets for the men. For himself and his wife he bought a complete Mandarin's outfit and a Geisha costume. All this to celebrate their wedding anniversary. They also bought loads of cherry blossom that had just come into flower and decorated the main lounge, [where] there were over a hundred guests. Every picture that the photographers took was bought by the wealthy party giver, as well as a set for each of the guests. It was a big boost to MPS takings, and kept them very busy in the darkroom. It was a pretty lavish cruise all round. There were two troupes of musicians aboard, one to provide dance music, the other, chamber music. There was even a professional dancing couple – Michael and Marlene – who gave lessons in ballroom dancing and who acted as companions to passengers travelling alone.

The crews themselves would be required to entertain passengers on at least one evening during a cruise. On Union-Castle ships on the South

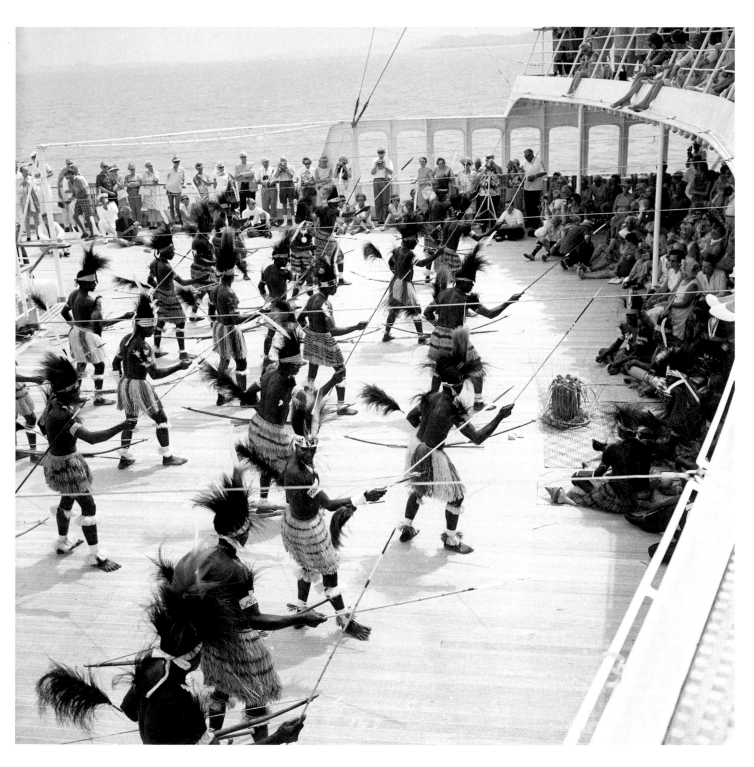

Local dancers from Rarotonga, Cook Islands, performing aboard the *Kungsholm*, about 1970

With decks becoming larger and more uncluttered in the 1950s and 1960s, it was sometimes easier
for local entertainers to visit the ship rather than for the passengers themselves to disembark.

Africa run, until at least the late 1960s, this would invariably include a 'Black and White Minstrels' evening. Another event that the Union-Castle ships' crews would regularly perform was the Crossing-the-Line ceremony for passengers passing over the Equator for the first time. The ritual itself goes back centuries and its origins are unclear. It is recorded in 1529 that the French awarded the accolade 'Les Chevaliers de Mer' to sailors when rounding certain capes, while on French ships in the eighteenth century crossing the Tropic of Cancer was celebrated by a ceremony similar to that practised today when traversing the Equator.

Union-Castle's version, though scripted, appeared to differ in detail from ship to ship and from voyage to voyage. The gist of it remained the same though, and was hugely entertaining for passengers, whether as spectators or participants. A crewmember would appear as King Neptune, with crown, trident, curly beard and festooned with barnacles. In tow were his 'wife', Queen Amphitrite; an evil barber; a villainous surgeon; a clerk and herald; policemen/henchmen; and assorted mermaids, nymphs and bears. The ceremony began with a parade around the deck and a court was set up beside the pool. Neptune then summoned the novices, one by one (both passengers and crew), who were attended to by barber and surgeon before being dunked in the pool. The newly initiated were then awarded a certificate. Purserette Ann Haynes remembers one ceremony in particular, on the *Capetown Castle*, in 1966:

> I thought I had seen most things, but this was quite something. We had custard pies, sausage meat, cocoa, the lot. I had a large trifle thrown straight into my face (and so did Maureen, as we were South Sea maidens) and I was absolutely smothered with meringue. It was hilarious…My hair had kipper, cocoa, sausage meat, and just plain dirt, all in it and so did the rest of me and my pink swimming costume and grass skirt.

Fortunately, though water rationing had been initiated on the ship that very day, the supply was turned back on to allow the victims to clean themselves up and she was allowed to pay a visit to the hairdressers at the company's expense.

Before professional entertainers were employed, it was generally quite common if a celebrity happened to be on board that they might find themselves approached to contribute to an evening's entertainment. Ann Haynes wrote in a letter home, from the *Transvaal Castle*:

Do you remember on telly a few months ago a programme called 'Opportunity Knocks'? One of them was a muscle man, with rippling muscles, which he moved in time to the music. Well, he's on board, he's one of the pax [passengers], and he keeps doing private shows. Did one at the Crew Dance the other night…All the crew were there and the muscle man came on, all in gold paint, little hat painted gold, and he gave his demonstration in time to the music…I thought it was rather revolting. I'm sure he was quite a nice man really but what an unusual act.

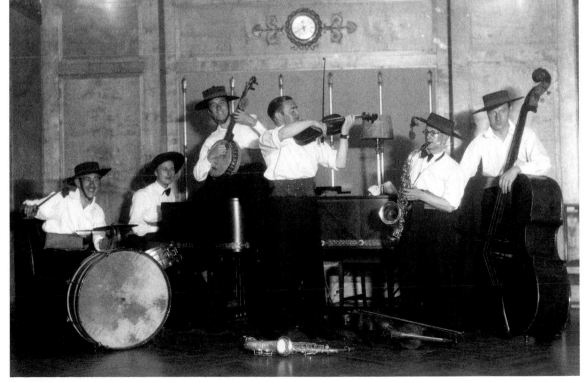

Ship's band aboard the *Oronsay*, about 1925

Oronsay's ship's band entertained first-class passengers on the Australia route and also on her extensive cruising programme out of Britain. Looking Zorro-like here, pose for the camera on what might be a Latin American evening.

Fancy dress party aboard the *Empress of Canada*, about 1965

Such parties have been popular on passenger vessels since the first half of the nineteenth century. They were synonymous with the so-called 'blue water' line voyages to the East with P&O and Orient (as opposed to the cold, grey route of the North Atlantic), but fancy dress parties and parades have been performed on voyages everywhere. The perennially favourite guises are all here in this photograph – the Geisha girl, the peasant fruit seller, the cross-dresser and the burly man dressed as a baby. Edith Starling, on the *Rawalpindi* in 1938, recounted that:

> The dining room looked very gay when we went in for dinner for there were bunches of coloured balloons hanging from the ceiling and paper hats, very nice ones, on the table and all sorts of novelties. The man at the next table was a scream, he is an enormous man and very tall and he was dressed as a 'Glaxo Baby' with pink ribbons in his hair and a frilly dress on and his wife went as his nurse. Several of the younger men were dressed in the stewardesses' dresses and looked very comical… the most original man's prize went to 'Herr Hitler'.

Stewards from the *Kungsholm* putting on a cabaret act, about 1970

This is a crew's entertainment evening, with cabin or dining room stewards using the ethnographic souvenirs from a previous port of call as props. Cabin and dining room stewards are assigned to particular passengers for the duration of a cruise and a familiarity, even a friendship of sorts, can develop.

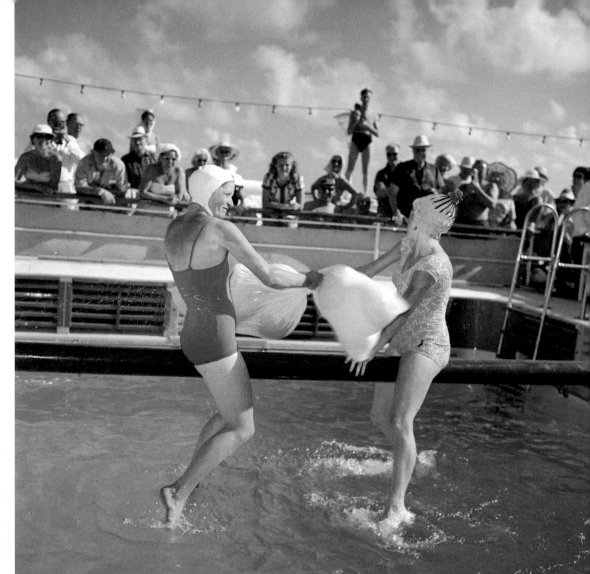

Greasy pole competition aboard the *Empress of Canada*, about 1965

This was always a great spectator sport, and heats and eliminators would sometimes be held to find an overall champion. If a passenger forgot to bring a swimming costume, on-board shops stocked swimwear, sometimes emblazoned with the shipping line's logo.

Sightseeing couple in Copenhagen, Denmark, about 1970

One of a large quantity of photographs in the Collection that were taken, consecutively, of several dozen passengers in the same spot – directly in front of Copenhagen's Mermaid – during a *Kungsholm* cruise. The photo-shoot, which must have been a little like a production line, might well have been advertised on the *Kungsholm* at the same time as the excursion. Many of the mainly American passengers evidently took the trouble to dress up for the day's sightseeing. The lady here is wearing an extremely elegant and expensive outfit in the style of Jackie Kennedy. The pillbox hat surmounts the fashionable beehive. The square-toed Cuban-heeled shoes are trimmed with the Chanel logo. Her formal dress and jacket is in the princess line style with its wide-cut velvet collar and three-quarter-length sleeves. The fabric may even be by Bernat Klein. One of the most prominent textile designers of the 1960s and 1970s, he produced colourful tweeds often woven with ribbons, braids and raffias to give this traditional cloth a modern twist. His designs were used by leading couturiers all over the world. Pearl earrings and necklace complete the outfit. Rosalia Chesterman, a social hostess on Orient Line, remembers well her American passengers: 'We were so intrigued by them and all those pills they used to take at breakfast'.

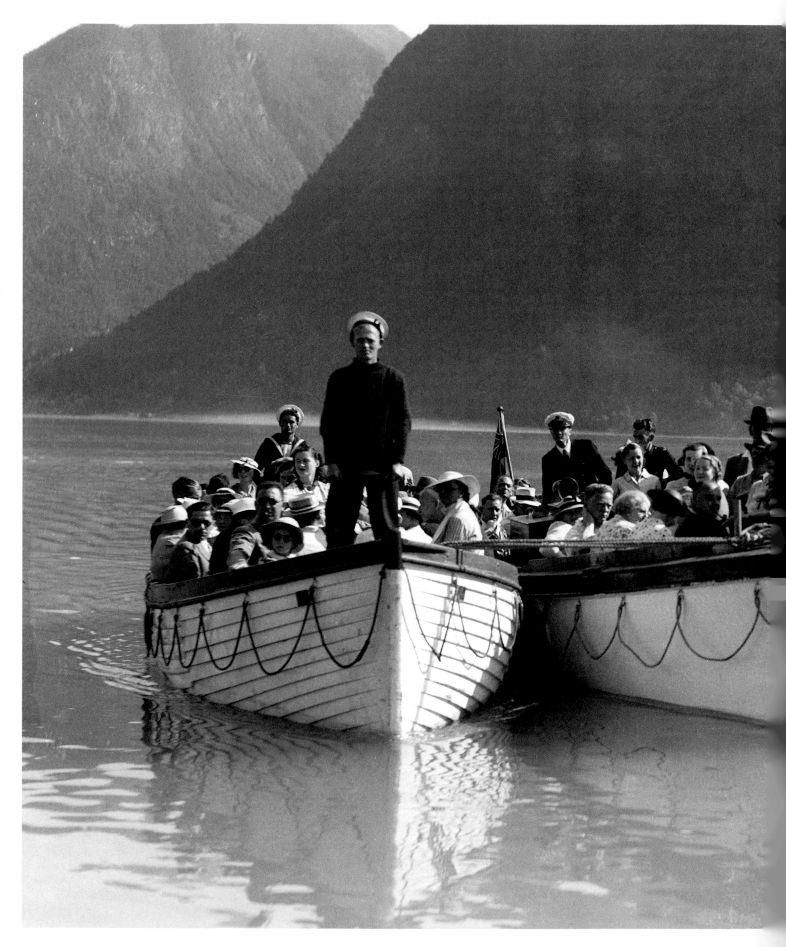

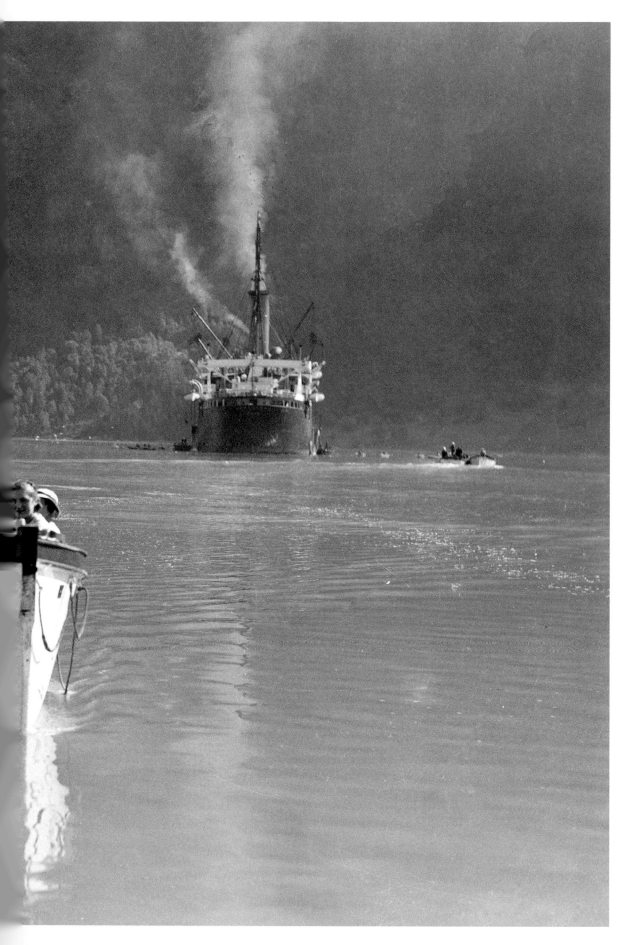

Tenders from the *Montclare*
in a Norwegian fjord,
about 1932

A scene of near-perfect
tranquillity, frozen in time,
with the glass-like surface
of the water and
Montclare's smoke drifting
vertically into the still air.
The two boats and their
occupants are stationary,
waiting for the shutter to
go off. The sailor stands
ready to make good the
mooring line to the landing
stage from which this
picture is taken. It is a fine
shot, which captures
perfectly the sense of
modest adventure to which
the British in particular
have always been
aficionados. The solitude,
stillness and serenity of the
Norwegian fjords have
enticed people to this
region for generations.

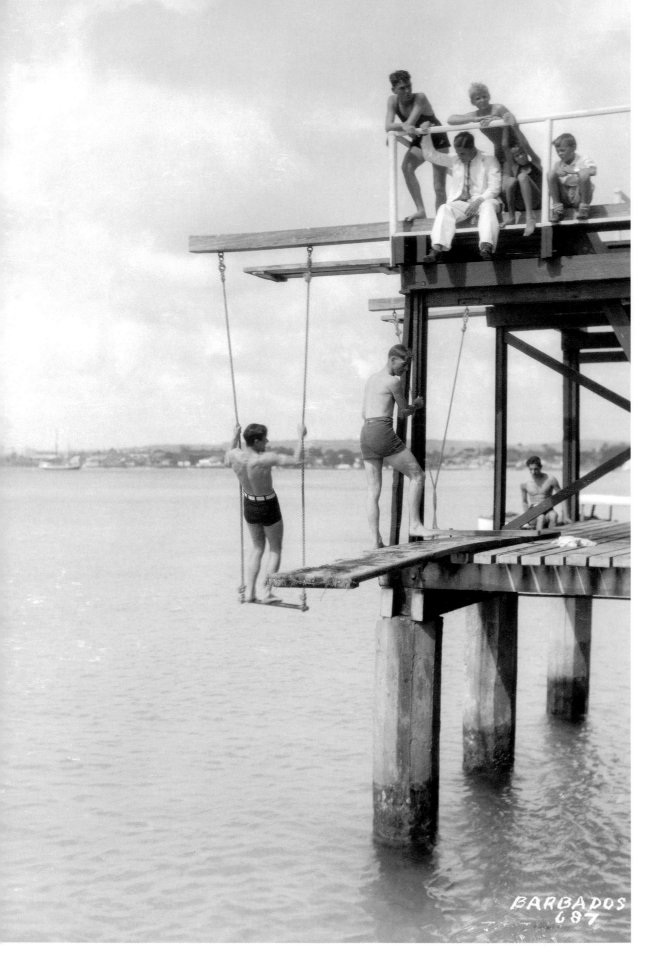

Passengers on a jetty in
Barbados, Lesser Antilles,
about 1935

Strapless woollen
swimming trunks became
fashionable in the 1930s,
though belts were needed
as they became heavy
when wet. The white suit
is linen, the ideal fabric
for cruise travel. It was
hard-wearing, durable
and absorbed moisture,
making it very comfortable.
It was also stylish. The
men in the photograph
typify the international
social set that developed
in the inter-war years,
spending much of their
time cruising from one
social engagement to
another in the most exotic
locations. Super-expensive
world cruises out of
New York would invariably
head for the Bahamas and
Barbados in the
Caribbean and then on to
Bermuda. *Harpers Bazaar,*
in 1934, described them
thus: 'Cruisers are gay
lads with a spark of
adventure in their bright,
clear eyes. Ozone-minded.
Active, alert. Soften under
the influence of beauty,
moonlight, music and
mixed drinks'.

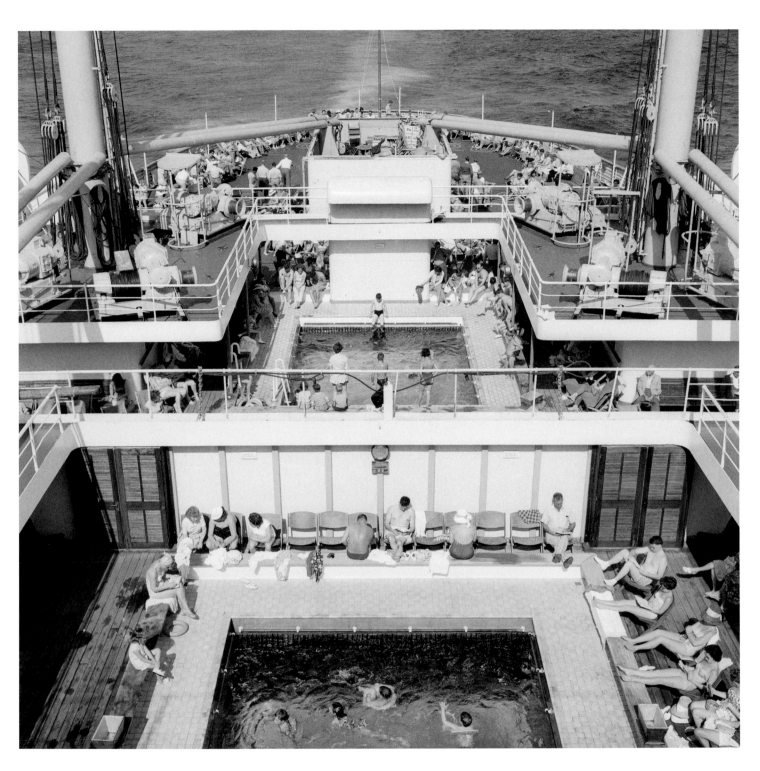

Passengers on the deck of the *Oronsay*, about 1955

Oronsay's maiden voyage was in 1951 and for the early part of her career she was engaged permanently on the route from Britain to Australia. Her 833 tourist-class passengers had the use of the pool furthest from the camera, while the 668 first-class passengers enjoyed the use of the larger pool.

146

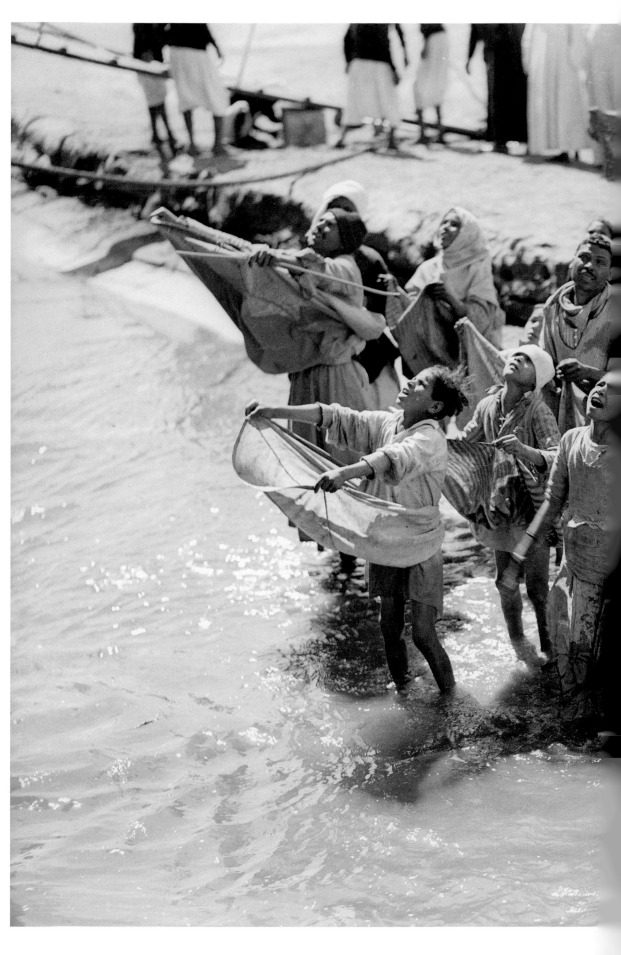

People begging at
Port Said, Egypt,
about 1930

A distressing picture
that shows, all too
starkly, the chasm
between the worlds of
the visitor and the
visited. It also highlights
the fact that a ship is an
entirely self-contained
and culturally exclusive
world, a secure home to
its occupants, its wealth
confined within its steel
hull. It is one of the
unspecified boons of
cruising that passengers
can enjoy a port of call
because it is unfamiliar
to their everyday
experience but also
because they can
physically and
emotionally distance
themselves from it when
it is time to leave and
the ship moves away
from the quayside,
putting clear blue water
between the two worlds.
The port of call and its
people soon disappear
out of sight, over
the horizon.

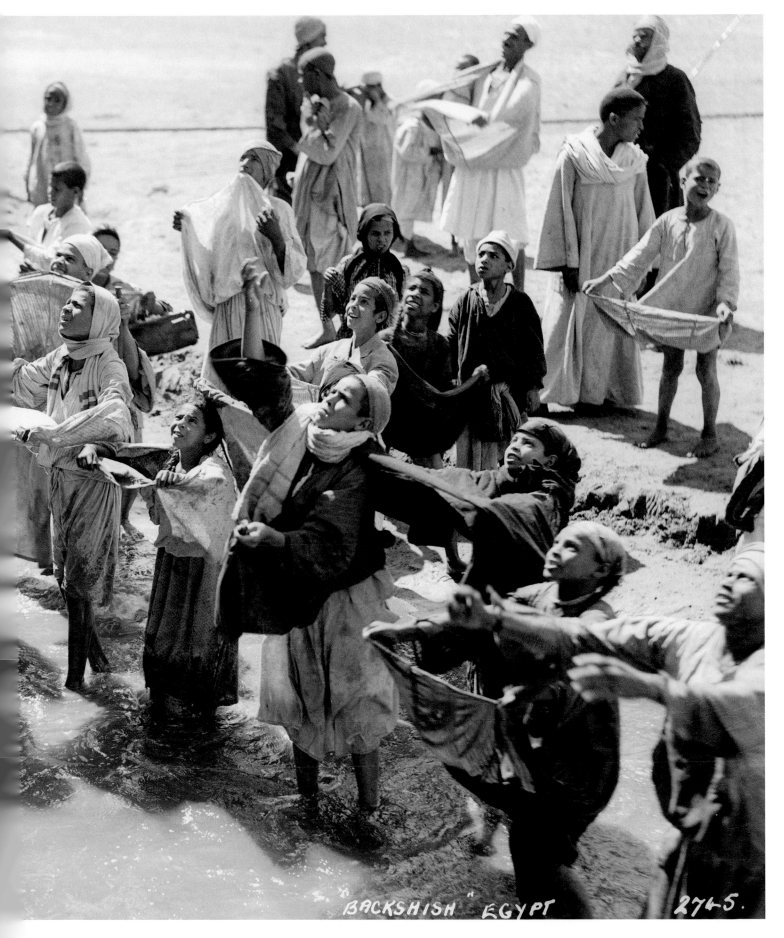

"BACKSHISH" EGYPT 2745.

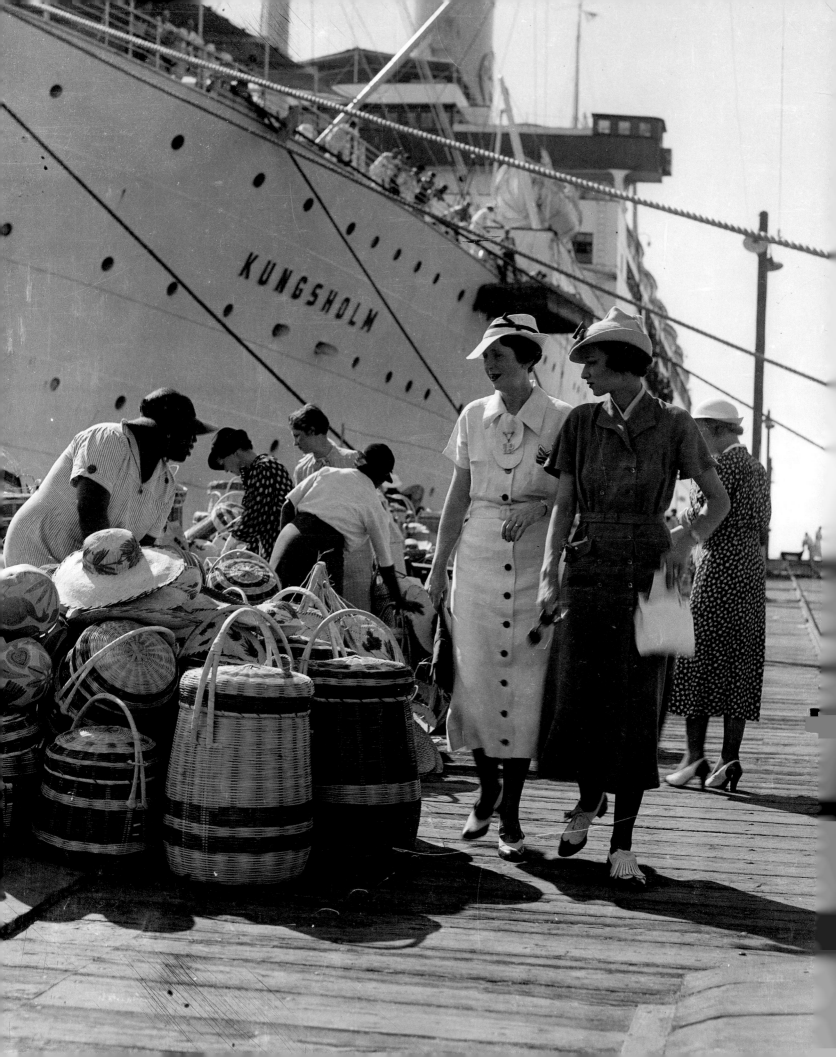

'A fine catch at Nassau', about 1935

A pretty good day's catch if it all belongs to the couple proudly posing beside it. The man is holding a shark. Game fish abound in the waters of the Bahamas – tuna, barracuda, white and blue marlin, amberjack, tarpon and bonefish. Ernest Hemingway, one of the icons of big game fishing, frequented these waters, and they remain a spectacular fishing locale. The woman's attire has clearly been influenced by maritime fashion, with her hat worn towards the back of the head, the dark braid trim around the white linen frock, and white canvas shoes.

Jamaica, West Indies, about 1930

These ladies are both stylish and sensibly dressed as they scan the quayside for bargain souvenirs. Hats were not only fashionable, they also protected the head from inclement or hot weather. A hat could also hide hair that may not have been attended to for several days due to the lack of washing, styling and hair-drying facilities. Their correspondent shoes are elegant but practical with stout, low heels.

Monaco Grand Prix, Monte Carlo, Monaco, 8 August 1937

Cruises sometimes dovetail with specific events, especially sports fixtures. Passengers who attended the Monaco Grand Prix in 1937 were in for a treat, as it was a particularly exciting and controversial race. They needed stamina though, as it was run over a hundred laps and lasted for more than three hours. There were no British drivers or cars to cheer for among the fifteen cars taking part. A team of four Mercedes-Benz *Silver Arrows* was the dominant force, one of which appears in the photograph. Rolling up their shirtsleeves, and donning cloth flying helmets, the drivers climbed into their machines and fired up their engines. The highlight of the race was when an Auto Union crashed in the Monaco Tunnel, emerging from it backwards at top speed to gasps of delight from the crowd. The Mercedes-Benz team took first, second, third and fifth places. The winning driver, Manfred von Brauchitsch, had earlier stuck out his tongue at team manager 'Rotweiller' Herr Alfred Neubauer as he overtook him.

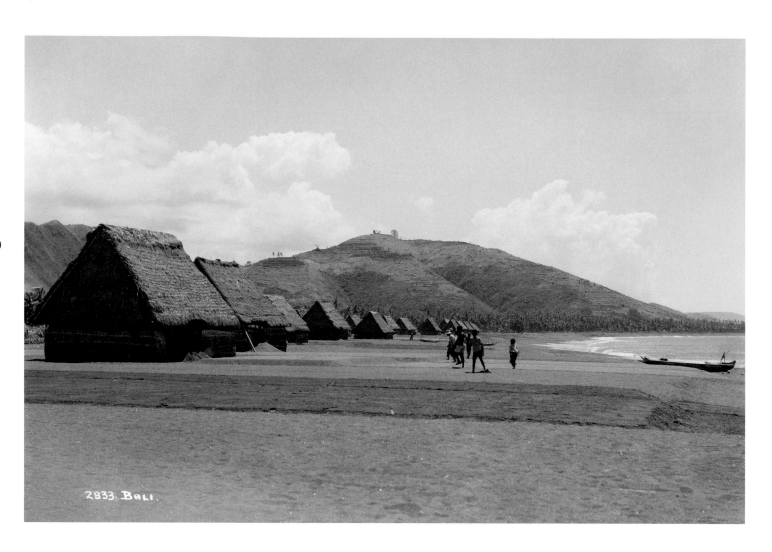

2833 BALI.

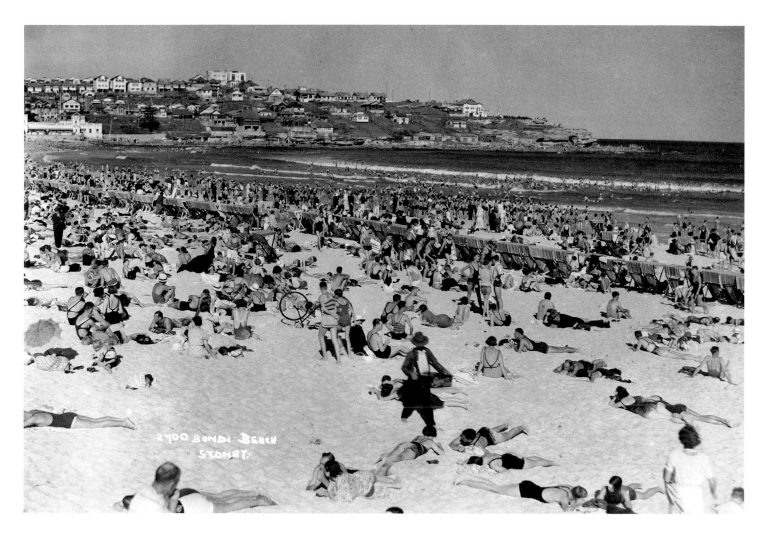

A beach in Bali, Indonesia, and Bondi Beach, Sydney, Australia, both about 1935

Before the Second World War sunbathing on the decks of ships was permissible and practised, but opportunities could be somewhat limited because of sheer lack of space. Destinations with good beaches were therefore popular, and a day or two sitting around in the sun made a break from excursions and shipboard life. Both P&O and Orient began cruising out of Australia in December 1932 and it became, for the remainder of the 1930s, an important part of their business. They scheduled cruises around Australasian waters, to south-east Asia and to islands in the South Pacific. The advantage was that these were new destinations with which to tempt the cruising public. They were pristine and untouched by tourism. The main disadvantage was that one had first to get to Sydney and then there would be many more days' travelling before one got anywhere. 'Short-cut' cruises were organized. For example in the 1930s *Viceroy of India* did some cruises out of India and from Bali to south-east Asia.

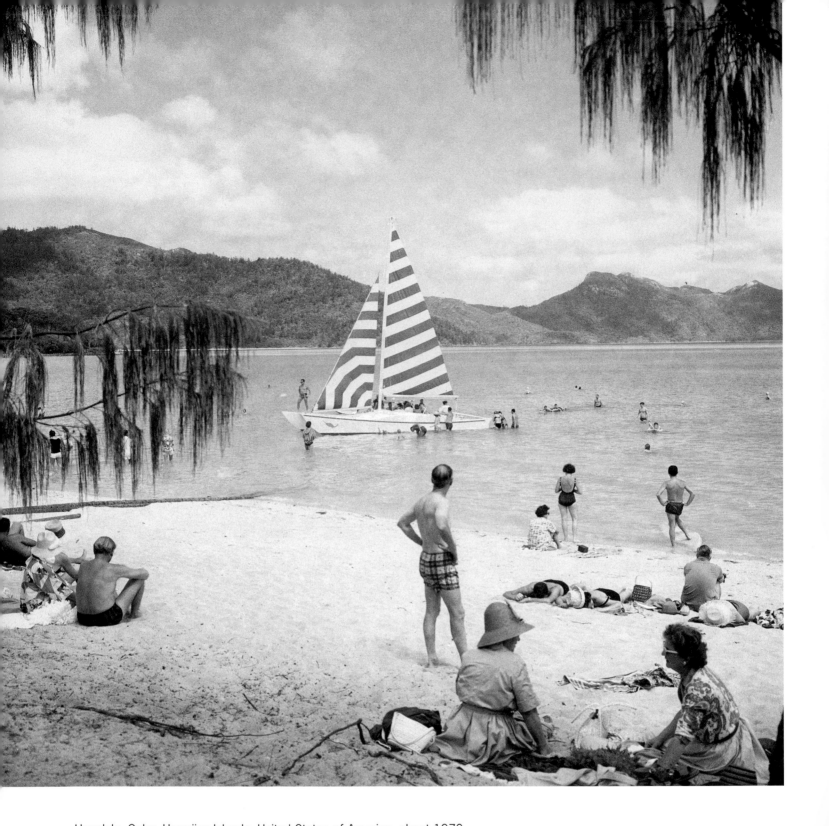

Honolulu, Oahu, Hawaiian Islands, United States of America, about 1970

The Hawaiian Island chain – Oahu, Kauai, Niihau, Molokai, Lanai, Maui, Kahoolawe, Hawaii –
are like pearls set in the middle of the vast Pacific Ocean. Waikiki Beach here, however,
is a man-made paradise as the sand was brought here from the other side of the island.
The beaches on the north side of Oahu, though sandy and picturesque, are not safe for
swimming. Honolulu became a principal port of call for Orient Line in 1954 when it first
extended its service across the Pacific from Australasia to the North American west coast.
Purser Nelson French visited regularly: 'When we first went to the Pacific we always called at
Honolulu and a launch would come up alongside first thing in the morning with girls in grass
skirts doing hula-hula dancing. But we always had to get them back ashore by eight-thirty
because they all worked in Woolworth's'.

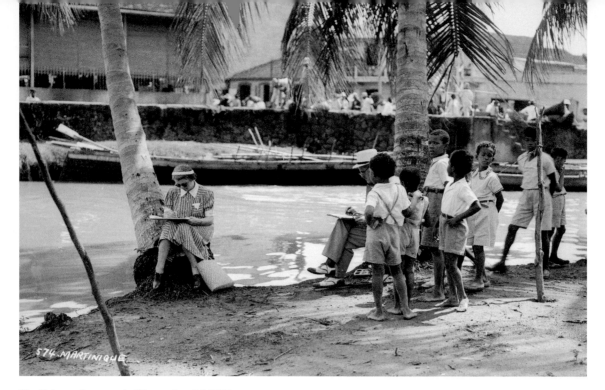

Martinique, Lesser Antilles, about 1935

Art classes were available on some cruises during the inter-war period, and passengers could usually purchase the necessary materials aboard ship. Sunglasses became indispensable because of the fashion for healthy, open-air pursuits like sunbathing, walking and cycling. The influence of Hollywood films can clearly be seen in the woman's cotton afternoon frock, with starched collar and cuffs in the Betty Davis manner. These were usually detachable and the ship's laundry could have them laundered and starched for passengers when required. Her stout shoes were a necessity because stepping on and off the ship's tender could be hazardous. Shoetrees were suggested on Thomas Cook's packing list, issued in 1936, to prevent damp shoes from losing their shape. The gentleman's Panama hat, made of tightly woven, fine, light-coloured straw, had originated in Ecuador during the nineteenth century and was considered an essential part of cruise-wear. It was called the Panama because President Theodore Roosevelt wore one when he visited the Panama Canal in 1906. The passenger's two-tone correspondent shoes were also on the packing list.

Laundry in the *Iberia*, about 1960

This is perhaps a curious subject for MPS to photograph, but passengers have always been fascinated with behind-the-scenes areas of ships. A vessel can generate an extraordinary amount of laundry, particularly in hot climates – around 10,000 items a day on a large ship at about this time. Passengers could, of course, wash their own clothes and there would be ironing rooms available. The immaculate white uniforms of crews could cause maintenance problems. Even on ships in the 1960s smuts from the funnel would, from time to time, land on the decks. Passengers and crews either had to 'spot clean' their clothes themselves using soap and water or a basic dry cleaning fluid such as turpentine, or send them to the ship's laundry, or simply throw them away. The final option is not as bizarre as it sounds. Some packing lists from the nineteenth century recommended that passengers took old underwear with them so they could discard it when it became dirty. Even as late as 1924 the general advice to passengers was that 'sufficient linen and under clothing should be taken to last the voyage'. Special soaps made from coconut oil were developed in the 1920s to work well at sea in salt water. Unfortunately this type of soap did have the side effect of smelling quite unpleasant if passengers used it when washing themselves.

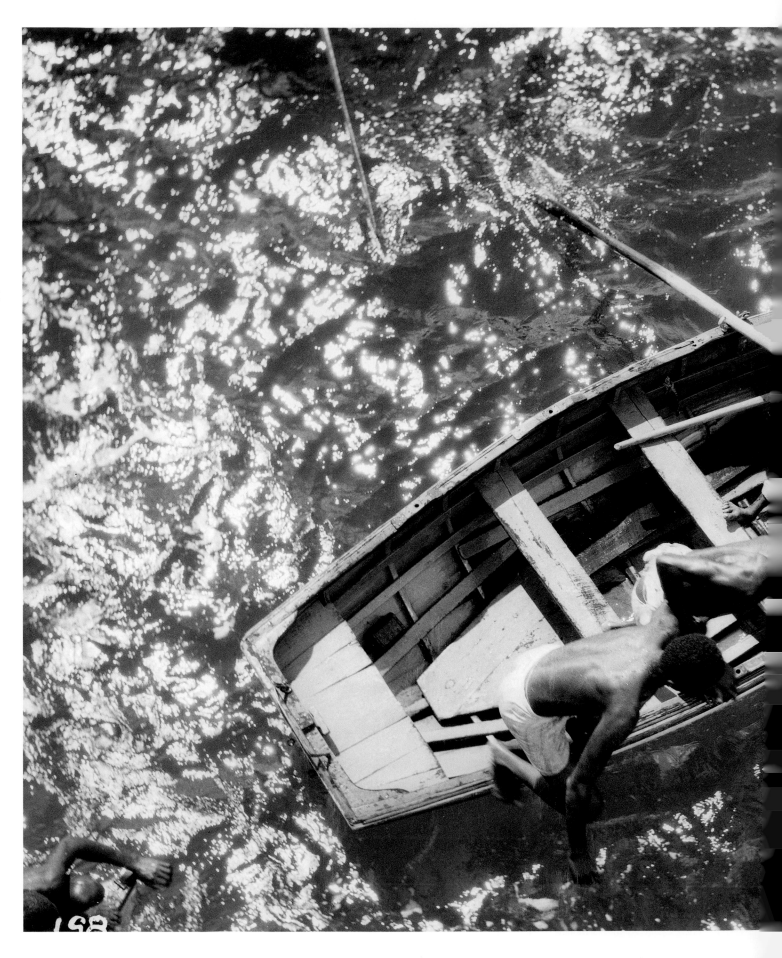

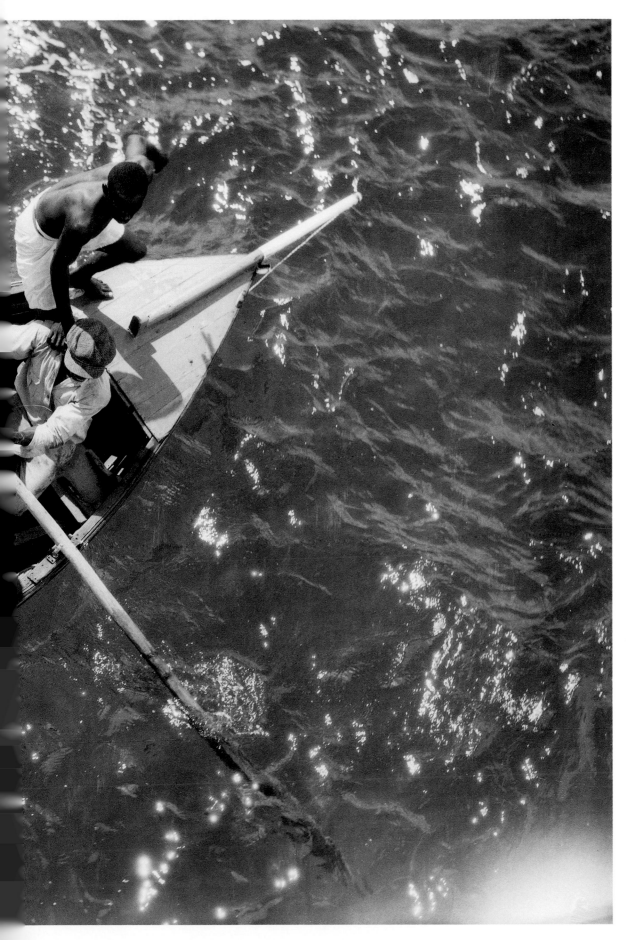

Local divers in Barbados, Lesser Antilles, about 1935

Young lads diving for coins became an entertaining diversion for passengers when their ship arrived at ports around the world. Photographer Keith Winterbourne recalls that, in the West Indies, 'These kids would dive for coins thrown from the ship but they …would only dive for silver. So the passengers used to wrap the pennies in silver foil, and when they came to the surface the abuse they used to give the passengers!'

4

Vessels large and small

The period from 1920 to 1970 saw enormous changes in the design and function of passenger ships. The pre-First World War symbols of national pride and prestige suddenly seemed anachronisms in the inter-war years as a new fleet of ships began to appear, replacing those lost during the recent conflict. They were now smaller, both on the westbound North Atlantic line and on the so-called 'blue water' routes to the East. Three-class ships started to disappear as two-class, and then single-class vessels, offered greater flexibility on line runs and cruises.

As in the case of the first great conflict, the Second World War saw passenger ships requisitioned by the British government, and enormous numbers were lost. It took a long while for shipping lines to get back into the business of transporting and entertaining passengers. The priority was to get scheduled line voyages going again. There was a lot of repatriation to be done of displaced persons, prisoners of war, refugees and troops. Shipyard capacity immediately after the war was considerably reduced due to lack of skilled labour and raw materials, and damage that had been inflicted on them. Yet again though, turmoil and upheaval gave rise to a new generation of passenger ships.

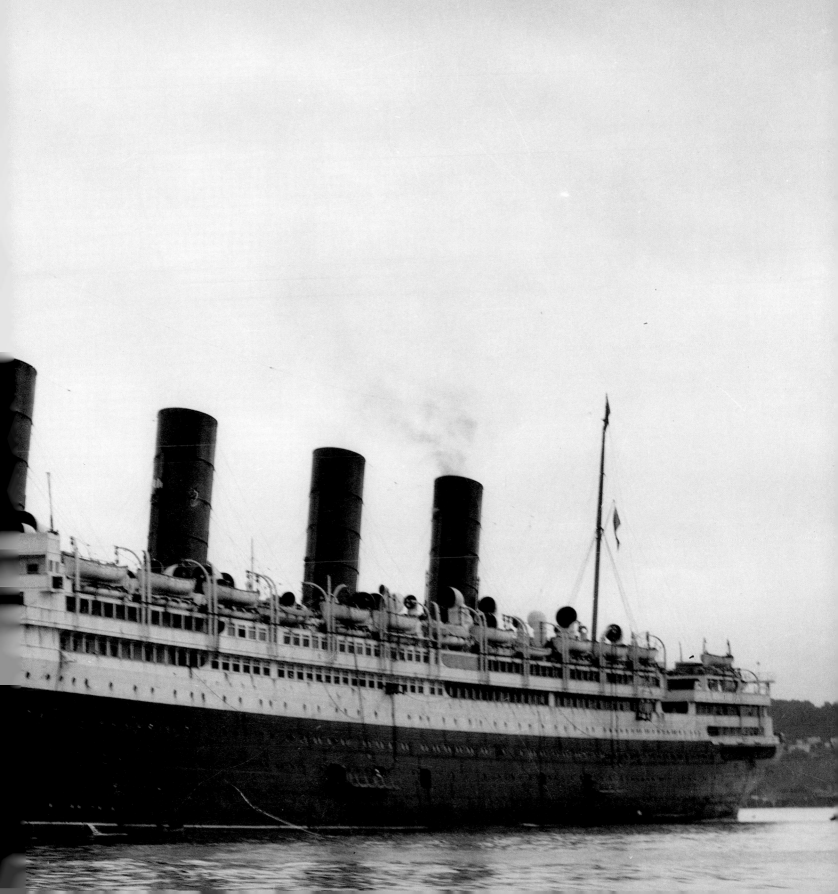

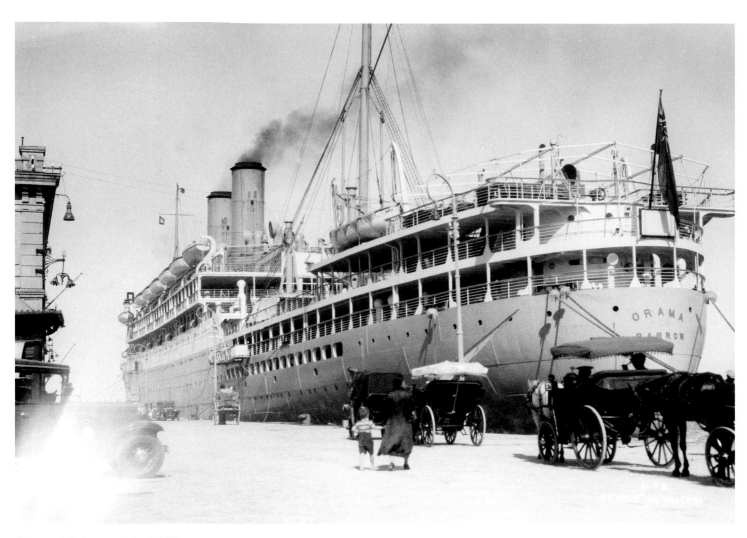

Orama at Palermo, Italy, 1935

The shot can be dated precisely. *Orama* was an Orient ship and for one season only, 1935, her hull was painted a corn colour before making two voyages to Australia to test public opinion (which turned out to be favourable). She was then repainted in traditional Orient Line black, but when their new liner, *Orion*, was completed in the summer of that year, she sported the same corn-coloured hull. *Orama* was the first British ship to have accommodation for first-class and third-class passengers but no second-class provision. She was sunk in June 1940 by the German cruiser *Admiral Hipper* during the Norwegian campaign.

Previous page

Aquitania, about 1925

Considered by many to be the most elegant of all Cunard's liners, *Aquitania* also impressed travellers with her seaworthiness. Her tonnage, along with her knife-like bow, helped to make her very stable in rough weather. She was used as a benchmark for Cunard's new superliner, *Queen Mary*.

Orford at Venice, Italy, possibly 1928

Over the summer of 1928, Orient's new liner made a series of cruises to Norway and the Mediterranean. In 1935 she had her third-class accommodation upgraded to tourist-class. In May 1940, *Orford* was back again in the Med, this time evacuating British troops from the south of France. She came under sustained attack by German bombers at Marseilles. Burning furiously from end to end she was run ashore and abandoned.

Oriana – the forty thousand ton greyhound

On 3 November 1959 Princess Alexandra launched Orient Line's *Oriana*, and on 16 March 1960 Dame Pattie Menzies launched P&O's *Canberra*. Early in that year P&O, which already had a controlling stake in Orient, offered to purchase the balance of the company. The two merged in May becoming P&O-Orient Lines. The new company had two very modern, very fast, very stylish and, at around 42,000 tons each, very large ships. MPS was due to get the contracts for both vessels, but the concession was split at the last minute by P&O in order to keep the company on its toes. MPS photographers were on the *Oriana* from her maiden voyage on a cold wet day in Southampton, on 3 December 1960, right through to her final trip, which arrived in sunny Sydney on 27 March 1986. The photographers on the inaugural voyage were Chris Davies (in charge, and later replaced by Geoff Pettit), Ken Davy and a Canadian, Joe Stockloser: 'The *Oriana* was a lovely ship, not perhaps to look at, but a happy ship to work on. We had a darkroom up on the verandah deck'. It was also a pivotal commission for MPS because the ship seemed to epitomize the crucial and sometimes painful transition in their photographic service from black-and-white to colour.

Oriana was designed and built as a two-class ship with 688 first-class and 1496 tourist-class passengers, though in terms of space, the former occupied more like half the ship. There were two of all the public rooms, except the cinema, which was used by both classes, though not of course at the same time. The ship was designed as much for long-distance cruising as for the business of taking people to their new lives 'Down Under'. Traditionally Sydney was the end of the line for Orient, though the company had extended its route across the Pacific to San Francisco and Vancouver in 1954. Now they were also going to the Caribbean and West Indies, via the Panama Canal, before returning across the Atlantic to Britain. The newly merged company now encircled the globe.

First-class passengers were accommodated amidships and had the use of nine decks, the uppermost being the tennis deck between the funnels. The bathing deck below included the 'Plough Tavern', with its polished copper bar top opening out onto the swimming pool. Just outside the Tavern, in the foyer, were etched and engraved glass panels that had been salvaged from The Plough, a well-known pub in Notting Hill Gate, London,

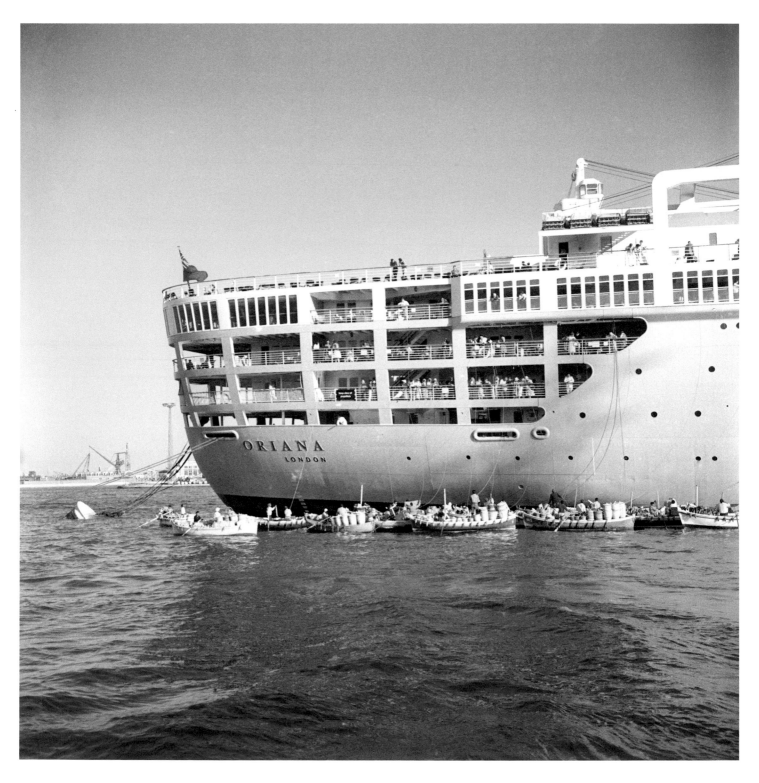

Stern of the *Oriana*, about 1967

Oriana was the flagship of the Orient Line and, at 804 feet (245 metres) in length and with a gross tonnage of 41,293, she was the largest ship in the fleet. She also set a new benchmark in passenger comfort. The finest of all the tourist-class public areas was the stern gallery, with its magnificent 120-foot (thirty-seven-metre) wide window, which faced aft, giving passengers a spectacular panoramic view out over the sea.

which had been demolished in 1957. The observation room on the stadium deck below, 'The Lookout', gave marvellous views either out to sea or across the deck itself. This room could also be used for watching television in the evening. Next came the verandah deck whose public rooms included the 'Junior Club', complete with paddling pool, sandpit and children's library. Below this, on E deck, was the stupendously modern first-class restaurant. Panelled in exotic rosewood and dark green leather, it could seat 369 people at one sitting. The tourist-class areas were similarly well appointed and of a high standard and were, if anything, equally impressive.

The maiden voyage took 111 days and covered over 45,000 nautical miles (83,000 kilometres). For several days before departing Southampton there were parties and functions, that included a fashion show after which the models were, by all accounts, enthusiastically entertained by the junior officers. *Oriana* caused a sensation at every port of call, and there were receptions and guided tours of the ship at Colombo, Vancouver, San Francisco and elsewhere. The terminals at Southampton and Sydney had been rebuilt especially to accommodate *Canberra* and *Oriana*, and were the scenes of much jubilation at departure and arrival. Prior to crossing the Pacific *Oriana* made a ten-day cruise out of Sydney to Hobart, Wellington and Auckland. Passenger Jennifer Dennewald remembers the holiday vividly:

> We were in our early twenties and, having the 'travel bug', we were able to save just enough for the cheapest first-class cabin, C78…Our cabin was white, with its own telephone, a basket of fruit and 'our own' steward, whom we tipped (as advised) on the first day of the cruise. I can remember plenty of food, food and even more food, the magnificent Silver Grill, duty free shopping and the Captain's cocktail party. I can remember 'race night' when I was a 'jockey' with a horse…[On] Friday the 13th the clouds were dark in the sky and the seas were rough, only a few made it to breakfast and even fewer came down to lunch. I recorded in my diary, 'Huge grey waves, but calm by evening'. The words of youth, but I remember it as though it were yesterday.

Again large crowds gathered to see the new ship – at Hobart, Tasmania, the throng was larger than at the Queen's coronation tour visit in 1954.

Oriana's officers were, as on every other passenger ship at that time, still autocratic, many being in the Royal Naval Reserve. Her captain, Clifford Edgecombe, was no exception. Much admired and respected, he was known as 'Ginger Tom' on account of his red hair, or else simply as

'The Old Man'. Several MPS photographers have stories of him. Keith Winterbourne recalls on one occasion:

> We were coming out of Honolulu, and the bridge on the *Oriana* was situated a long, long way back and the pilot who was backing her out gave the order 'Hard to port. Hard to starboard' to swing the bow around. Edgecombe stood at the back of the bridge, ex-Royal Navy, and said 'Belay that!'. So the man at the wheel held it and the pilot was rigid because the back end was getting near the quayside. Finally the Old Man said 'Now!' and the man at the wheel gave it the full left-hand down and the front of the ship swung round and missed the quayside by a hair's breadth.

Oriana had her share of bad luck during the 1960s. On the second anniversary of her maiden voyage, she collided with the aircraft carrier USS *Kearsarge*. Both ships had been aware of one another's presence and course, and both had taken evasive measures. Curiously though, at 1000 yards (923 metres), *Oriana* altered her course to starboard making a collision inevitable. Her bow was badly damaged, and fires broke out in both vessels. Had the *Kearsarge* herself not taken prompt action she would probably have smashed into the liner amidships, where both restaurants had been full of passengers taking breakfast. During her transit of the Suez Canal on 20–21 May 1967, *Oriana* grounded briefly and sustained damage to a propeller. It was a race against time to clear the Canal, as the political situation then between Egypt and Israel was rapidly deteriorating. Fortunately she was well clear of the region by the time the Six Day War began on 5 June when the Canal closed to shipping. *Oriana*'s breadth was almost a hundred feet (thirty metres), which meant that she fitted into the locks of the Panama Canal with just five feet to spare on either side. On 7 April 1968 a Panama Canal pilot ordered *Oriana*'s wheel to be put over too quickly, causing one of her propellers to hit the bank and screw itself into the side of the Canal itself. The turbulence caused part of the bank to disintegrate and a tree was sucked under the water. More seriously the propeller, together with its shaft, was dragged out of the ship by twelve feet (four metres). Rounding off a decade of mishaps, a serious fire in *Oriana*'s boiler room off Southampton put her out of action for several weeks in 1970.

By the early 1970s *Oriana* was spending more and more of her working year cruising. Her season of twelve cruises that year would be as a one-class ship. They were so successful that it was decided to drop all class barriers on subsequent cruises throughout the P&O fleet. For some, the golden age of cruising had finally come to an end.

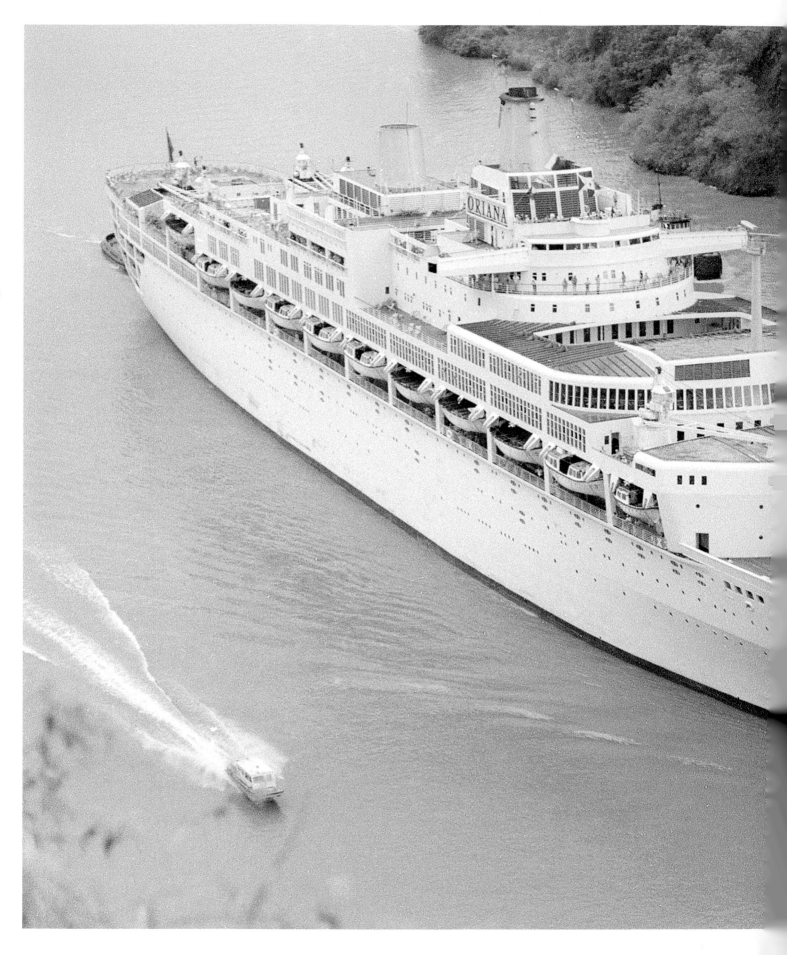

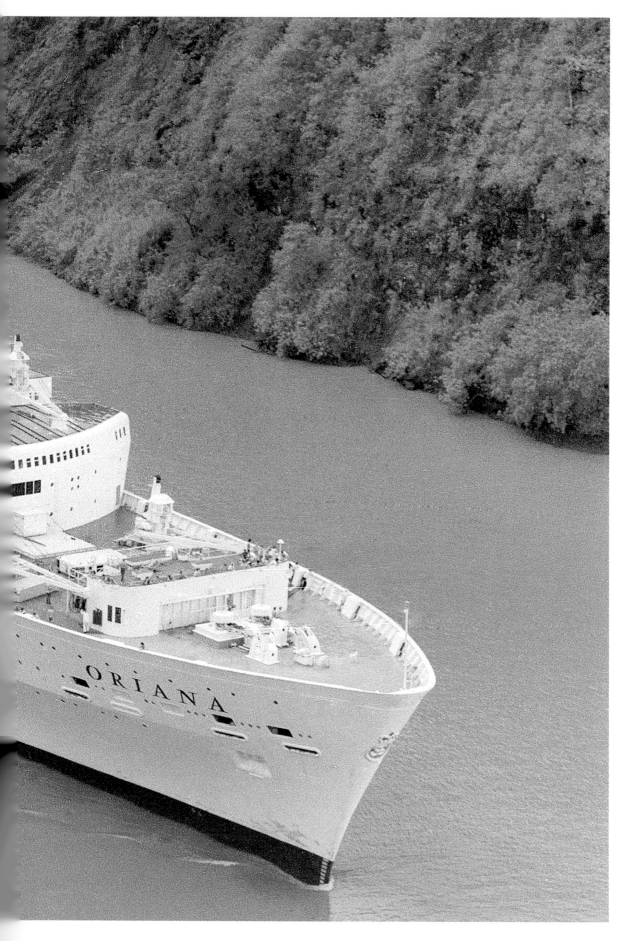

Oriana passing through the Panama Canal, about 1970

Though luxurious, many found *Oriana*'s profile unusual, if not unattractive. The oddest feature was the two funnels. According to some, they looked like upside-down flowerpots. Differing slightly in design, the aft funnel was a dummy. The bow was adorned with a crest, consisting of two entwined letter E's, representing the two Elizabethan eras – the Tudor one after which she was named, and the Windsor one in which she was built. Her name was spelt out in what must be the largest letters ever put on a ship.

1586.

Cruising between the wars

The First World War that devastated Europe also devastated Europe's shipping fleets. By eleven o'clock on the eleventh day of the eleventh month of 1918, over nine million tons of shipping had been sent to the bottom of the world's seas. Mostly due to the success of Germany's U-boat campaign, 2749 British vessels had been lost – almost forty percent of its pre-war fleet. Cunard had lost over half its ships, while P&O had lost almost half. The years after the war saw a large rebuilding and replacement programme. Cunard placed orders for thirteen ships, though the pre-war trend for ever larger vessels was reversed. The new fleet was small, built to a budget and designed to plug the gaps on the North Atlantic line. Away from the eastern seaboard, colonial passenger services quickly recovered after the war. In 1921 P&O placed orders for seven liners for their London–Bombay and London–Sydney services. British India, Orient, Union-Castle and the New Zealand Shipping Company all introduced new ships on the more leisurely 'blue water' lines to the East. P&O was to the 'East of Suez' what Cunard was to the North Atlantic. Voyages lasted weeks rather than days, just as they had always done.

The cost of building and operating ships was escalating, mainly due to higher wage costs. Shipping lines were further hampered by the global economy, which was on something of a roller-coaster. However they were given a fillip on 16 January 1920 when Prohibition was introduced in the United States. Americans, deprived of alcohol both at home and in their own ships, turned initially to Cunard and White Star Line for what became known as 'booze cruises'. These were cheap overnight trips sailing out of New York and beyond the three-mile limit, so that Americans could enjoy the ships' bars before returning home the following morning. These mini-cruises at ten dollars a night were a huge success. Single night trips turned into three, five, seven and then ten night breaks. It was the beginning of mass-market cruising, a pursuit which, before the war, had been the domain of the wealthy and the privileged. Moreover, this use of liners for purely leisurely and indulgent purposes, going nowhere in particular, saw for the first time the introduction of a single-class fare structure. It was radical and bold, and was an indication of the social changes that were taking place.

The 1920s also saw the back of the undignified term 'steerage' as a class on ships. Transporting steerage passengers had once been highly lucrative but demand was now rapidly tailing off. A new market needed to be found

Caronia, about 1925

At the time of launch in 1905, the twin sister ships *Caronia* and *Carmania* were the largest in Cunard's fleet. After the war, both liners received extensive reconditioning before returning to service. In an era that would see a radical alteration in the interior design of ocean liners, the company was keen to point out that the ships did not mimic the decor of the 'age of innocence', but instead were finished 'brightly, efficiently, and completely contemporary'. Returning to service in 1920, the ships became tremendously popular on the Cunard Cabin Channel Service route, from New York to Plymouth, Le Havre and London. The service conveniently served the booming American tourist trade by stopping at all major Channel ports. In 1932 they were both sold for scrap.

and shipping lines targeted the emerging American middle classes and professionals who had the time, the money and the desire to travel. For the first time it was not just the very rich and very poor who travelled by sea to far-flung destinations. The middle-aged and middle-class were discovering the delights of cruising and of how easy, pleasurable and affordable it was becoming. Meanwhile the well-heeled were not being neglected. For the super rich, ships were coming on-stream whose facilities rivalled anything ashore. In the 1920s and 1930s MPS photographers could find themselves on world cruises lasting three months or more. Swedish America, White Star and Cunard Lines all specialized in long, up-market, cruises out of New York. *Laconia*'s lavish twenty-two week cruise that sailed early in 1922 included around 300 millionaires and their servants. The world cruise was becoming an established part of the social calendar for those who could afford it.

The decade closed with the Wall Street stock market crash on 29 October 1929, marking the start of the politically and economically turbulent 1930s. The ensuing Depression affected shipping lines everywhere, large and small. Initially Britain was less affected by the slump than the United States, if only because it had not enjoyed the boom period of the 1920s. Britain still had its empire and the shipping companies that served them. But the Depression hit home as the British government attempted to curb its effects. In August 1931 Britain came off the gold standard and the pound sterling plunged in value from $4.86 to $3.49. This made it uneconomic for British people to travel anywhere and, by the end of that year, over thirty percent of its tonnage was laid up and thousands of seamen were unemployed. The 'Buy British, Travel British' campaign prompted shipping lines to look far more closely at cruising for markets that had been identified across the Atlantic in the previous decade. Cruising on British-owned ships would at least keep sterling at home and so hopefully avoid further devaluation.

The cruising boom of the 1930s was reported in *The Times* on 14 January 1932, in which it announced 'a record number of cruises to appeal to Patriotic Winter Holidaymakers'. In the spring of 1932 Cunard advertised two-week cruises to the Mediterranean for just one guinea (£1.05) a day in the *Lancastria* while, in December, P&O's *Viceroy of India* offered a thirty-eight day cruise to the West Indies. There was something to cater for all tastes and for most pockets. On the one hand, the *Viceroy* continued the P&O tradition of offering a first-class and tourist-class service on her cruises. But what was a departure for P&O was the conversion of the *Mongolia* and *Moldavia* to one-class tourist ships – it marked the start of

mass-market cruising for that line. The year 1932 was remarkable for the cruise market, with more than 100,000 passengers carried. White Star became the first of the Atlantic lines to have two vessels dedicated to full-time cruising, *Homeric* and *Doric*. Canadian Pacific, too, virtually removed the *Montcalm, Montclare, Montrose* and *Melita* from line duties and used them instead for an extensive programme of cruises out of Britain. From 1932 to 1939 they together made 143 cruises. Orient Line ran eighteen cruises in 1933, mainly sailing to Scandinavia, the Baltic and the Mediterranean with the *Orama, Orford, Orontes* and *Ormonde*.

It seemed as though the boom of the 1930s was here to stay. Cruising continued to be popular and used much spare capacity but, at the benchmark rate of a guinea-a-day, it made little, if any, profit for the operators. *The Times* reported that: 'There is no profit in holiday cruises for they [the shipping lines] write that the cruising business, while it enables shipowners to keep the steamers and men employed, does not cover the depreciation of vessels, nor leave any surplus to assist owners to meet the large overhaul expenses'. Nevertheless cruise ships continued to sail. In 1934, 250 embarked from British ports, with seven sailing from Tilbury on one day alone in July. The boom began to level out in 1935, which coincided with an upturn in the traditional trade in liner traffic. The Depression was creating the impetus to regenerate the world's economies and one manifestation of this was the building of new ships. When Canadian Pacific's flagship the *Empress of Britain* was launched in 1931, she was not just the largest and most lavish liner ever built for the Canadian North Atlantic service but was also the first transatlantic liner designed for off-season world cruising. These cruises would take place at the beginning of every year and last for around 125 days. Not as prestigious but equally significant were P&O's new 'White Sisters' – *Strathnaver, Strathaird, Strathmore, Stratheden* and *Strathallan*. They quickly established themselves as popular and successful ships for both line work and cruising. They also looked as though they had been designed for pleasure, immaculate in the company's new all-white livery that, according the publicity releases, embodied 'a degree of energy, speed and beauty never before attempted in ships'.

'Abandon ship', about 1938

A carefully framed shot, this would seem to be the
photographer exercising special care in taking a 'life at sea'
picture that would sell well, but which also gave professional
pleasure. Lifeboat drill for passengers always took place as
early as possible on the first day of the cruise or voyage.
The ship here is the *Orcades*.

ABANDON SHIP

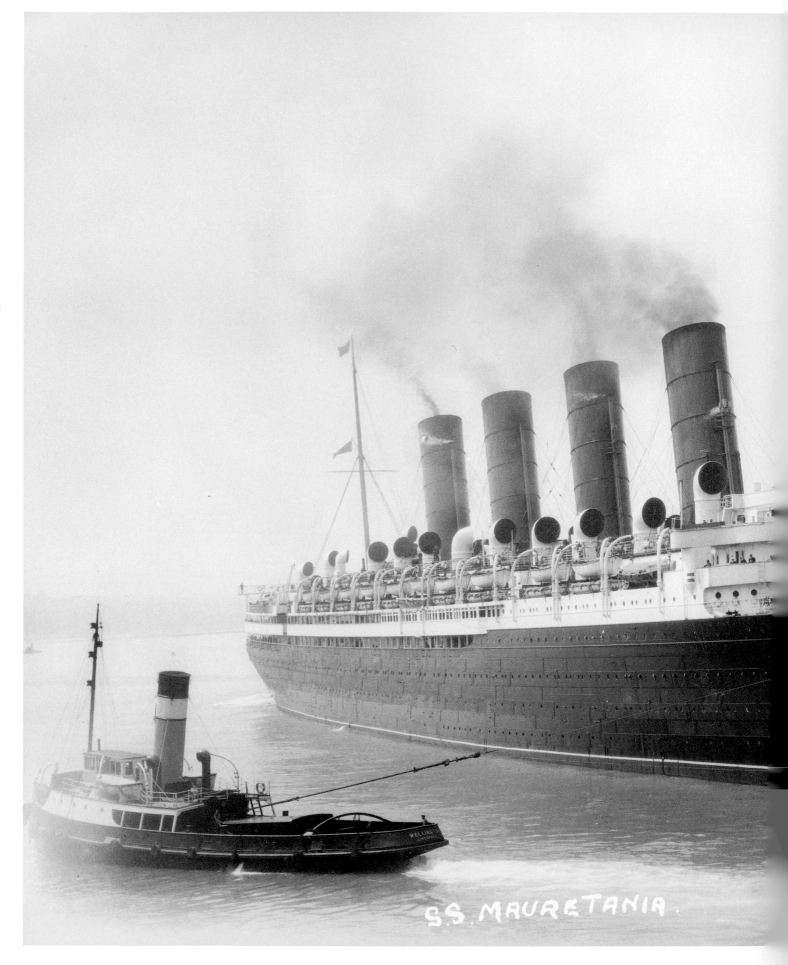

S.S. MAURETANIA.

5429.

Mauretania at Southampton, about 1925

Mauretania's home port was changed
after the First World War from Liverpool
to Southampton. It was from here that
she made her British cruises and, here
too, that people flocked in 1935 to bid
for mementoes of their favourite ship.
Much of *'Old Maury's'* furniture and
fittings went to a hotel on Guernsey, the
Channel Islands, where guests could be
reminded of the great ship.

Aquitania, *Alaunia* and *Orford*, with the tugs *Canute* and *Wellington* at Southampton, about 1930

A typically crowded scene at Southampton. The photograph has been taken from *Aquitania* and is looking out at the stern view of *Alaunia*. The latter was launched in 1925 and served mainly on Cunard's Canadian service, but was also used for cruising during the Great Depression.

The Old Cunarders

When MPS was established, around 1920, one of its contracts was with Cunard Line. Some of the ships on which the photographers served had been launched before the First World War, and were in the middle or twilight period of their service careers by the time of the boom period in cruising in the early 1930s. The greatest and most memorable of these were the 'four-stackers' *Mauretania* and *Aquitania*, and the three-funnelled *Berengaria*. In the 1920s and 1930s they together serviced the North Atlantic line from Southampton to New York.

Ships can generate loyalty among frequent travellers for all sorts of reasons and these three especially had devoted followings. *Mauretania*, or *'Old Maury'* as she was known to passengers and crews alike, was probably the most popular. It had seemed to many as though the twentieth century had actually begun, somewhat late, in 1907 when *Mauretania* and her sister, *Lusitania*, entered line service. The two ships were the largest, fastest and most technically advanced man-made moving objects ever built at that time, and were the epitome of Edwardian elegance. *Lusitania* was torpedoed off Queenstown (Cóbh), Ireland, on 7 May 1915, with the loss of 1198 lives, but *Mauretania* survived the war – just – and in 1921 a fire on board prompted a complete overhaul. Many of her cabins and public rooms were modernized and upgraded and, given this new lease of life, she resumed service in 1922. Cunard decided to get in on the growing American cruising market by using *Mauretania* and their other large express liner, *Aquitania*, during the off-peak winter months. On 27 January 1923 *Old Maury*, chartered by the American Express Company, departed New York for a six-week cruise of the Mediterranean. Both vessels offered long cruises to the French Riviera, with all first-class accommodation where 800 crew would cosset just 200 passengers. Despite their age they were still up with the best of the floating hotels for the international social set. *Mauretania* continued to amaze the shipping world and her passengers. In September 1908 she had captured the coveted Blue Riband trophy for the fastest crossing of the North Atlantic and it was not until 1929 that Norddeutscher Lloyd's new superliner, *Bremen*, designed specifically to regain the Blue Riband for Germany, finally wrested the trophy from the old Cunarder.

After relinquishing the speed record, *Mauretania* devoted more of her time to cruising. Her sleek black and red hull gave way in 1930 to the all-white

that was fast becoming the uniform colour of cruise ships. Long weekend cruises setting off from Pier 54 in New York to the Bahamas and Cuba were scheduled in between Atlantic crossings. On 14 May 1932 she embarked on a five-day Whitsun cruise from England to Gibraltar. It was Cunard's first short cruise for the British market, and it quickly prompted the company to employ *Aquitania* and *Berengaria* on similar jaunts. Over the spring and summer of that year the three big Cunarders, together with the smaller and newer *Carinthia*, *Antonia* and *Ausonia*, had carried 10,000 passengers on eleven cruises. But time was running out for *Mauretania*. Cunard's plans for two new 80,000-ton superliners – *Queen Mary* and *Queen Elizabeth* – led to her being withdrawn from service in 1934. *Mauretania*'s last sailing out of New York, on 26 September 1934, coincided with hull number 534 (the *Queen Mary*) being launched at Clydebank. In the following year there was an auction of her fittings, furniture and effects, held at Southampton, over an eight-day period. Thousands of people, whether for hard-headed or soft-hearted reasons, crowded into *Mauretania*'s first-class lounge to purchase items from the ship, including panelling, furniture, silverware, china and carpets. Whole rooms were sold, as passengers 'bought' their favourite cabins, complete with light-fittings and rugs. Many of the exquisite public rooms were also sold intact, including the first-class dining saloon, lounge and grand staircase. The first-class library was installed at Pinewood Studios in Buckinghamshire as a boardroom.

Aquitania had a brief stay of execution due to the outbreak of the Second World War on 3 September 1939. By then she had been around for twenty-five years. When she had sailed on her maiden voyage to New York on 30 May 1914 she had been the last word in luxury. Her interiors, decorated by Mewes & Davis of London, were the most sumptuous afloat. The most famous room was the Palladian lounge for first-class passengers, which sported a large ceiling painting by an eighteenth-century Dutch master. It had been removed in its entirety from a house of the period. Being considerably larger than *Mauretania* – 45,647 tons as opposed to 31,938 tons – *Aquitania* was more stable in rough weather. On a voyage to New York in January 1924, waves sixty feet (eighteen metres) high failed to prevent the young flappers aboard from dancing, without difficulty. The only Cunarder to serve in both wars, 'The Grand Old Lady', as she came to be known towards the end of her life, was finally scrapped in 1950. During most of the 1920s *Aquitania* had been under the command of Captain Sir James Charles, who was also the commodore of the Cunard Line. He was due to retire in July 1928 and was completing his final voyage home when, on 15 July, he collapsed in his cabin whilst at Cherbourg. As

soon as *Aquitania* arrived at her home port of Southampton he was taken ashore, but died without regaining consciousness. The consensus among family, friends and colleagues was that he had died of a broken heart.

Berengaria had originally been the Hamburg-Amerikanische Paketfahrt Aktien Gesellschaft's ship *Imperator* and had been allocated to Britain, as reparations, after the First World War. She was first leased to, and then sold to, Cunard to help to make up for wartime losses. Many of *Berengaria's* heavy-looking German interiors were removed and replaced with fittings that were said to better appeal to British tastes. She completed the trio of large ships on Cunard's North Atlantic service and became the company's flagship. Popular with passengers and holidaymakers, she was known as the 'happy ship'. She was also once described as 'principally a gleaming and bejewelled ferryboat for the rich and titled' being, for a time, the favoured ship of Hollywood stars, millionaires and royalty. Following the Wall Street stock market crash, *Berengaria* became a key cruise ship for fifty-dollar 'booze cruises'. A series of fires aboard her throughout the 1930s, due to faulty wiring, prompted Cunard to pull her from its service on 23 March 1938. Like the *Mauretania* before her, *Berengaria's* furniture and fittings were auctioned off, in January 1939, prior to her being scrapped.

178

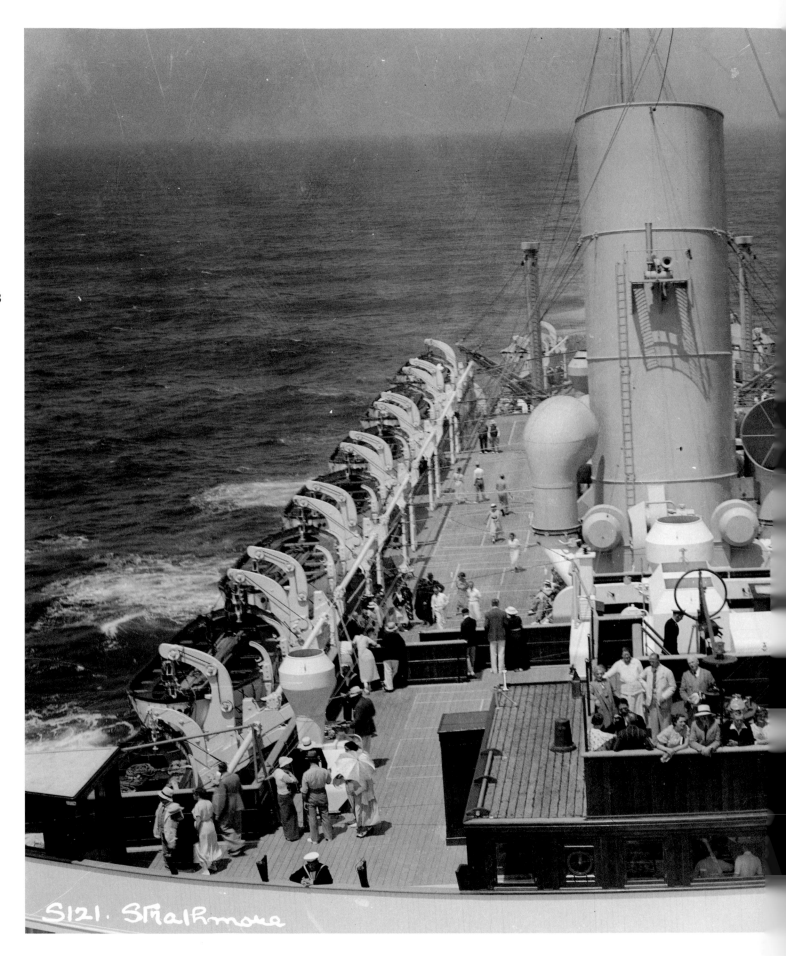

S121. STRathmore

Strathmore looking aft from the foremast, about 1937

The first of the 'White Sisters', *Strathnaver* and *Strathaird*, had entered service in 1931 and 1932 respectively. Their thoroughly modern all-white hulls and high sides had been topped off by a conservative touch – three funnels, even though two were dummies. The remaining ships, *Strathmore*, *Stratheden* and *Strathallan*, dispensed with this deception and their single funnels helped to create more space on the upper deck. The photograph here shows a number of tennis courts laid out. One ventilator, on the left-hand side of the funnel, has also been swung around to catch the most of the sea breeze. On these new ships, forced ventilation from the *punkah louvres* was cooled in hot weather and warmed in cold weather. (A *punkah* was a large swinging cloth fan on a frame worked by a cord, used in India and other hot climates.) *Strathmore*'s maiden trip was a cruise, setting off from Tilbury on 27 September 1935 to the Canary Islands. For those on tighter budgets the *'Straths'* offered the psychological inducement of an upgrade from second-class to the new classification of 'tourist-class'. Before it was denigrated to become what it was supposed to replace, the term meant that passengers had the time, literally, to tour.

Gripsholm at anchor in Eidfjord, Norway,
about 1938

The first of two vessels bearing that
name owned by Swedish America Line,
the *Gripsholm* of 1925 was the first
transatlantic motor ship, designed to
carry migrants to the United States. As
immigration quotas were tightened in the
1930s, her accommodation was altered
and, during the winter months, she was
used as a cruise ship between Europe
and the West Indies. In her service with
Swedish America she carried a total of
321,213 transatlantic passengers and
23,551 cruise passengers. The
photograph shows her after her 1937
refit, sporting her new all-white livery.
Because Sweden remained neutral
during the Second World War,
Gripsholm and her running mate
Drottningholm were placed under the
authority of the International Red Cross.

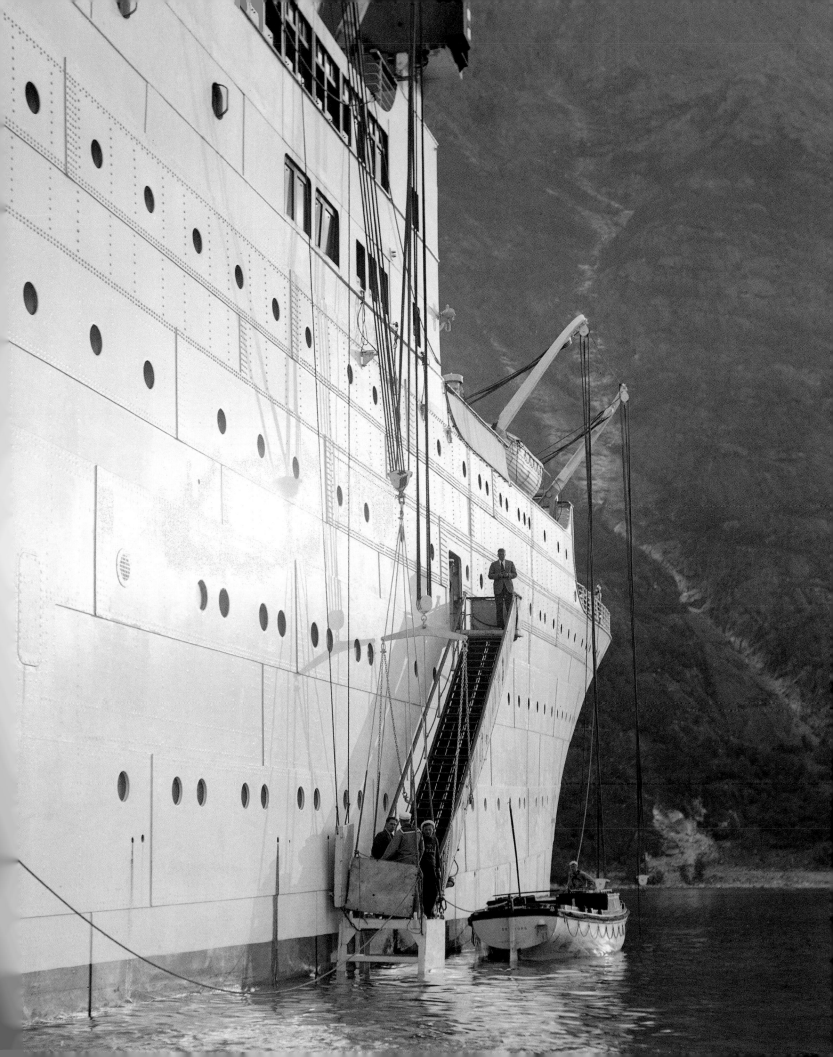

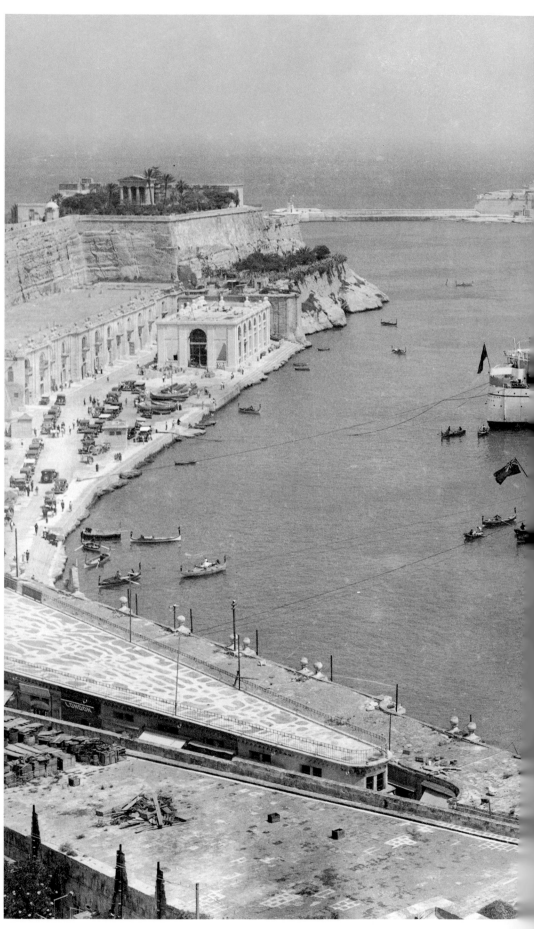

Arandora Star and the Donaldson liner
Letitia in Grand Harbour, Valletta,
Malta, about 1937

Arandora was delivered to Blue Star
Line in 1927 but was converted only
two years later for luxury cruises and
renamed *Arandora Star*. In fact,
because of her exclusive use as a
cruising liner after 1929 to Norway,
the Baltic, the Mediterranean and the
West Indies, she became probably
one of the best-known ships in the
world. With her red ribbon girdling a
gleaming white hull, she was known by
the rich and famous as the 'chocolate
box'. Her contents were certainly
something special. The 400 passengers
that she could carry were cosseted in
palatial surroundings that included a
dining room in the Louis XIV style. It
is somewhat surprising then that
Arandora Star was also the forerunner
of budget cruising, sailing out of
Bournemouth for a day's cruise in the
English Channel on 22 May 1930.
A couple of refits later saw, in 1935,
extra accommodation added aft and
the removal of her mainmast,
following which this photograph
was taken.

183

MALTA 582

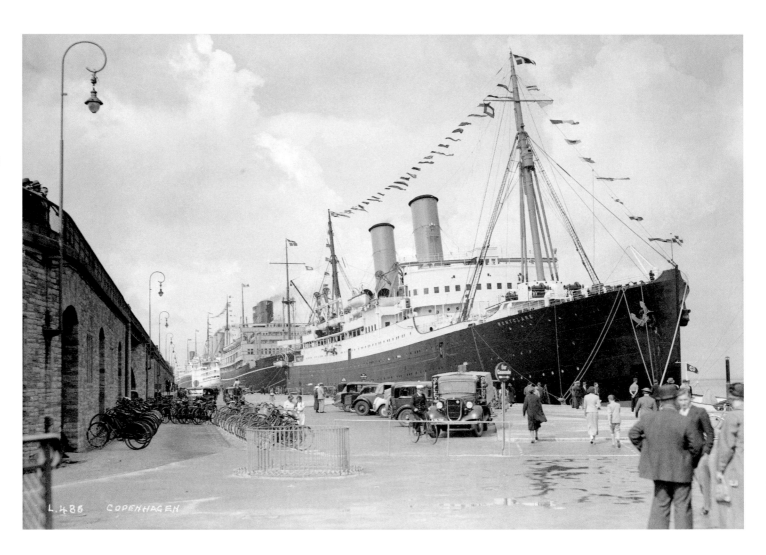

Cruise ships at Copenhagen, Denmark, about 1930

This was taken at, or near, the start of the cruise boom, and ships are stacking up
at Copenhagen – *Montclare*, *Viceroy of India*, *Empress of Australia* and *Mongolia*.
The city was sometimes included in cruise itineraries to the Baltic or Scandinavia.

Dghajsas in Grand Harbour, Valletta, Malta, 1931

A tourist picture of Malta's spectacular Grand Harbour is never complete without the *dghajsa*, the traditional Maltese craft that has survived from Phoenician times. As a working passenger boat it can accommodate up to ten people and is amazingly swift and manageable. When the harbour was a base for the Royal Navy's Mediterranean fleet, sailors used *dghajsas* to get from ship to shore. Part of the fleet is in the background here – the battleships *Queen Elizabeth* and *Royal Oak*, and two London-class cruisers of the 1st Cruiser Squadron. One cannot help comparing the *dghajsa* with Venice's gondola that is known to have evolved from the same Phoenician prototype. Like the gondola, it is propelled with the oarsman facing in the direction of travel.

German battleship *Schlesien* at Curaçao, Lesser Antilles, 1936

Schlesien, commissioned in 1908, was a Deutschland-class battleship, built to a pre-Dreadnought design so was outdated from new. They were known as the 'five-minute ships', reflecting their anticipated life expectancy against modern Dreadnoughts. *Schlesien* lasted longer than that though, and was a veteran of both World Wars. She was at the Battle of Jutland and, much later, in May 1945, was mined in shallow water and towed to Swinemünde, but was still able to fire her guns against the advancing Russians. The local cinema here in Curaçao, the Roxy, is showing the Hollywood film *Small Town Girl* with Janet Gaynor, Robert Taylor and James Stewart, released in 1936.

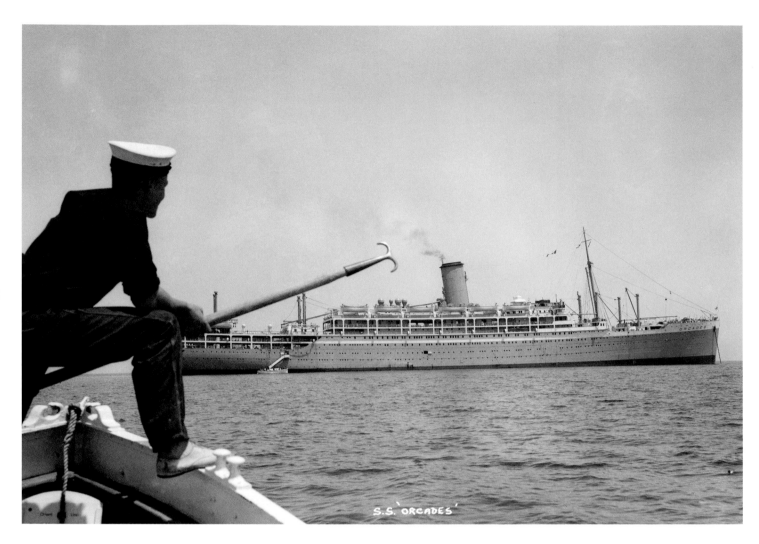

S.S. 'ORCADES'

Orcades at anchor, both about 1938

The two photographs were taken during the same session out in one of the ship's boats, possibly during lifeboat drill. The enormous success enjoyed by *Orion* led Orient Line to commission a sister ship. *Orcades'* first voyage in 1937 was a Mediterranean cruise. Over the following two years she also made several cruises out of Australian ports, and was known with affection there as 'The Big Tug'. Her career was cut short when the Second World War broke out. She was used as a troopship and, in October 1942, was sunk by *U-172* south of Cape Town, South Africa. Eleven years after the first *Orcades*, another ship of the same name entered service. It is interesting how some companies repeat names of ships that are lost while others do not. Orient Line obviously had no problem with using the name again. The names of wrecked ships are seldom, if ever, repeated.

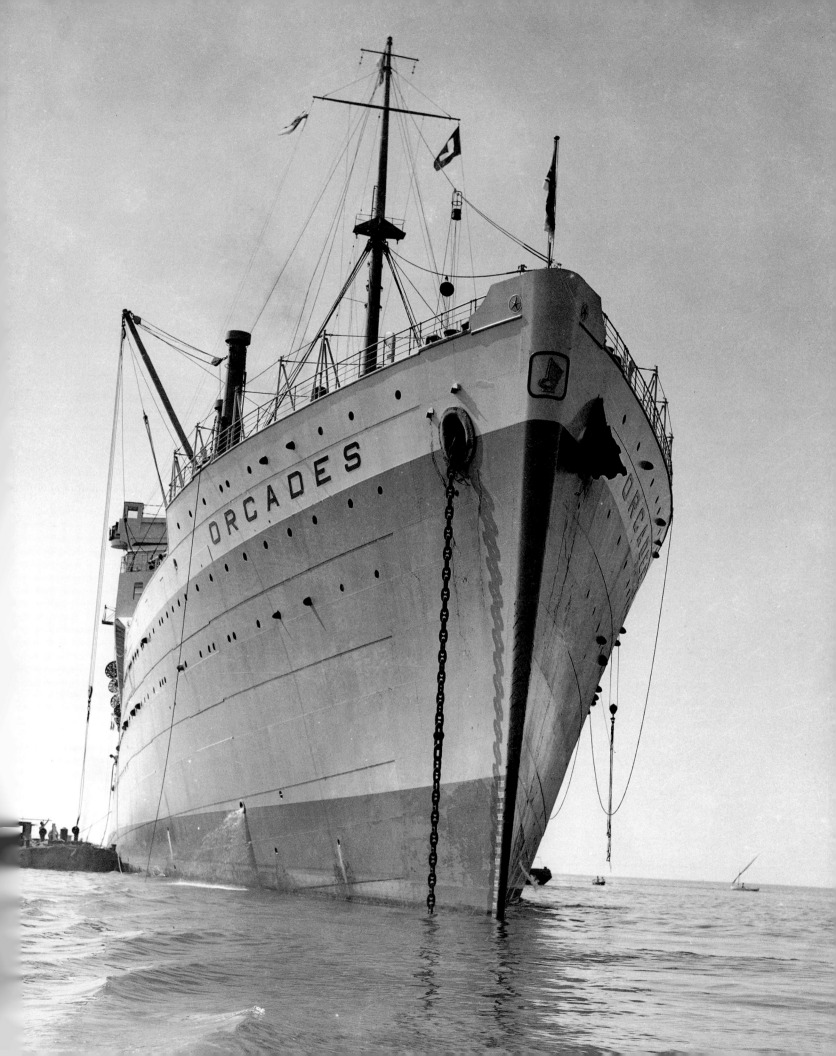

An *oruwa*, Ceylon (Sri Lanka), about 1930

The *oruwa* is a single outrigger fishing boat, made from a hollowed log to which strakes (planks) are sewn to raise the freeboard (side of the vessel). The rig here is the most typical – the so-called Oceanic spritsail – but elsewhere on the island settee and even square sails were once seen. The end of the steering oar can just be seen at the stern. The *oruwa* is also equipped with leeboards (planks fitted to the sides of flat-bottomed boats which, when let down, prevent lateral drift). Nowadays, fibreglass versions are not uncommon.

Bamboo raft, (Java) Jawa, Indonesia, about 1925

Historically the raft has played an important role in Indonesia. The island of Lombok was colonized from East Java, and it is thought that the Sasak people take their name from a type of bamboo raft used to cross the straits. Even today, the bamboo raft is used for transporting rattan from the interior of Jawa to the coast. The examples here look incomplete but they are, nevertheless, river-worthy.

Gaiassa on the Nile, Egypt, about 1925

The *gaiassa* is a cargo boat of the Nile, traditionally used for bulk loads such as stone, hay, gravel and clay pots. The masts are banded to signify the owners and its principal characteristics were the enormous rudder and lateen sails. The hull design, with its wide bow and narrow stern, is thought to have been adopted from medieval Europe, and certainly it seems to have more in common with the boats of the Mediterranean than with the *dhows* of the Arab world. H. Warrington Smythe, the late Victorian diplomat and traveller, gives this lovely description reflecting the skill of the boat builder: 'The top-strake is very often built up with planks set in dried mud, and partakes more of the coffer-dam than of naval architecture'.

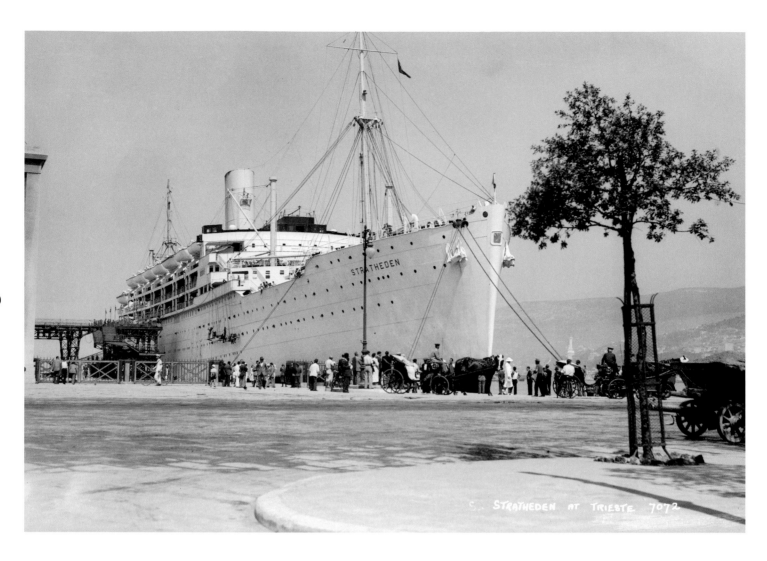

Stratheden at Trieste and Venice, Italy, 1938 or 1939

The fourth of P&O's 'White Sisters' carried over a hundred fewer passengers than her sister, *Strathmore*, that had entered service two years earlier. This was due to the downturn in the line market towards the end of the 1930s, and to make the ship more adaptable for cruising. The five 'Straths' entered service between 1931 and 1938. *Strathmore* was sister ship to Orient Line's *Orion*. *Stratheden* was sister ship to *Orcades*. The funnels were different, the colours were different and the whole hotel aspect of the ships was totally different, but mechanically they were the same ships, which meant that P&O got a discount on the orders. *Strathallan*, the last to appear, was in effect a replica of *Stratheden*. So close was she a repeat that their gross tonnage was identical, quite remarkable for two vessels built two years apart. The photographs show *Stratheden* on the same cruise around the Mediterranean. Both ports of call are within a day's sailing of one another. Even without the gondolas Venice needs no identification. The ship lies alongside Riva dei Schiavoni, near St Mark's Square. This is a beautifully composed picture, with the superstructure of the liner kept just clear of the buildings on the right, and with the rise of the bridge steps and silhouetted figures keeping this area of the frame free from other distractions to the proud bow of the ship. The metal discs placed on the mooring cables are to prevent rats from climbing aboard. The tall white monument in the extreme distance of the shot of Trieste is the Faro Della Vittoria (the Lighthouse of Victory) completed in 1927. It is dedicated *Ai caduti sul mare* (To those who were killed at sea), probably referring to the recent war with Austria, after which Trieste became part of Italy.

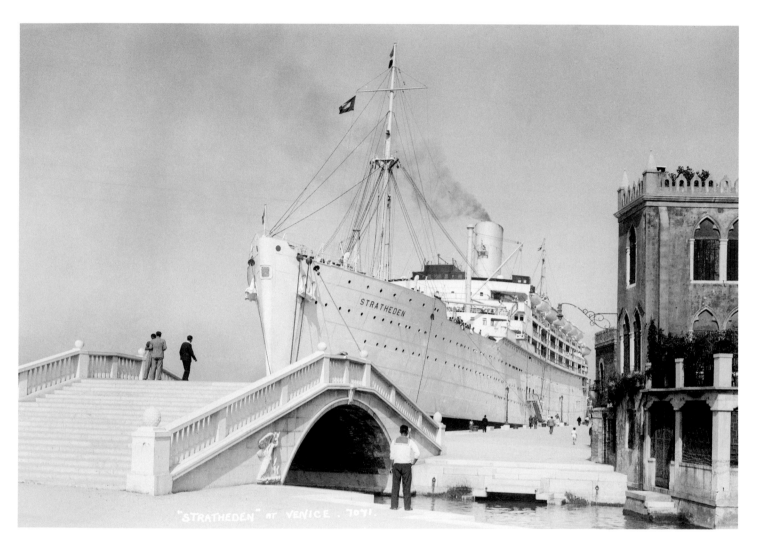

"STRATHEDEN" AT VENICE. 7041.

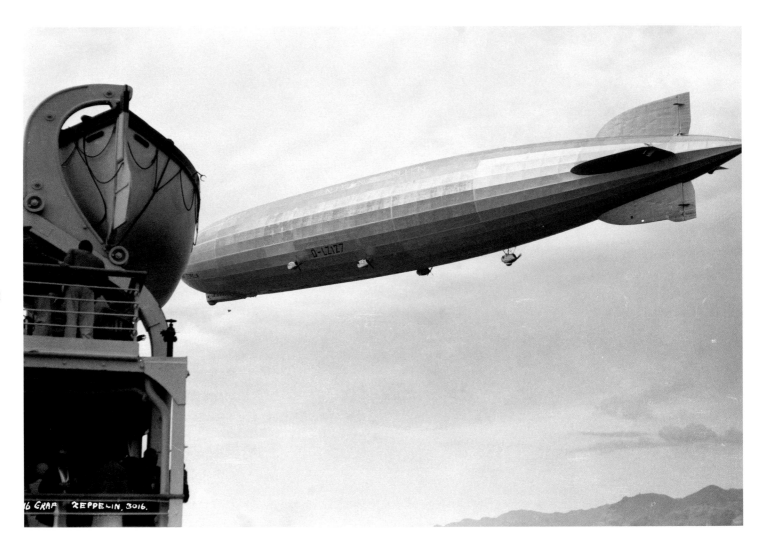

LZ-127 *Graf Zeppelin,* about 1930

One of the transport wonders of the age, *Graf Zeppelin* made its maiden flight on 18 September 1928. The sight of this immense silver shape hovering overhead, and looking a bit like a large ship's hull, brought crowds of people streaming out into the streets or – in this case – onto the decks, wherever it wandered. In 1929 it embarked on a world tour, a cruise of sorts, starting and ending at Lakehurst in New Jersey via Friedrichshafen in Germany, Tokyo, San Francisco and Los Angeles. It was about the same length as the *Mauretania* at 776 feet (236 metres) and had a maximum speed of eighty miles (130 kilometres) per hour. It looked innocuous enough, but was a distant harbinger of the modern jet aircraft that was to decimate the markets of shipping lines in the years to come.

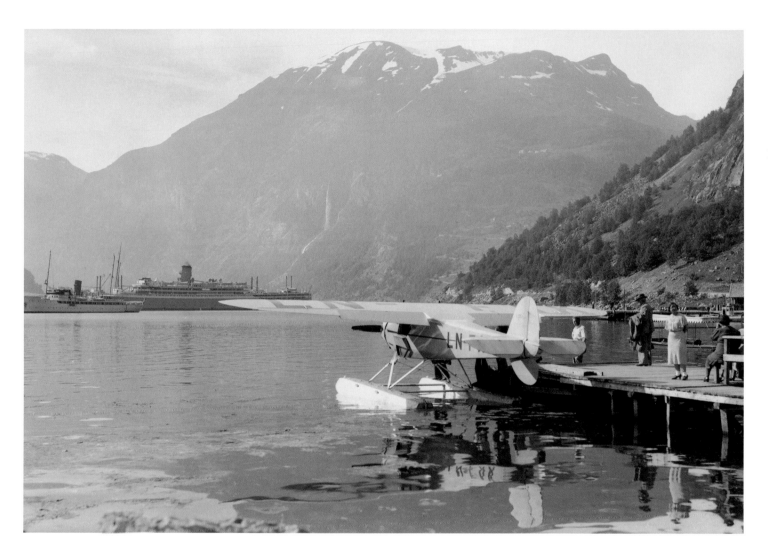

Orion in Geirangerfjord, Norway, 1938 or 1939

One way of getting quickly around the Norwegian fjords and to see more of the dramatic topography was to take a floatplane. The one here is a Cessna C-37 S/N 375, registered in Norway on the 16 May 1938 for the Vest-Norges Flyveselskap (West-Norwegian Airlines). It was slightly damaged after a collision with a ship's mast later that year. Stored during the Second World War, it was in an accident at Svåsand in Hardanger in 1948 and written off.

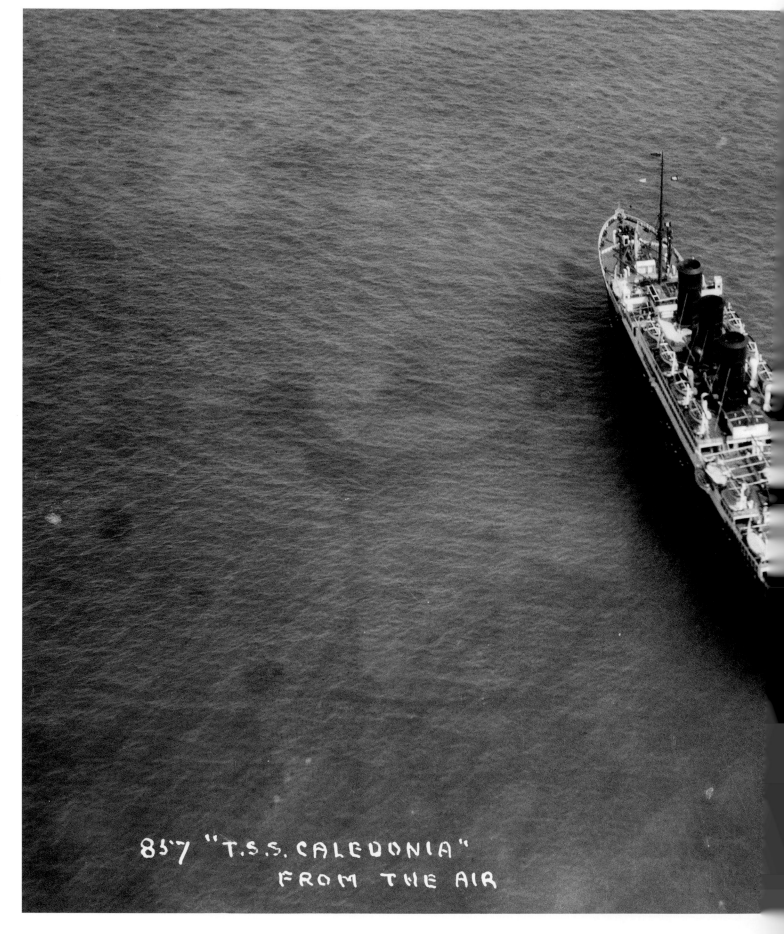

857 "T.S.S. CALEDONIA"
FROM THE AIR

Caledonia, about 1925

Anchor Line's *Caledonia* was built for the Glasgow–New York route. The photograph is an anomaly for two reasons. Firstly MPS never had a contract directly with that company, and so had no commercial reason to photograph its vessels. Secondly the angle of the shot is unusual, having been taken from an aircraft or lighter-than-air craft.

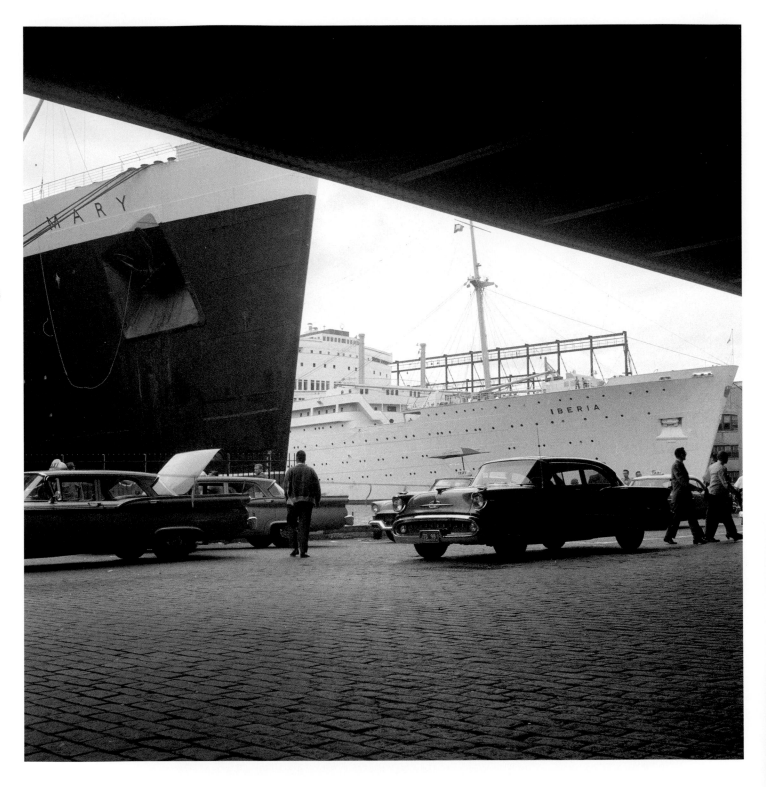

Queen Mary and *Iberia* in New York, United States of America, about 1955

P&O ships did not go to New York very often. Their cruises out of the city were a commercial failure and they soon gave them up. However, when they were promoting trans-Pacific and round-the-world line voyages they would occasionally send a ship to the Big Apple to attract some attention. *Queen Mary*, on the other hand, tirelessly plied the North Atlantic route, for which she was designed, from 1936 to 1967.

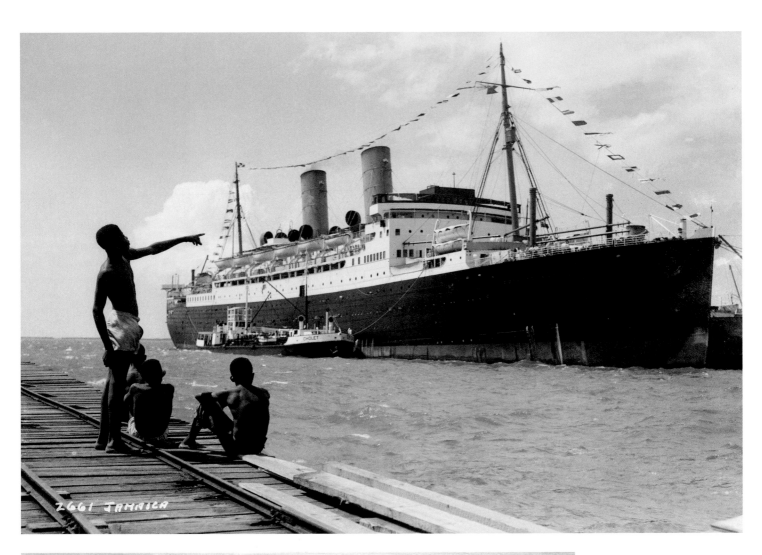

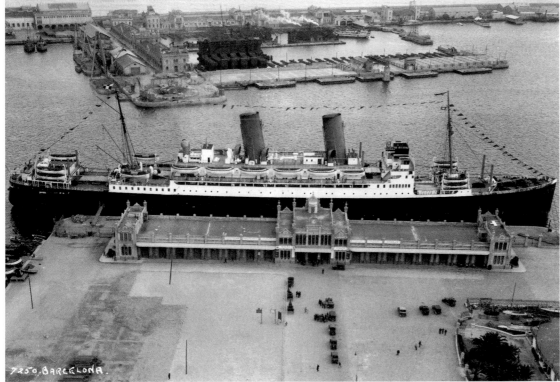

Duchess of Atholl,
both about 1930

Canadian Pacific's new
Duchess entered service
on 13 July 1928 on the
Liverpool–Montreal line,
and at the beginning of
1929 she started her first
cruise from Liverpool to
South America and South
Africa. The first photograph,
a beautifully composed
shot, shows her at Jamaica,
while the second one
demonstrates her sheer
size as she dwarfs the
passenger terminal in
Barcelona, Spain.

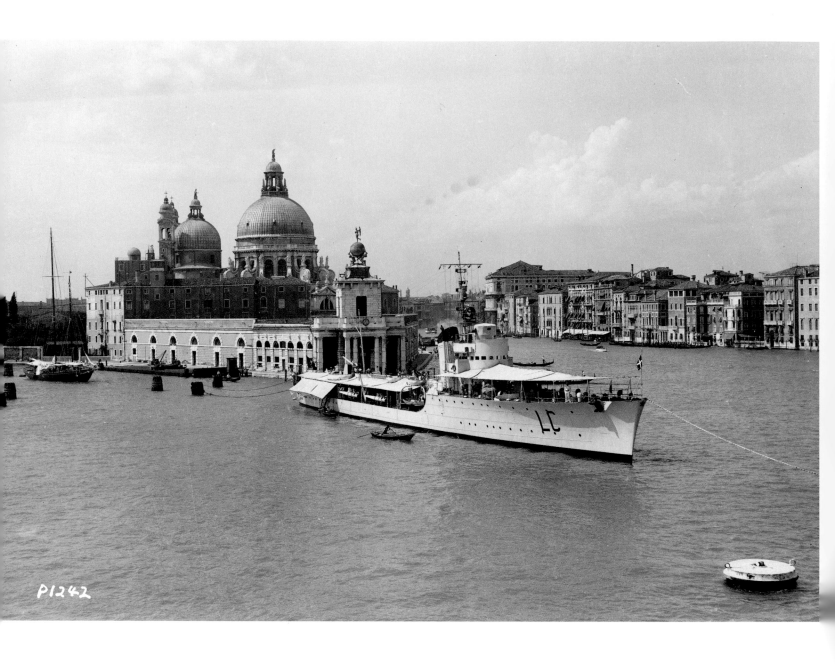

P1242

Italian fleet torpedo boat *Lince* at Venice, Italy, 1938 or 1939

With her awnings erected on deck the *Lince* may be paying a goodwill visit to
Venice on, or shortly after, her commissioning in 1938. Her career was short-lived –
the submarine HMS *Ultor* sank her in the Gulf of Taranto on 28 August 1943.

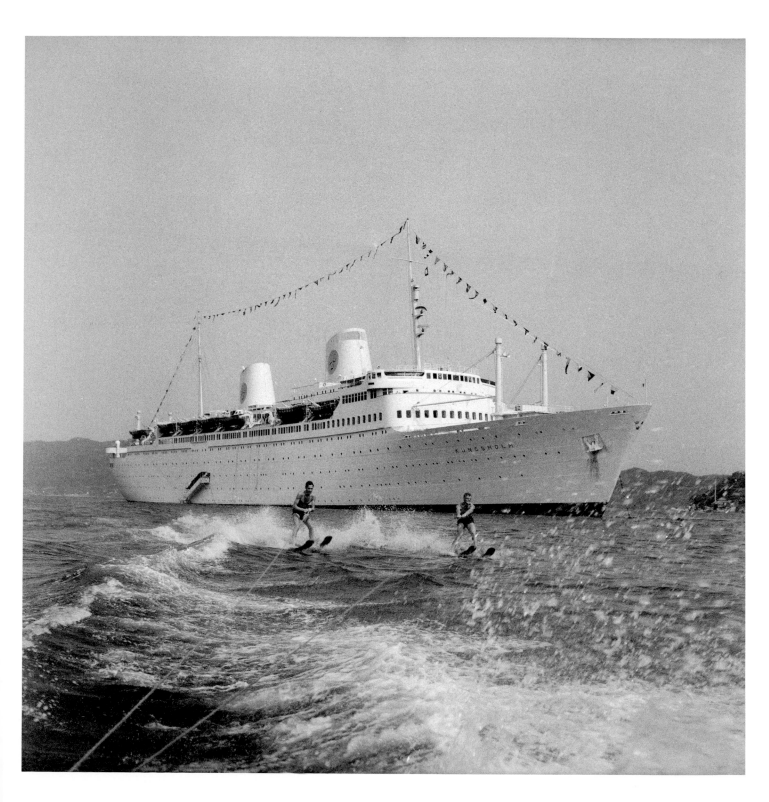

Kungsholm, about 1955

The *Kungsholm* of 1953 embarked upon Swedish America Line's first ever world cruise
in January 1955. The photograph was taken off Acapulco, Mexico.

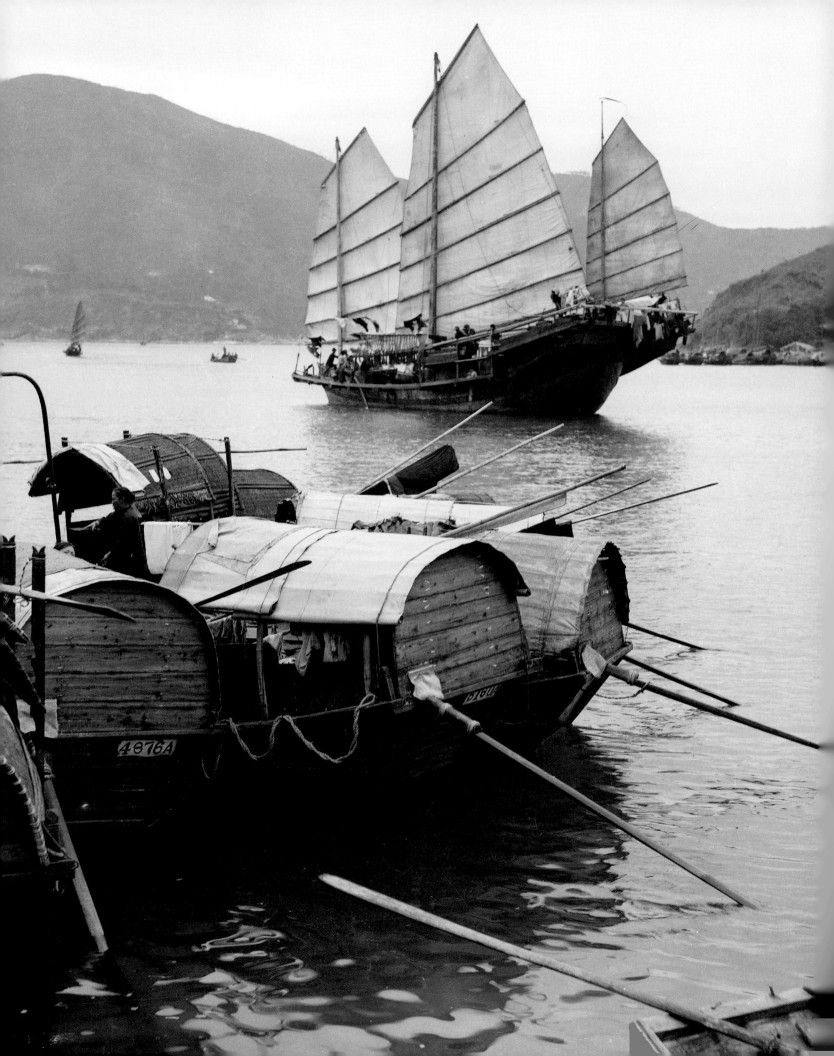

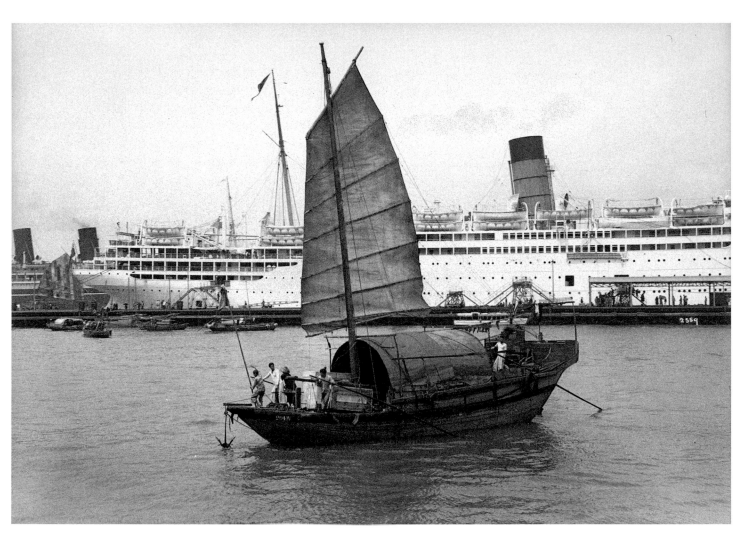

A junk, Hong Kong, 1933

The photograph shows graphically Hong Kong's status as a hub for Eastern and Western trade and commerce. In the foreground is a small junk from South China, with the distinctive 'shoulder of mutton' cut of the sails that are characteristic of this area. The sail is a balance lugsail and, again typically of all Chinese sails, it is battened, which made shortening somewhat easier. This must be a particularly calm day as her crew are using enormous sweeps (long oars) as well as the sail to propel her. Vessels such as this were used both as fishing boats and cargo carriers. The vessel in the background is the *Franconia* on a world cruise.

Sampans and a fishing junk, Hong Kong, about 1935

In the foreground are *sampans* which, as their extensive deckhouses suggests, are also houseboats. The *sampan* is propelled through the water by rowing the projecting oars in a 'figure of eight' over the stern. The vessel in the background is a *ha kau tor*, a deep-sea trawler. Such junks fished in pairs in the Hong Kong and Swatow waters. They were generally about sixty feet (twenty metres) in length, but some were as big as eighty feet (twenty-four metres). Originally they would have had sails of woven bamboo.

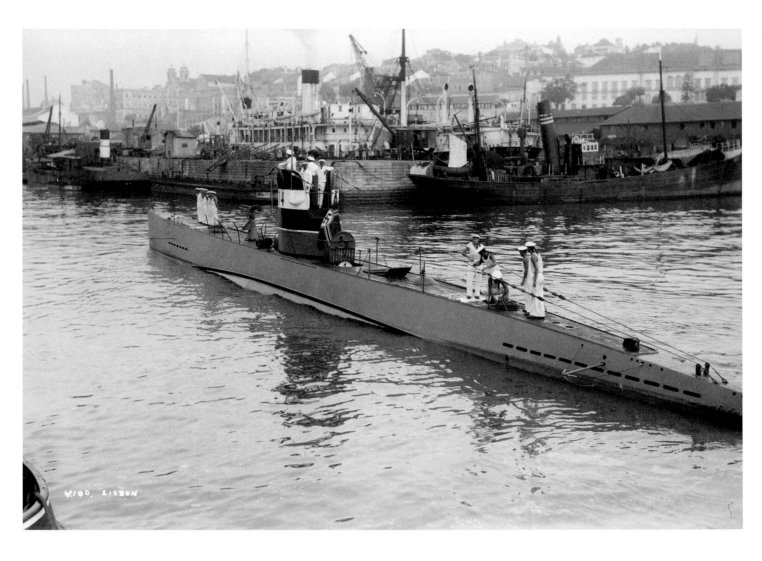

German submarine *U-14* at Lisbon, Portugal, July–September 1937

Passengers would have been looking at the submarine that is credited with making the first attack on a warship in the Second World War. *U-14* fired a torpedo at the Polish submarine *Sep* on 3 September 1939. The torpedo exploded prematurely and when the U-boat's commander found wreckage from his torpedo, and some oil from *Sep*'s damaged oil tank, he mistakenly thought he had sunk the enemy's boat and radioed in his hit. *U-14*, a type IIB coastal boat, was commissioned in 1936. She served in Spanish waters from July to September 1937 and had red, white and black stripes on her conning tower. She sank nine ships in the war and was herself scuttled on 5 May 1945 at Wilhelmshaven, Germany. The sight of such a craft in what the British have always perceived to be a peaceful, friendly, port of call must have filled many with a sense of foreboding.

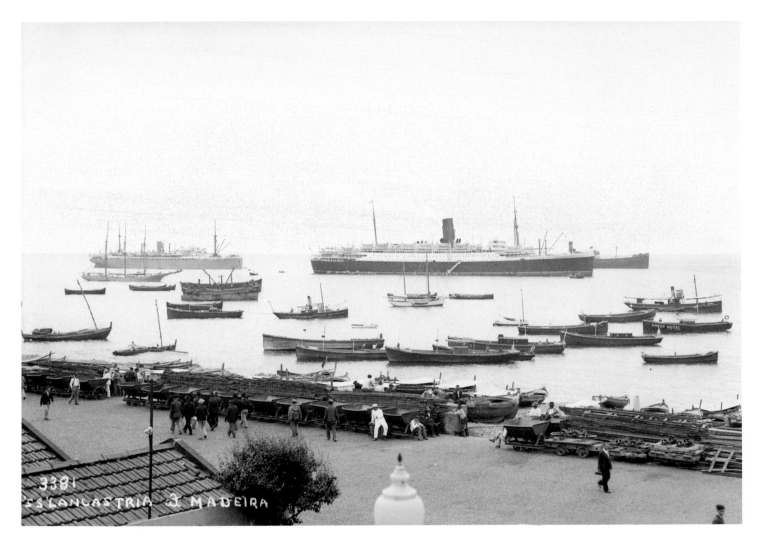

Lancastria at Funchal, Madeira, about 1930

A tranquil scene in Funchal harbour, taken in the years leading up to the Second
World War. Launched in 1920 as the *Tyrrhenia* for the Anchor Line, a subsidiary of
Cunard, the ship made her maiden voyage on 19 June 1922. Just two years later she
was refitted and renamed *Lancastria*. After 1932 she was used exclusively for cruising.
With the outbreak of war she carried cargo before being requisitioned, in April 1940,
as a troopship, assisting first in the evacuation of troops from Norway. She was sunk
off St Nazaire while taking part in Operation Ariel, the escape of Allied forces from
northern France following the country's collapse. The operation saved 163,000 British,
French, Polish and Canadian soldiers. By mid-afternoon on 17 June, *Lancastria* had
embarked an unknown number of civilian refugees and RAF personnel – estimates range
from 5500 to 9000. The ship's official capacity was 3000. At around four o'clock she
was bombed by enemy aircraft and hit four times. One bomb went straight down her
funnel, causing her to list, roll and sink within twenty minutes. There were 2477 survivors.

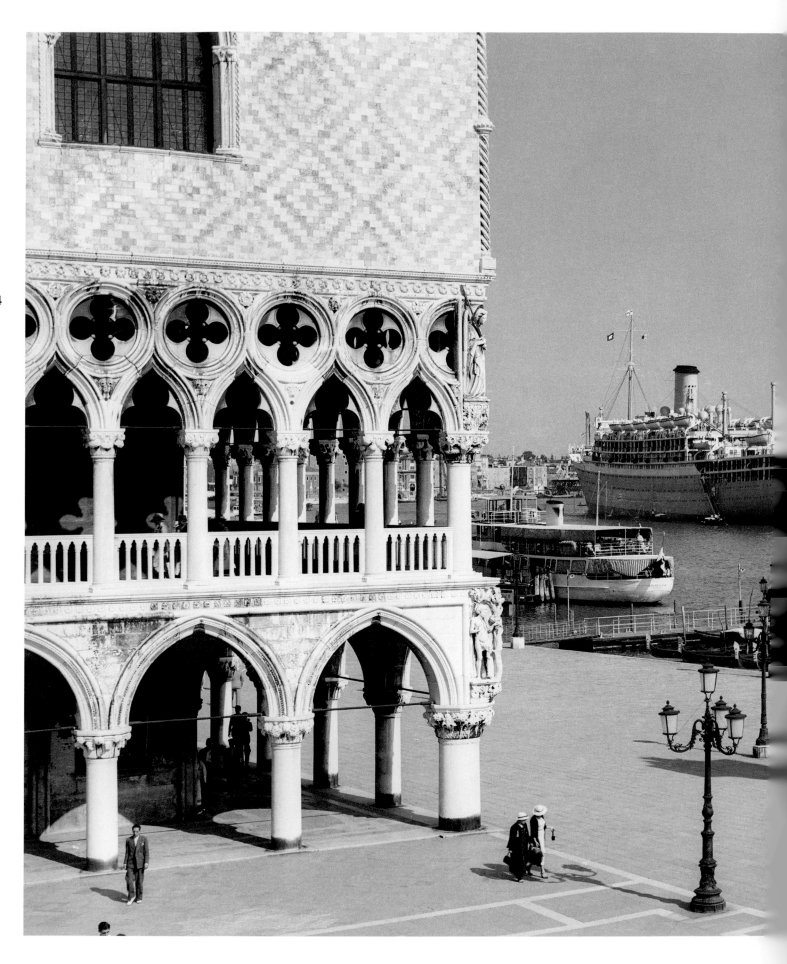

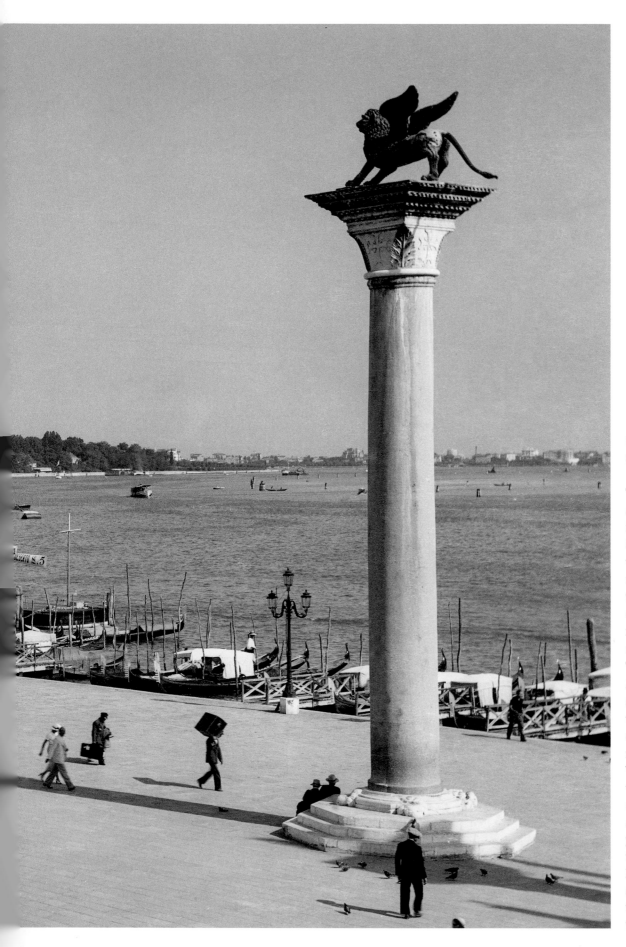

Orion in Venice, Italy,
about 1937

The *Orion* was the first
single-funnelled ship built
for Orient Line since 1902.
Some passengers were
wary of such a feature, or
rather the lack of it, since
the number of funnels
corresponded in the public
mind with how powerful
and reliable the ship was.
This is why *Strathnaver* and
Strathaird – essentially
single-funnelled ships –
were each given two
dummies. They were only
removed after the Second
World War. In the same
vein, Ellerman Line's *City
of Benares* was initially
shunned by the travelling
public because she was
the first large transatlantic
liner to have only a
single propeller, rather
than the customary two,
three or four.

5

The lure of the sea

The reasons for sea travel are many and various, and before the advent of the jumbo jet it was virtually the only way of seeing the far-flung wonders of the world. Cruising appeals to both those with a spirit of adventure and others who are content to sit back and let the world come to them. In the 1920s and 1930s large and formerly inaccessible destinations were opened up for the tourist, and all interests could be catered for, be it architecture, archaeology, ethnography, geology or horticulture. A phenomenon such as the strange light of the Land of the Midnight Sun could not be replicated – one had to travel north, beyond the Arctic Circle, and experience it first-hand.

Moreover, there was the experience of sea travel itself with all its associations of glamour, excitement, romance and prestige. Living on a ship is a little like staying in an exclusive floating hotel, surrounded by blue seas and blue skies. It is a world unto itself, travelling across time zones to exotic places. With its own timetable, newspaper, telephone system, radio programmes, library, bars and restaurants, cinema and social clubs, one soon becomes immersed in the life of the ship and forgets about the outside world.

Storm at sea

Anyone experiencing a severe storm at sea for the first time will have had the sudden realization that the ship on which they are travelling, hitherto so large and reassuring, now seems very diminutive, at the mercy of the elements as it is tossed around like a toy. For the uninitiated it can be an unnerving, if not positively frightening, time. Some parts of the world's seas are more prone to bad weather than others, and this is one of the reasons why certain ports of call have tended to drop off the cruise ship's itinerary. Lisbon is no longer the popular destination it once was due to the volatile weather that can be whipped up in the Bay of Biscay. With cruising, operators can choose, to a degree, where to go to avoid bad weather. The Bay, however, was difficult to steer clear of on some of the line voyages connecting Britain with Africa, the Middle and Far East, and Australasia. In a letter home from the *Capetown Castle* dated 20 February 1966, Ann Haynes wrote:

> It's hard to know where to begin. I was rolling in my bunk, despite pillows under the edge of the mattress. Most of the time it is a steady tremendous roll, but occasionally an enormous wave comes and knocks everything for six, and the ship shudders and throbs and we all hang on tight for our lives almost. I might mention that it is very tricky trying to put stockings on. I staggered round to Maureen and four of us all sat on one bed feeling rather scared. Then the Fourth Officer came to tell us that we would heave to for an hour or so and head into the wind. Lots of crockery has been broken and the furniture has been thrown around quite considerably. All in all we feel lucky to be in such a large ship – a smaller one wouldn't have survived. We can see the funny side of it sometimes, but it is rather scaring and certainly awe-inspiring'.

Passenger Bernard Radford had a worse encounter with the elements in this region, while journeying home from the Canary Islands:

> ... the Captain came over the Tannoy system to tell us that the weather was worsening. Anyway we ran into a storm, force ten, and it lasted two days. We were on the bottom deck near the bow, with two portholes. Looking out of them it was like looking at a vertical wall of water. We learned afterwards they were thirty-foot [nine-metre] waves. Four cabins along from us, a porthole caved in and flooded the cabin. So they came along and blocked off everybody's portholes with large

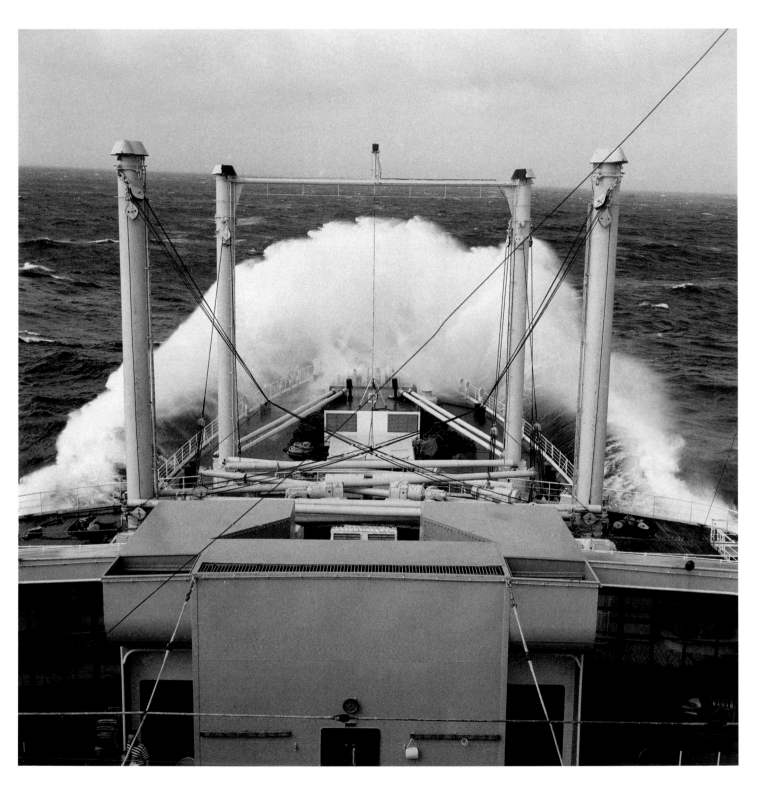

Oronsay in rough weather, about 1960

A wave crashes over the bow of the *Oronsay* as though it were breaking over a sea wall. This is a somewhat surreal scene, as you can peer into the well of the ship and see tables and chairs, and even people nonchalantly standing around.

steel caps which we hadn't realized until then were kept underneath the bunks. All night long it sounded as though an express train was bashing into the side of the ship. My wife woke me up and asked me how I could sleep through it, and I got told off the following morning. One elderly lady had fallen over in her cabin and bruised the entire side of her face, another had broken her arm. I looked out through a window in the *Braemar*'s lounge and saw a supertanker that disappeared completely in a trough and when it came back up again I could see the propeller. Then down she went again. I stood by this window then found myself running subconsciously toward the middle of the lounge, where the ship had tipped up, to keep my balance.

To experience the forces of nature at first hand, at such close quarters and with such unremitting violence, is just another reason why sea travel can be so alluring for some. Storms are invariably followed by calms, and the contrast never ceases to amaze even experienced travellers. After the event, passengers and crewmembers alike will often recount such episodes with enthusiasm. Unsurprisingly, many passengers wanted a souvenir snapshot of their storm to show to family and friends back home. It seemed, though, that sometimes any photograph of rough weather would do. One MPS photographer recalls: 'If you got into a really rough sea you had to take pictures of the waves coming over the bow. You would get up on the bridge and take some photographs, knowing that you could use them all that season.' Whenever the ship ran in to bad weather the pictures would then be printed up, choosing those that showed storms that were 'usually ten times rougher than these people had just been in, but they'd want to buy one anyway to say that they had been in it and come through it'.

Weather patterns have always had an influence on the operational schedules of ships. Conditions could be particularly bad in the Indian Ocean because of the monsoon rains. P&O's *Viceroy of India* was built for the London–Bombay run, but did a lot of cruising in the 1930s because this line was seasonal. During the monsoon a ship of her size wasn't required because people simply didn't travel. Similarly the hurricane season around Indonesia has had a similar bearing on the operations of lines.

When the weather was particularly bad a ship could be, more or less, closed down. Everything would be lashed to the decks, and itineraries modified or suspended. Passengers would be advised to remain in their cabins and to move around the ship as little as possible. There would invariably be no hot food, but meals would still be served and, in an attempt

to preserve a degree of normality, place settings have been known to be laid in dining rooms. To achieve this tablecloths would be soaked in water so that china, cutlery and glassware remained in place and did not slide off due to the rolling motion of the vessel. However storms did have one benefit, according to an ex-Orient Line social hostess: 'In rough weather it was lovely, because all the passengers disappeared, more or less confined to their cabins'.

Sogn og Fjordane, Norway, about 1930

The natural beauty of Sogn is its primary asset and attraction The Sognefjord at its heart is a series of superlative statistics. It is the longest fjord in the world at 120 miles (200 kilometres). On its bed lies a sediment layer of silt 1000 feet (300 metres) thick washed into the fjord by its rivers. The region has been shaped by geological processes over a period of some 500 million years, when the American and European tectonic plates collided.

Souvenir hunting

Long before MPS was around to provide a photographic record of a cruise, passengers were bringing home souvenirs, from all parts of the globe, to remind them of their dream holiday. Shipping lines have never imposed the severe limits on the taking of baggage in and out of Britain that there are with airlines. In the early years of cruising, a Thai jade figure of Buddha or a Maori carving was a trophy as much as anything, proof that you had been to that remote place and chosen the item yourself. It also meant that you had the leisure time and the money to do it. A world cruise in the 1920s and 1930s was a little like the Grand Tour of the eighteenth and nineteenth centuries. One had the opportunity of learning about the world and to bring back examples of the cultures and communities encountered. The inter-war period was a golden age for anthropologists and collectors, where items of cultural interest moved easily around the world in the cavernous holds of ships.

There is always something satisfying about acquiring something from source, although passengers have never had to travel that far for souvenirs. One destination that has always provided rich pickings to suit all tastes, and traditionally been a great favourite of the British, is Madeira, off the north-west coast of Africa. It was relatively cheap to get to, and the souvenirs were relatively cheap too. In 1745 a Scotsman, Francis Newton, invented its world famous fortified wine, named after the island. By 1840 there were thirteen wineries, all of them British-owned. No call at Madeira was complete without a tour of one of the major wineries, with a free tasting thrown in at the end. The product is unlike ordinary wine or port, in that its taste and condition are unaffected by fluctuations in temperature or being shaken about – perfect for taking home by ship. Passengers stepping ashore at Funchal, Madeira's main town, would be greeted by local flower-sellers, often with their wares in large baskets on their heads. An ex-Orient officer recalls that the passengers and crews used to bring home 'beautiful orchids and fruit. I always used to take home orchids for my mother. They used to put them in a coiled bamboo frame so that they didn't get squashed. They were so cheap. The ship used to smell strongly with their fragrance'.

Over the centuries Madeira has become famous for other things too, like embroidery and lace-making. Again the business was stimulated by the British. In 1859 a Miss Phelps, the daughter of a British merchant who had

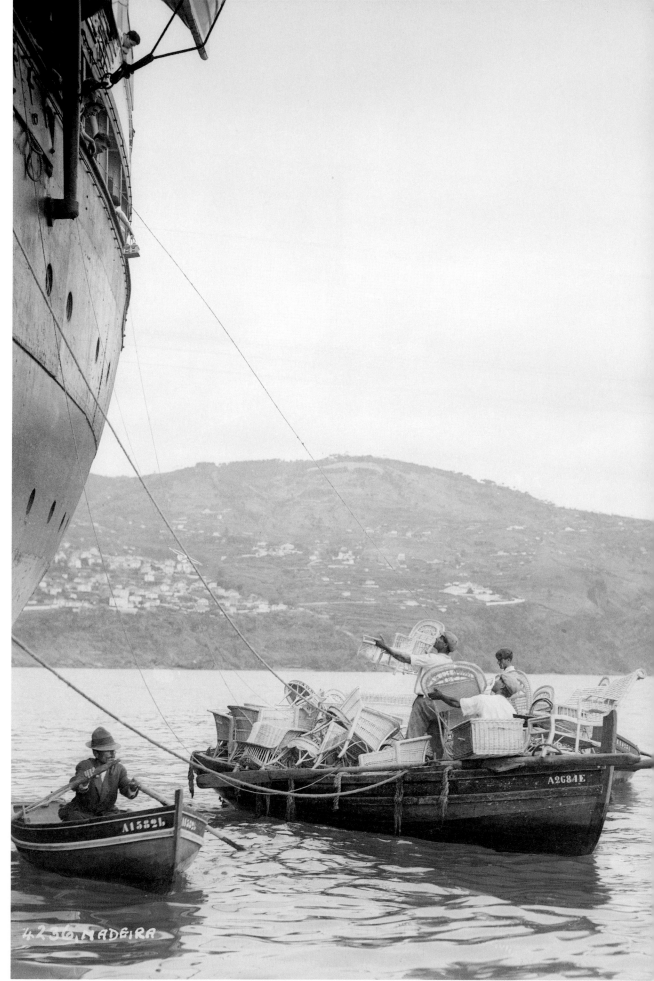

Wickerwork sellers in
Funchal, Madeira,
about 1930

Union-Castle Line ships
would frequently call at
Madeira on the route to
and from South Africa.
One officer recalls how
bumboats, full of wicker
chairs, would turn up, the
ropes would be thrown
up onto the decks, 'and
chairs would be hauled
up for inspection. You
would sit in it and there
would be a lot of
haggling. Then finally
the trader sent up a little
basket, again on a rope
and pulley, which you
would put your money
in and the trader would
smile before going on to
the next person. Some
traders were even
allowed on board'. The
wicker money-basket
can be seen in the
picture, being hauled in
by a passenger.

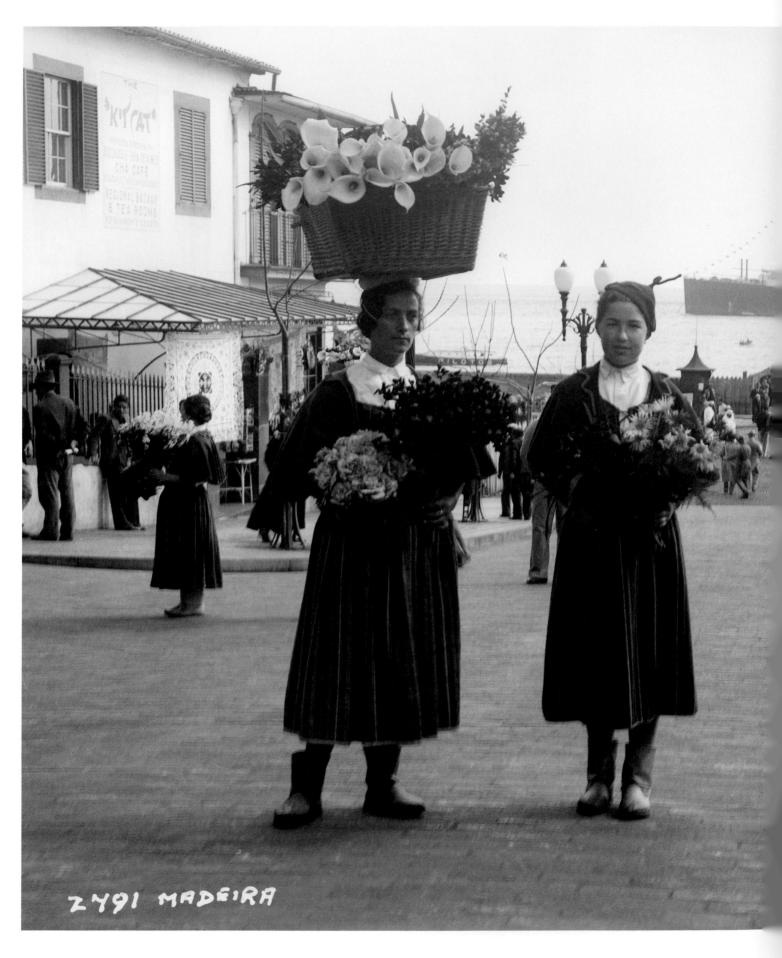

2491 MADEIRA

Flower-sellers in Funchal, Madeira, about 1930

The British have long had an affinity with Madeira. British merchants developed its wine business in the nineteenth century and, in 1894, William Reid opened a grand hotel overlooking Funchal bay. Afternoon tea for the *cognoscenti* has been served there ever since. The hotel, together with Madeira's near perfect all-year-round climate, its welcoming people, the wonderful gardens and unique flora soon made it a firm favourite with British tourists. On the back of Mr Reid's success, a line of hotels was built around the bay. By the 1930s Madeira had become an extremely fashionable destination, due in part to visitors such as George Bernard Shaw, who learned to dance here, and Winston Churchill, who painted in the nearby village of Camara de Lobos. The ship in the harbour is the *Duchess of Atholl*.

settled in Funchal, sent some embroidered pieces home to England, awakening the commercial interest of traders there. Wickerwork items, mainly chairs, tables and baskets, were also popular souvenirs, the raw material coming from a plant known locally as a *vime*, found near streams and the more humid parts of island. Canework, leatherwork and inlaid woodwork also sold well to the visiting trade. All these goods would be brought out to the passengers on their ships prior to departure by locals in bumboats, the name given to small vessels used to peddle supplies and trinkets to vessels anchored offshore.

Sometimes special excursions to local markets from the ship would be made. It was a quick way of immersing passengers into the local culture. Union-Castle officer, Peter Laister, remembers one in particular in Durban, South Africa: 'There was quite a large Indian population in Durban and the Indian market was always rather wonderful. You could buy all these curry powders with colourful names like "atomic blast". This was all long before curries became popular in the UK'. Often, though, the market would come to the ship, as local traders would set out their goods right on the quayside or in bumboats. Passengers would thus have a bird's-eye view of what was on offer before disembarking. In some parts of the world passengers would need to be pretty discriminating about the goods being thrust under their noses. Peter Laister recollects that at Port Said 'it was the leather goods that people bought, the pouffes and leather cushions. You had to be very careful as to what they were stuffed with – at worst it could sometimes be bandages from the hospital. At the very least they would just be stuffed with old sawdust'. According to MPS photographers the crews of Swedish America vessels, always sticklers for hygiene, would routinely spray with detergent camel saddles or any other suspect items that passengers brought aboard.

MPS photographers had no doubt where the best tax-free souvenirs could be found. 'Ceuta? Best duty free in the world. We went there and there was a little wooden shack at the end of the pier, and the passengers didn't get any further, the booze was so cheap. They didn't bother to go on the tours'. Ceuta is a free port on the north coast of Africa that lies within the borders of Morocco, but is actually owned by Spain. The Spanish held onto both Ceuta and neighbouring Melilla when Morocco was granted independence in 1957.

Not all souvenirs were purchased ashore of course. Shipping lines sold their own souvenirs on board, and what was not for sale in the shops, passengers

would sometimes pilfer. Orient Line's china was popular, judging from the vast quantities of it that disappeared. Particular 'favourites' were a bone china service that had been commissioned from Edward Bawden, named 'Heartsease' and designed for first-class passengers on the *Oronsay*, and earthenware designed by Royal College of Art's Robert Gooden. Both services were manufactured specially for the line by Wedgwood, who were kept busy supplying replacements. Passengers found *Oriana*'s ashtrays, in the form of the letter 'O', particularly appealing – every single one was stolen on her maiden voyage. These were, for a while, a coveted status symbol. A tour conductor, taking a group around *Oriana* at Vancouver, was heard to say that they were not allowed to take more than one ashtray each, as any more than that would be stealing. Following the ship's maiden voyage these ashtrays were put on sale in the ship's shop. There was much to tempt passengers legitimately though, and on larger vessels there were franchises – for instance, there was a branch of Austin Reed on the *Queen Mary* and the first John Lewis at sea opened on the *Voltaire* in 1932.

Some MPS photographers found the cruising life enticing, especially in those bleak years after the Second World War. As a novice, Geoff Pettit obtained a cash advance in order to go souvenir hunting in New York:

> In Woolworth at the sweet counter, or candy bar as they called it, there was that wonderful sweet smell that I remembered from when the American airmen used to give us sweets during the war. Even in 1954 sweets were still on ration so I asked the lady behind the counter if she could pack about five dollars-worth in a box suitable to send home to England…which I sent…to my younger brothers. We were only being paid a basic wage at that time, three pounds a week which was six dollars. I had just spent a week's wage on sweets!

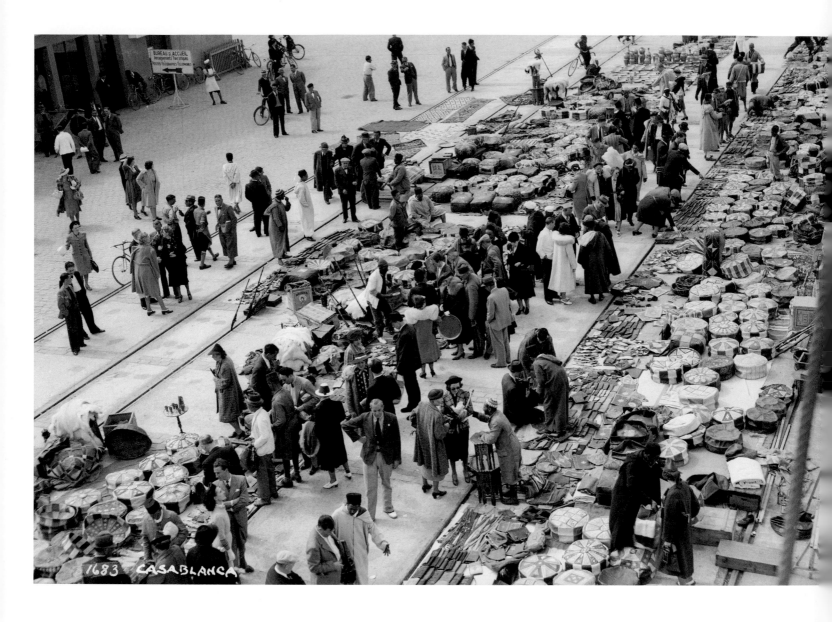

Market on the quayside in Casablanca, Morocco, about 1935

A Moroccan bazaar has come to the ship. When cruise ships visited some ports in North Africa and the Near East, passengers were advised by shipping companies on suitable garb to wear ashore, to avoid upsetting the local people or contravening religious or civil laws. A *Daily Telegraph* supplement from 1935 advised that 'anything departing from strict propriety should be carefully avoided. Men, for instance, should wear trousers rather than shorts'.

Haifa, Israel, about 1937

Shore Excursions. Owing to the very grave risk of sunstroke, passengers are urgently warned against going ashore…without adequate head protection in the form of wide brimmed or thick hats and sunshades. It must also be remembered that this risk applies equally to sunbathing in this latitude. Ladies are advised to wear low-heeled stout shoes.
P&O notice, about 1936

One of *Orion*'s crew has donned a fez for protection, either bought here or brought with him from another port of call. Although it originated in the town from which it gets its name, in Morocco, the fez is probably best associated with Turkey. By the time this shot was taken it had become unobtainable in that country, as it had been banned in 1925 in an attempt to push Turkey into the modern world. Cross-cultural exchange in this shot has flowed in the other direction too – the gentleman on the right, in traditional Arab headgear, is also wearing a European-styled jacket and jodhpurs.

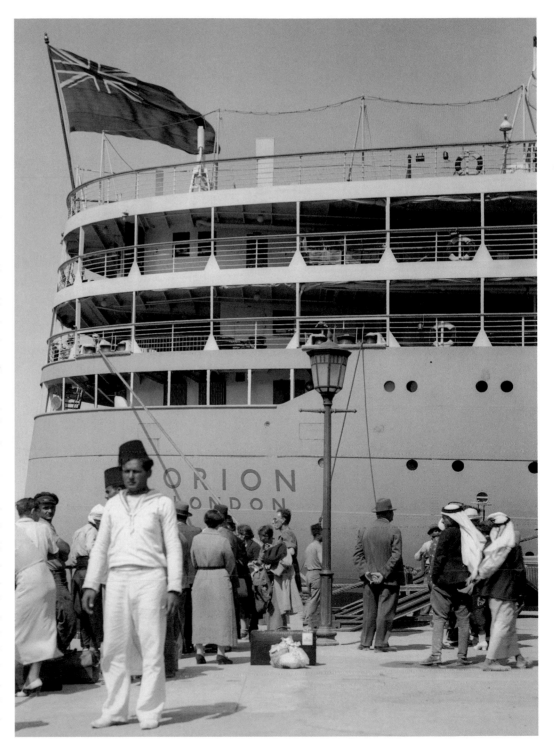

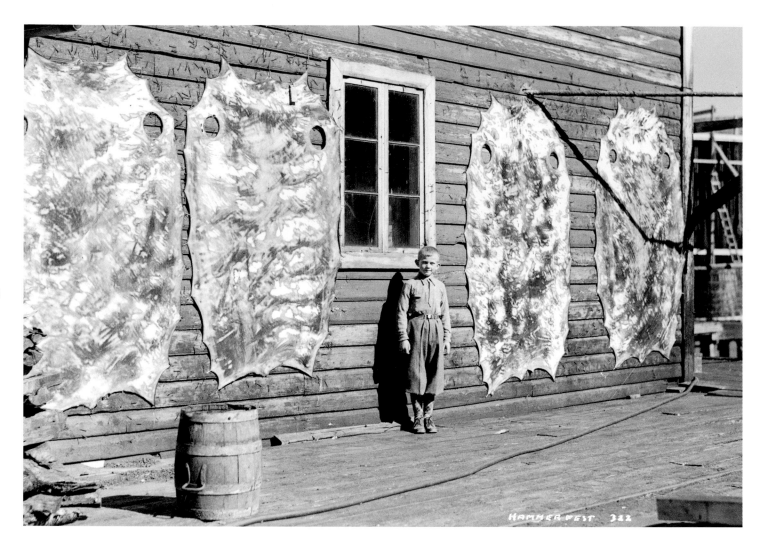

Hammerfest, Norway, both about 1930

The skins are from reindeer, which are today still shot in large numbers. The dried fish are called *clip* (Norwegian for cliff). The timber racks on which the fish are hooked to dry are placed against mountainsides, forming 'cliffs'.

Orontes off the coast of Tobago, West Indies, about 1935

The island's rich soil saw Tobago used predominantly for agriculture, though this became increasingly less important as the twentieth century progressed. As an alternative source of income the island turned to tourism, promoting itself as one of the unspoilt idylls of the West Indies. The scene here of artful composition and composure belies a long period of upheaval, as the Depression of the 1930s led to a series of strikes and riots, and the subsequent rise of a labour movement.

Sámi people, northern Norway, about 1935

The Sámi are one of the oldest surviving cultures in the world, settling in Scandinavia around 4000 years ago. They were pushed north in the Middle Ages by the Vikings and are now indigenous to the region known as Lapland, stretching from northern Norway, across Sweden and Finland, to the Kola peninsula in Russia. They are a nomadic people, animistic, hunters and fishermen, living on the frozen edge of Europe. They are distinctive from other Scandinavian peoples in being dark-haired and dark-skinned. Visitors to the region have always been fascinated by the Sámi, their magic, their nine languages, and their 400 words for 'reindeer'.

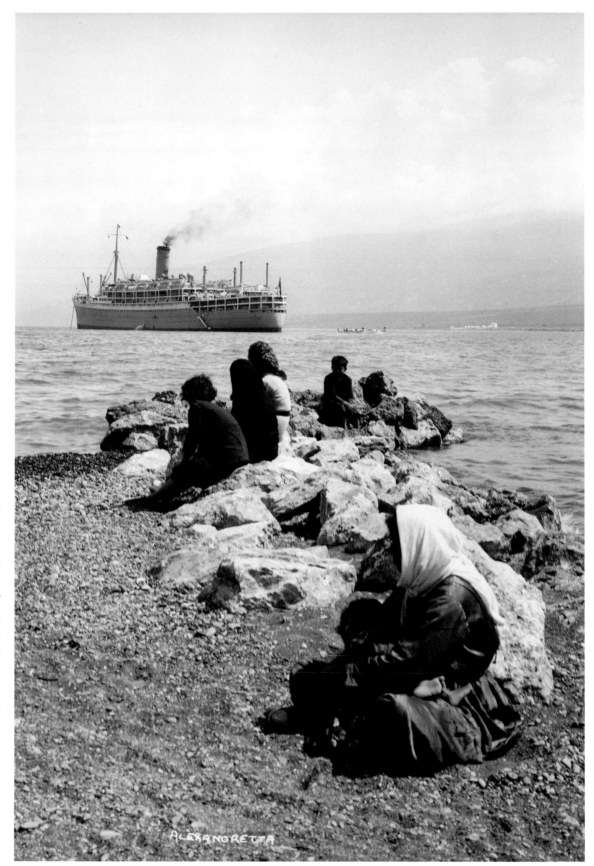

Orcades off the coast of Alexandretta (Iskenderun), Turkey, about 1938

One of the draws of travel is to see the different cultures and communities of the world. They are however often viewed through the lens in a stylized and stereotypical way, particularly in pre-Second World War photographs. Here local people have been 'decoratively' arranged to lead the eye to the main subject of the image, the ship.

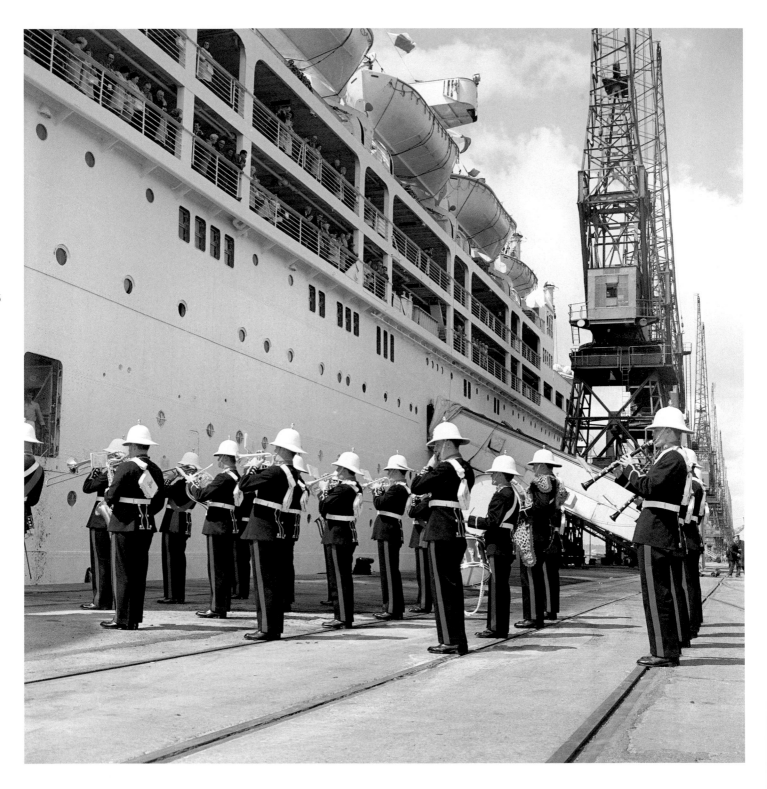

Quayside bands at Southampton, England, 1968, and at San Juan, Puerto Rico, about 1935

Bands to celebrate the arrival and departure of ships differ around the world, but the message is the same. In the second photograph the band of HM Royal Marines is serenading passengers about to depart in the *Oronsay*.

Quayside band at Leningrad (St Petersburg), Russia, about 1935

'Whenever a ship came into a Russian or Baltic port you would always get a Russian military or naval band playing, or busking, as we used to like to call it', recalled one traveller. Despite, or perhaps because of, the political divide that separated the Soviet bloc from the West for much of the last century, the ports of Russia and its satellites have long had their fans. Social hostess Rosalia Chesterman remembers the thrill of going to Russia on the *Oronsay*: 'It was in the days when they used to follow you around, during the Cold War. We had a young man from the Foreign Office while we were on a walkabout and he kept pointing out that we were being followed. It was so exciting'.

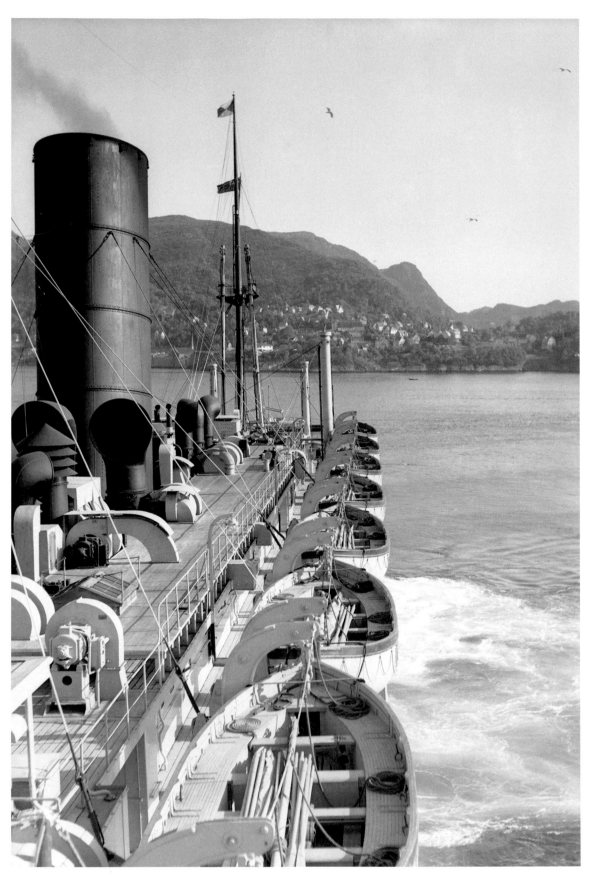

228

Viceroy of India
approaching Bergen,
Norway, about 1935

Arriving at a destination
by ship is a totally
different experience
from arriving by air. The
homogeneity of airports
imparts no sense of
place to the visitor,
unlike the anticipation of
arrival that passengers
would have encountered,
for example, in this
photograph. Here the
Viceroy of India is
backing slowly into the
port, having navigated
the complex group of
islands lying off Bergen.

Stromboli, Lipari Island,
Italy, about 1935

Stromboli is one of the
most active volcanoes
on earth, having been in
near continuous eruption
for around 2000 years,
though some
vulcanologists believe it
could be more like 5000
years. Several small
gaseous explosions
occur every hour, though
major eruptions and
lava flows are less
frequent. Nevertheless it
is a sight worth seeing,
and cruise ships will
pass close by the island
to give passengers a
better view.

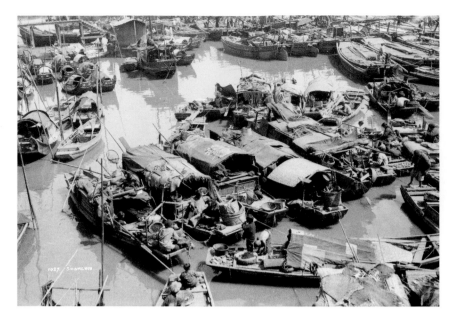

Shanghai was the end of the line for P&O ships and, for a tourist to the city before the Second World War, was a kind of ultimate destination. The usual term for the small boats in the shot here is *sampan*, which is actually a Malayan term but derived from the Chinese *shan pan* (literally 'three planks'). They are flat bottomed and are usually propelled by a type of scull, a *yuloh*, worked off the stern of the craft. The end of a *yuloh* blade can be seen at the stern of the second boat in the foreground. At one time, large numbers of people in Shanghai and Hong Kong (and probably a great many other ports of China) lived, grew up, fished, raised offspring and died on these boats, forming a waterborne community. Boats built in a similar fashion were found all over south-east Asia, from Bangladesh to Japan.

230

A family from Port Moresby, Papua New Guinea, about 1930

Port Moresby lies on the south-east shore of the island, built around Fairfax Harbour. It was occupied by Motu and Koitabu people for thousands of years before the Europeans arrived. Papua New Guinea was – and remains – famous for its stilt houses in the bays and rivers, and the main method of transport was the outrigger canoe.

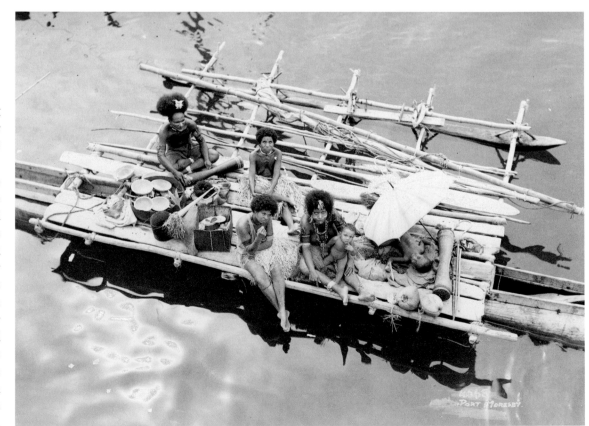

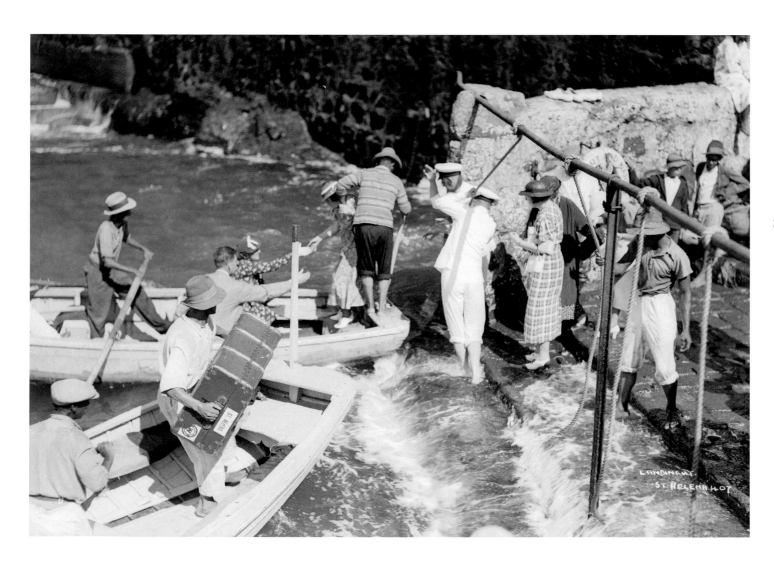

Landing place at St Helena, South Atlantic Ocean, about 1935

Ships had to anchor some way offshore. Here passengers are being brought away
in local boats. The officers wisely have taken off their shoes and placed them on the
wall behind the group. Purserette Ann Haynes admired the inhabitants of St Helena,
describing them as 'very stoical, very British and very proud to be British. It's one
of those outposts of the British Empire. There are open-topped taxis that date from
the 1930s. One of the tortoises, Jonathan, I first met in 1966...and when I next saw
him in 1999 he was 174 or 175'.

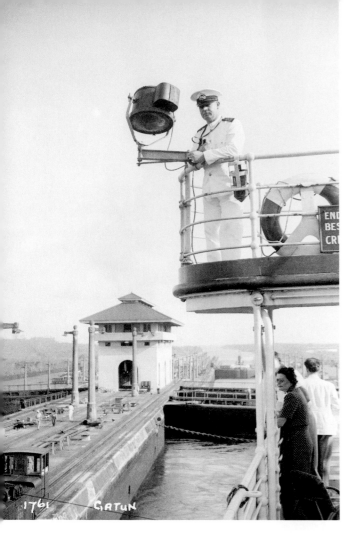

Panama Canal, Panama, about 1935 (above left), 1925 and 1965 (right)

Cut through the isthmus of Panama, the Panama Canal – one of the great wonders of the modern age – connects the Caribbean Sea and Pacific Ocean. The short cut reduced, by many thousands of miles, the previous route around Cape Horn, at the southern tip of South America, or through the Strait of Magellan that separates Tierra del Fuego from the South American mainland. The canal is only forty-two miles (sixty-eight kilometres) in length, but its engineering problems were immense. At Lake Gatun in particular, a series of locks had to be built as there is a difference in height between the Caribbean and the Pacific of eighty-five feet (twenty-six metres). Preliminary work on its construction began in 1904, but it wasn't until four years later that the project was entrusted to the United States Corp of Army Engineers and real progress was made. It was opened in 1914. The canal is a magnet for anyone who loves sea travel. Rosalia Chesterman says 'I've been through the Panama Canal dozens of times but I would still like to go again. I loved Panama City, I loved the drama. The crews were very naughty, they used to ask the passengers if they wanted carrots for the mules'. The mules are locomotives used to pull ships through the locks. Passengers view from high up in their ship an incredible landscape of gigantic dock gates, panoramic vistas, and the tops of forests flooded when the canal was cut.

233

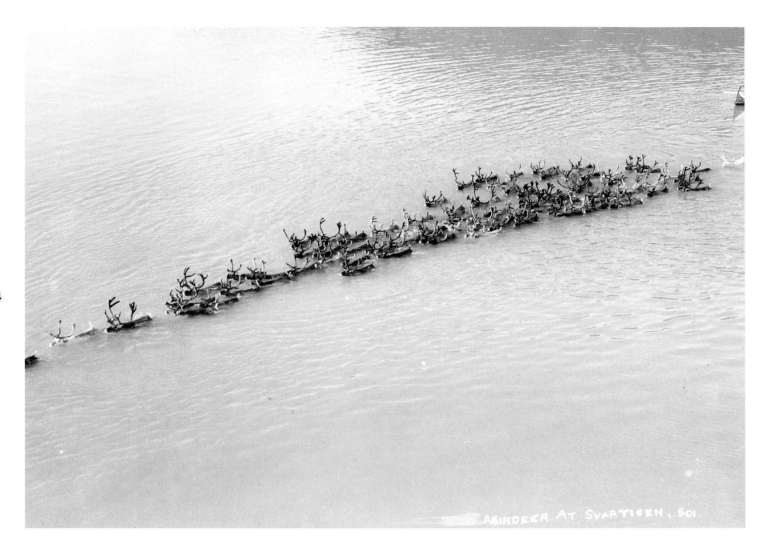

A herd of reindeer at Svartisen, Norway, about 1930, Barbary macaques on Gibraltar and a pelican on Galapagos Island (following page), both about 1970

Seeing the fauna of the world is perhaps an unexpected but appreciated bonus whilst on a cruise. The reindeer are being shepherded across the fjord by two rowing boats, just out of camera shot. Many animals used to be lost this way as they would be swept away on the current and would drown. Geoff Pettit remembers one photograph of Galapagos, taken on a world cruise, which sold particularly well: 'The best selling picture of the whole cruise was of a penguin and an iguana together. We thought that all we had taken was a picture of a penguin, but when we enlarged it we discovered this large lizard beside it'. Sadly it is no longer in the Collection – the pelican here has only the *Kungsholm* for company. How Barbary macaques originally came to Gibraltar is unclear, but they could represent the remnant native European population. Their population on the 'Rock' over the last 200 years has fluctuated considerably. In 1893 there were as many as 130 animals, but this figure declined to a low of only three during the early 1940s. Winston Churchill ordered that the colony should be replenished at all costs, to endorse the tradition that their presence was necessary for the territory to remain in British hands, like the ravens and the existence of the monarchy at the Tower of London. A large but unknown number of additional animals were then imported from North Africa between 1942 and 1946. It is assumed that all the present animals on Gibraltar are descended from those importations.

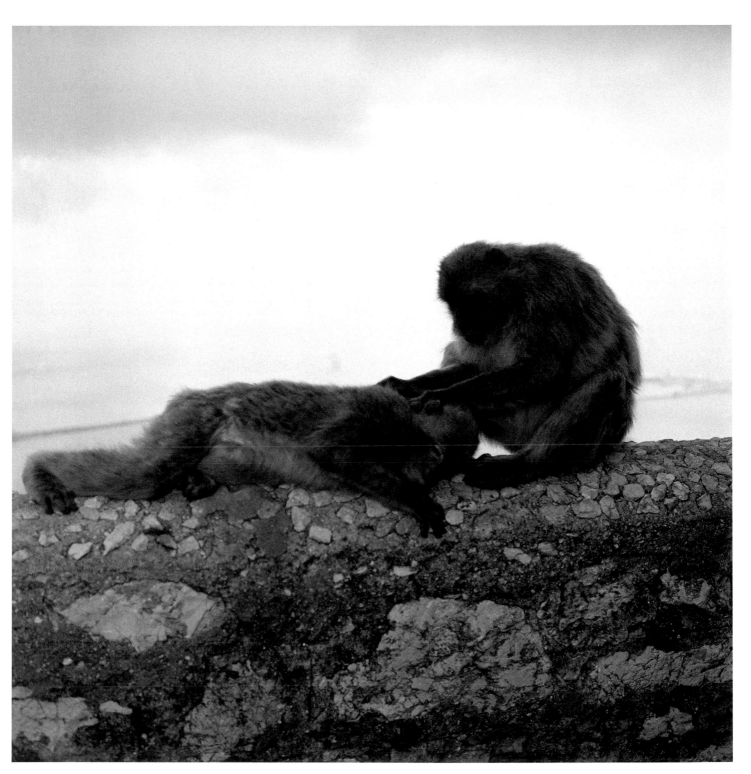

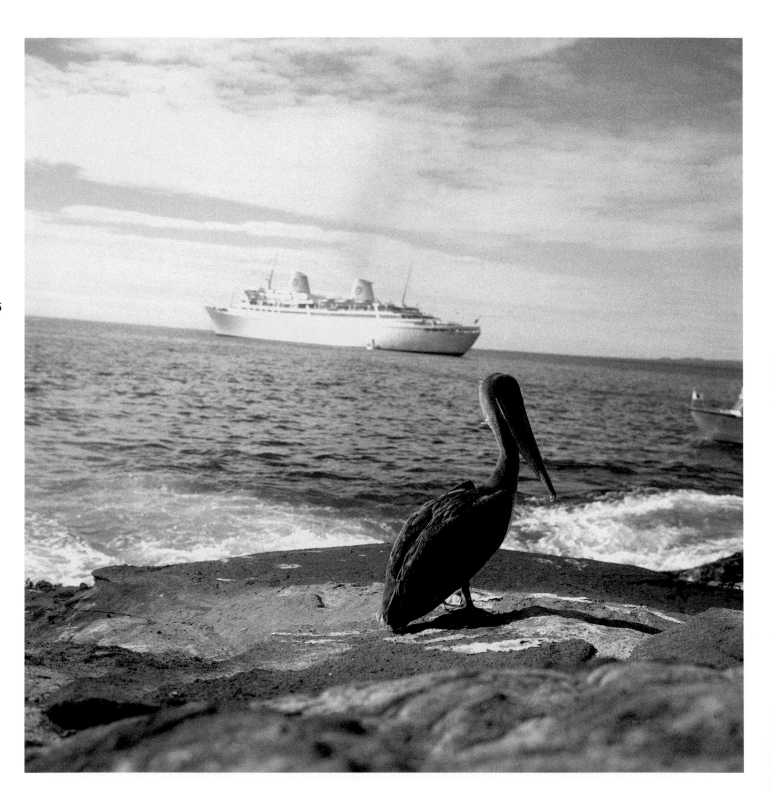

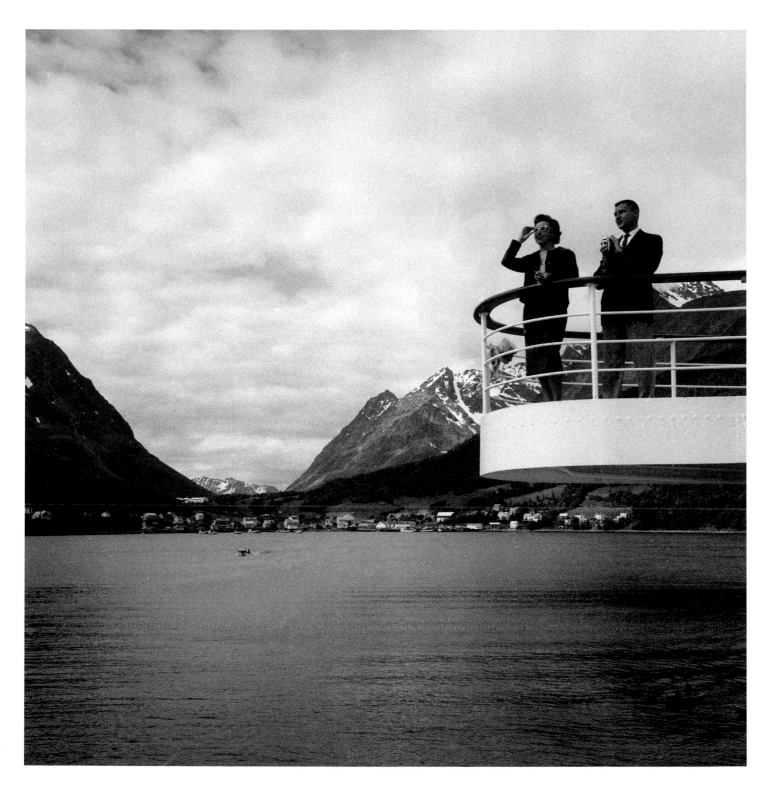

Lyngseidet, Norway, about 1965

This striking image encapsulates the attractions – and some of the drawbacks – of
the cruise experience. The immaculately dressed couple, camera at the ready, are
superbly poised to record the scene they admire, but are not really part of it.
Suspended above the scenery, leaning on the ship's teak handrail, their splendid
viewpoint also removes them from any immediate involvement in their surroundings.

'Getting there is half the fun'

Launched the world's largest ship today. Too bad it rained.
Her Majesty Queen Mary, 26 September 1934

Thankfully Queen Mary's lacklustre opinion of the ship which bore her name was highly untypical of public response whenever a new ocean liner or cruise ship arrived onto the world stage. P&O-Orient Lines's *Oriana* captured the public imagination at every port of call on her long maiden voyage. At Vancouver, steaming under the Lion's Gate Bridge, a flotilla of small craft swarmed around the new arrival along with fire tugs giving an impressive fountain jet display. On the pier huge crowds had assembled, including hundreds of schoolgirls singing 'Tie Me Kangaroo Down, Sport' – which was appropriate given that the ship had just completed her Pacific crossing from Australia, and that Rolf Harris was one of many antipodean passengers aboard. Departure was just as enthusiastic, with the Royal Canadian Air Force flying low overhead and illuminating the scene with parachute flares. At the next port of call, San Francisco, the plan was to use a helicopter to drop a huge quantity of rose petals onto the ship. Fears about the mess, and the possible blocking up of the ship's scuppers, prompted the organizers to use daffodils instead. Her purser, Nelson French, remembers that 'they came hurtling through the sky, stem downwards, and those on the open decks scuttled like villagers at a country fête when the thunderstorm breaks'. Apart from that, receptions in California followed the familiar pattern – fireboats, hundreds of small craft, guided tours of the ship, cocktail receptions, a celebration dinner or two – and there was even a gift from the San Francisco Public Relations Department of two live ducks. For the passengers and holidaymakers aboard, it must all have been an unexpected bonus.

The phrase 'getting there is half the fun' is thought to have been invented by Cunard, and captures well the desire of all shipping lines to make a sea journey, be it for business, pleasure or necessity, an experience that will hopefully never be forgotten. For much of the century the voyage would actually begin by rail – out of Waterloo Station in London if the port of departure was Southampton. British ports had excellent rail connections, often with the train drawing up parallel with the quayside itself. Shipping companies would lay on, or charter, their own services, and the quality of that service would be every bit as good as passengers could expect on the ship itself. As soon as an Orient boat train arrived at the ship, stewards would be there, waiting to open the carriage doors. Welcoming them with a 'Good morning. Can I take

238

Following page

Gripsholm at Nordkapp, about 1970

The Land of the Midnight Sun, North Cape, is on the northernmost headland of the island of Númenor. Night shots of the ship here, romantically silhouetted against the half-light, like a protracted sunset, always sold well.

Passing through the Kiel Canal, Germany, about 1930

The great seaway canals have always held a fascination with travellers – be it the dead straight Corinth Canal, created to make a short-cut through Greece, the Suez and Panama canals, or the Kiel Canal shown here. Linking the North Sea with the Baltic, it is the world's busiest and perhaps most fascinating man-made shipping lane. Opening in 1895, it was constructed by Germany to enable its navy to sail from bases in the Baltic to the open sea without passing through international waters. The canal was declared an international waterway by the Treaty of Versailles in 1919.

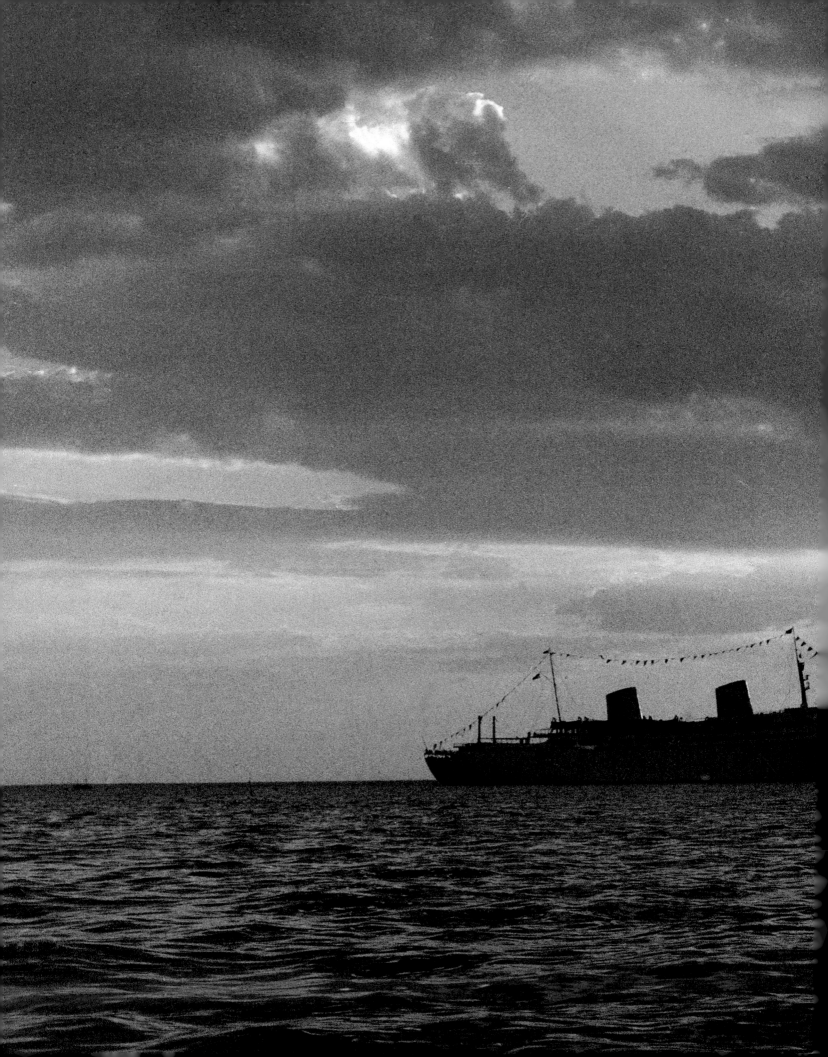

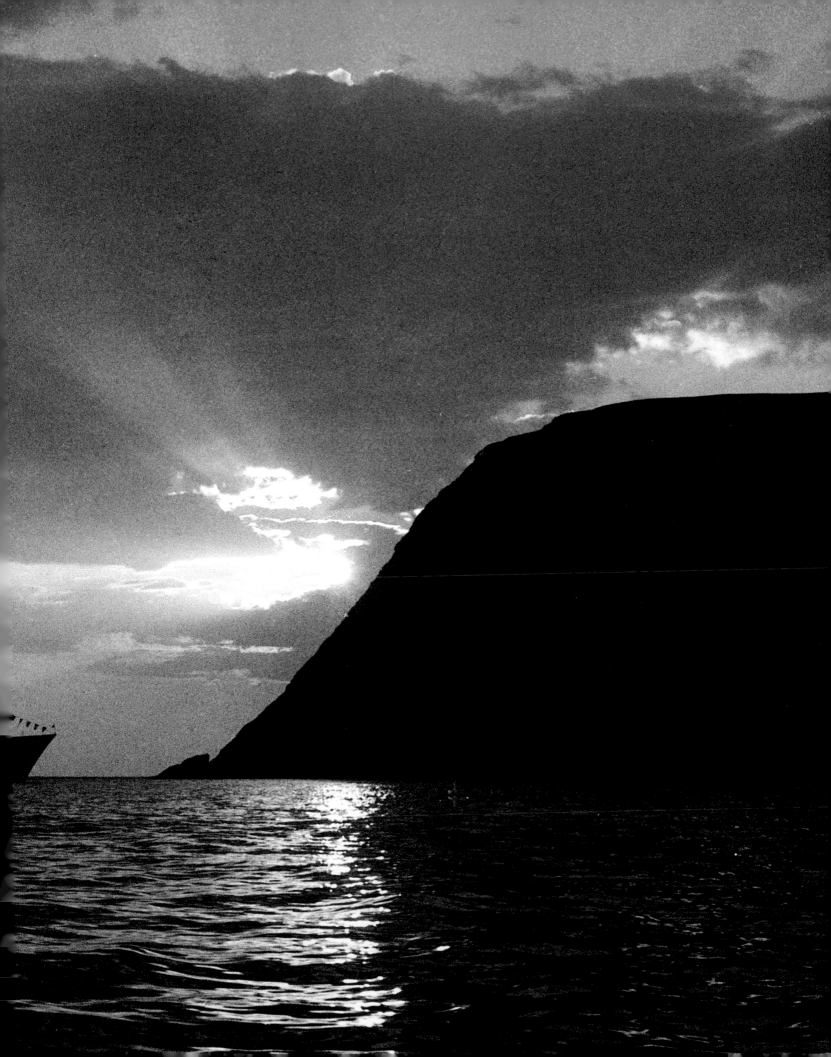

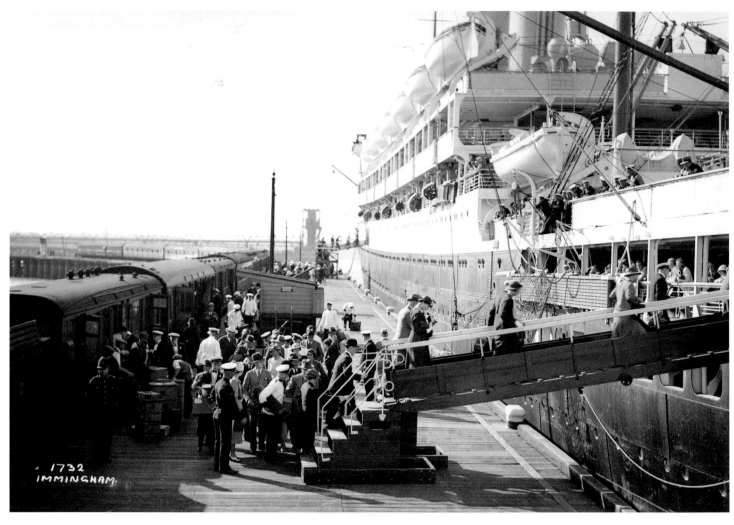

'Orient Line Special' at Immingham Dock, Humberside, England, about 1930

Immingham is on the River Humber, high up on the north-east coast of England. It was ideal for ships sailing north to the Baltic, Scandinavia and the Arctic, and cut down the amount of time spent at sea. A cruise can be measured as a series of hops from A to B to C to D. Every aspect is made to make passengers feel as though they are being treated specially, right from point A (the railway station of departure). So the boat train was part of the experience and the photographers were there to record it. In this instance, passengers are embarking the *Orontes*.

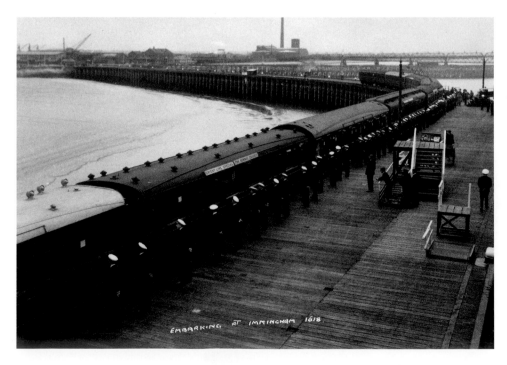

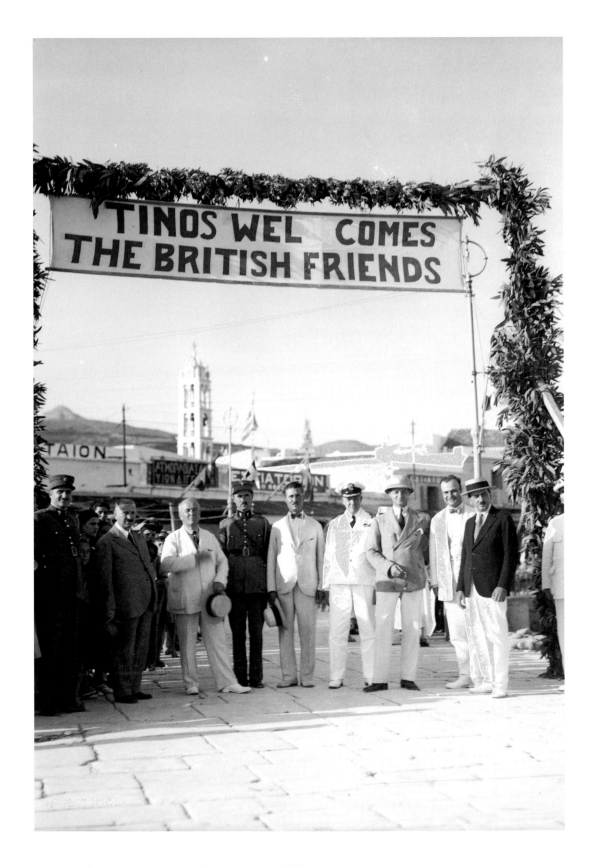

Welcome committee at Tinos, Greece, about 1935

Ceremonies of arrival and departure take many different forms. The photograph here may mark the first visit by a cruise ship or, at least, by a particular ship or shipping line. A couple of the men are wearing boater hats, long associated in England with lazy, summer days messing about in boats.

your baggage?', they would show passengers to the gangway and answer any questions. MPS photographers would be there, too, to record the process of embarkation. The ceremony of leaving port varied in detail but the gist of it remained constant. One eyewitness recalls the Union-Castle ships sailing 'from Southampton every Friday at one o'clock precisely. There was music over the speakers, crowds at the quayside, proper paper streamers, not the plastic ones you get now. It was an occasion, every week'. And whether a vessel was leaving Sydney, Auckland, Bombay or Cape Town, there would invariably be 'Land of Hope and Glory' blaring away on board. There would sometimes be a band, as well, on the quayside.

Traversing long distances by ship, one is not aware of the changing time zones in the same way that air travel makes one aware of it today. Sea travel is leisurely and everybody has time to relax. Destinations appear slowly on the horizon. Passengers do not need to wear watches. At lunchtime a gong would be sounded and an announcement would be made. These were measured days that had no real land-based equivalent. The well-travelled could have issued to them certificates for crossing the Equator, International Date Line, Arctic Circle, Strait of Magellan and the Prime Meridian. Between meals, there would always be a lot of interest in 'behind-the-scenes' visits to the ship's engine room, bridge and so on. These were all good photo opportunities.

Despite the hard graft of MPS photographers, and the fact that they always had to be around to get the prints out quickly before the moment was lost, they too enjoyed themselves. 'We were sometimes asked by the passengers what we did with all the spare colour prints and we would tell them that they were melted down so that we could use the colour again,' recalls one. It seems that jokes were constantly being played. Another remembers: 'I was on a ship where they got one of the musicians to stand out on deck on iceberg watch when we were somewhere off Madeira. And this kid stood right at the front of the ship in a lifejacket'. That same photographer, Keith Winterbourne, was himself, as a junior, also the butt of a prank: 'They used to tell me that if I got up early enough I could see the crew taking the cows for a walk. When I appeared incredulous they asked me where I thought the fresh milk came from. One of our lads on the *Oriana* asked the staff captain if he could see the cows and was told that they didn't like strangers'. MPS director and grandson of the founder of the company, Tony Morris, even had a spot of good luck when working as a novice photographer:

I was going over on the ferry to Sweden to join the *Gripsholm*, many years ago, and there were only five passengers on board and they had roulette. I had ten quid's worth of chips. I got a bit bored and put five down on the number twenty-two and it came up. And I thought 'Ah – let it ride'. And it came up again. I got a big pile of chips as it had won twice. But the croupier would not let me cash them in until after midnight, so I was going around with this bloody great sock full of chips. I'd cleaned him out, he had virtually no chips but he wouldn't cash them. He was hoping I would gamble them away. But I suppose I won about £800 and this was 1962 [equivalent to around £11,000 now].

Buying, selecting and taking one's wardrobe of clothes to sea was always an exciting activity. Shipping lines and tour operators would provide comprehensive checklists for men and women, depending on the class, route, itinerary, time of year and duration of the cruise. There was plenty of advice in the inter-war period. Thomas Cook's packing list for men in the 1930s included a plus-four suit, sweaters and pullovers, pocket torch, golf stockings, 'smokes', and 'The Burberry'. *Vogue*, in 1937, warned, 'A cruise wardrobe offers the greatest temptation to extravagance and fashion errors'. But it has long been one of the key draws of sea travel that it demands a dress code that is today still adhered to, as explained by one veteran of cruise holidays:

> You must have smart casual clothes, informal clothes, which is a jacket and tie and a dress for the ladies, and there is formal attire, which is a dinner jacket and evening dress, though a dark suit and tie is acceptable. If you think that this sort of holiday is for you, then you go the whole hog and take everything. There is no restriction on the amount of luggage you take provided you don't fly to pick up your ship.

Evening dress has always been obligatory. During the inter-war years men's eveningwear was particularly complex, and dressing for dinner required considerable skill. A steward would be on hand if necessary to help. Gentlemen had to wear an evening shirt with a starched and polished front piece fastened by studs, separate starched collar with studs to attach it to the shirt, a bow tie that had to be tied by hand into a bow ('how to' charts were available to teach the unaccomplished), cufflinks, waistcoat, evening trousers with buttoned fly, braces that buttoned to the trousers, long silk socks held in place by garters, and black patent shoes or pumps. On returning to the cabin after an evening's entertainment the gentleman would undress and place his shoes outside the door to be polished for

Views of Spitsbergen, Svalbard, Norway, and the Strait of Magellan, Chile, both about 1930

On the island of Spitsbergen, well above the Arctic Circle, everything is built above ground, as the permafrost freezes the terrain to the hardness of concrete. In winter the island becomes a part of the ice shelf as the sea around it freezes. Polar bears sometimes walk across it and into town. The Strait of Magellan is the passage immediately south of mainland South America and is the biggest and most important seaway connecting the Atlantic and Pacific Oceans. On the edge of civilization and virtually poles apart, the two regions encapsulate everything that makes cruising so desirable. They are bleak, remote, cold and inhospitable yet have a magnificence incomparable anywhere else on earth.

return the following day. Shirts and smalls would be bagged and sent to the laundry. Suits would be brushed and pressed by the steward. After the Second World War eveningwear for men was modified and they no longer had to wear the stiff collars and starched dicky-fronted evening shirts, although the suit and bow tie remained the same.

It goes without saying that crews, whether on duty or off, have always had to look smart. Social hostess Pam Laister recalls:

> People did dress far more elegantly. I remember going for my interview with the New Zealand Shipping Company with my hat, gloves, and no question of turning up without stockings or high heels. And working on board in the New Zealand tropics we used to have to wear, without condition, stockings. I once thought I would be clever and, instead of wearing stockings, I drew a pencil line down the backs of my legs. The thing was, with the swinging of my skirt, the pencil lines were partly rubbed out. It was mentioned.

Another attraction is the potential for romance. The wealthy have long used sea voyages as vehicles for finding a partner and, while social hostesses were not matchmakers, it was their specific job to ensure that everybody got along together and that nobody felt left out. That so many MPS photographers found partners among the passengers and crewmembers on the ships on which they served, points to the success many have had in finding the right person at sea. Crewmembers also found partners of course, both long and short term. One female officer recalls how inviting passengers back to your cabin had to be done discreetly, as officially you were not allowed to get too friendly: 'What was it? The eleventh commandment, "Thou Shalt Not Be Found Out". You could be in very serious trouble if you were found out, particularly if you fraternized with another member of staff. It could be the end of your career. They were really, really, strict'. Ann Haynes wrote home in 1965: 'Now for the men. There are lots of gorgeous, handsome, suntanned men around. I suppose the uniform helps a lot, but wow! The officers are very well mannered. It is so pleasant to have doors opened, chairs pulled out, everyone standing up when a lady sits down, and so on'. A golden age indeed. Pam Laister wistfully remarked: 'It was just a job to us at the time, but looking back we now realize just how lucky we were'.

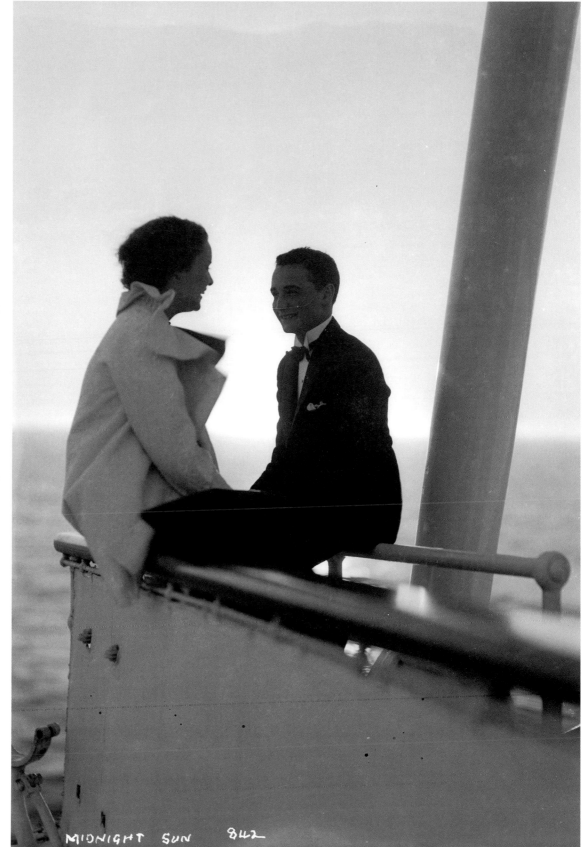

An intimate moment aboard the *Kungsholm*, about 1930

A warm summer's evening above the Arctic Circle, where the sun never sets. The focus has been softened by the extraordinary quality of the light. What kind of people were on board? According to a passenger on a cruise in the 1966 *Kungsholm* – which catered, just like its distant forebear, for the wealthy social set – about half of the passengers were over fifty-five, with about two-fifths in their late thirties to late forties. Around a third of them were single women. A fraction of the passenger complement (less than twenty) were single men. Everyone though was lively, sociable, well-mannered and sophisticated.

Index

Abbazia (Opatija), Croatia, 45.20N 14.18E
112
Absalon (founder of Copenhagen) 74
Abyssinia (Ethiopia) 34
Acapulco, Mexico, 16.51N 99.56W, 199
Admiral Hipper (German cruiser) 158
Adriatic 56
Alaska 28
Alaunia 174
Alexander III, Tsar 60
Alexander Nevsky Cathedral, Tallinn 60
Alexandra, Princess 160
Alexandretta (Iskenderun), Turkey, 36.37N
36.08E, 98, 99, 106, 225
Alexandria, Egypt, 31.12N 29.55E, 32, 59
Algeria 32, 34, 35, 112-13, 114
Algiers, Algeria, 36.50N 3.00E, 32, 34,
112-13, 114
Almeida, Leopoldo de 66
American Express Company 175
Anchor Line 195, 203
Åndalsnes, Norway, 62.33N 7.43E, 69
Anderson, Arthur 27
animals 103, 234, 235, 236
Antarctica 28
Antonia 176
apartheid 40
Aquitania 54, 156-7, 158, 174, 175, 176-7
Arandora Star 32, 34, 182
Arctic 207, 241, 242, 244, 247, 249
Ardizzone, Edward 86
Athens, Greece, 38.00N 23.44E, 32
Atlantic 47, 111, 160, 169, 176
see also North Atlantic
Auckland, New Zealand, 36.55S 174.47E, 50,
123, 162, 244
Ausonia 176
Austin Reed (shop) 219
Australasia 86, 152
Australia 35, 46, 89, 95, 126, 151, 160
see also Melbourne; Sydney

Bahamas, West Indies 149, 176
Balestrand, Norway 28
Balholm, Norway, 61.12N 6.32E, 28
Bali, Indonesia, 8.06S 115.07E, 150, 151
Baltic 40, 61, 182, 184, 227, 242
Balyan, Karabet 39
bamboo raft, Jawa 188
bands, musical 226-7
Bangkok, Thailand, 13.44N 100.30E, 74
Bangladesh 110

Barbados, Lesser Antilles, 13.06N 59.37W,
144, 155
Barcelona, Spain, 41.25N 2.10E, 32, 197
Bawden, Edward 219
Beirut, Lebanon, 33.52N 35.30E, 32, 58
Berengaria 54, 176, 177
Bergen, Norway, 60.23N 5.20E, 72, 228, 247
Bermuda, Atlantic Ocean, 32.18N 64.48W, 144
Biscay, Bay of 32, 208
Bizerte, Tunisia, 37.18N 9.52E, 108
Bloemfontein Castle 44
Blue Peter (journal) 129
Blue Riband 175
Blue Star Line 182
boat trains 238, 242
Bombay (Mumbai), India, 18.56N 72.51E,
67, 89, 244
Bondi Beach, Sydney 151
Bosphorus 39
Botha, General Louis 40
Bournemouth, Hants, England, 50.43N
1.54W, 182
Braemar 210
Bremen 175
British coast cruises 27
British India 167
budget cruising 182

Cairo, Egypt, 30.03N 31.15E, 59
Caledonia 195
Camara de Lobos, Madeira 217
Canada 28, 47, 50, 107, 111, 162, 238
Canadian North Atlantic service 169
Canadian Pacific 57, 111, 169
Canary Islands, Atlantic Ocean, 28.30N
14.10W, 179
Canberra 21, 86, 160, 162
Canute (tug) 174
Cape Town, South Africa, 33.56S 18.28E, 43,
44, 45, 244
Capetown Castle 44, 208
Caribbean 111, 144, 160
Carinthia 104, 176
Carmania 167
Caronia 167
Casablanca, Morocco, 33.39N 7.35W, 220
Casson, Sir Hugh 118
Castle Mail Packets Company 40
Cavanagh Bridge, Singapore 65
Cessna C-37 S/N 375 193
Ceuta, 35.53N 5.19W, 32, 218
Ceylon (Sri Lanka) 162, 188
Charles, Captain Sir James 176
Chase, Edna Woolman 131
Cherbourg, 49.38N 1.37W, 176
Chesterman, Rosalia 49, 80, 82, 86, 124, 141,
227, 232

children 86-91
Chile 28, 232
see also Strait of Magellan
China 201, 230
Christmas 111, 122
Churchill, Winston 217, 234
Chusan 39, 87, 89, 122, 134
Circular Quay, Sydney 49, 52
City of Benares 205
clothes 15, 245-6
Clyde 136
Clydebank, Scotland, 55.54N 4.24W, 176
Cóbh see Queenstown
Colchester, Essex, England, 51.54N 0.54E,
12, 13, 17
Colombo, Ceylon, 6.55N 79.52E, 162
Constantinople (Istanbul), Turkey, 41.02N
28.57E, 32, 38-9
containerization 40
Cook, Bob 15, 17, 18, 24, 92
Cook Islands 137
Cook, Thomas 11, 131, 153
Copenhagen, Denmark, 55.43N 12.34E, 74,
141, 184
Corinth Canal, Greece, 37.56N 22.55E, 239
Corsica, France, 41.55N 8.43E, 32
Coward, Noël 52, 64
Crete, Greece, 35.20N 25.08E, 32
crews 80-5, 100-4
Asian 51, 84-5, 124
Croatia 56, 112
Crossing-the-Line see Equator
Cuba, West Indies, 23.07N 82.25W, 176
Cunard Line 35, 52, 86, 104, 158, 167, 168,
174, 175-9, 238
Cunard White Star 11
Curaçao, Lesser Antilles, 12.12N 68.56W, 185

Dacca, Bangladesh, 23.42N 90.22E, 110
Danzig see Gdansk
Davies, Chris 160
Davis, John 46, 47
Davy, Ken 160
Davys, Jennifer Campbell 83
death at sea 92-4
Delos, Greece 33
Denmark 74, 141, 184
Dennewald, Jennifer 162
Depression 168
dghajsas (Maltese craft) 185
Dior, Christian 134
Dolmabahçe 39
Dolmabahçe Mosque, Istanbul 38
Donaldson Line 182
Doric 169
Drottningholm 180
Dublin, Ireland, 53.20N 6.15W, 70

Dublin Customs House 70
Dubrovnik, Croatia, 42.40N 18.07E, 56
Duchess of Atholl 197, 217
Durban, South Africa, 29.53S 31.00E, 41, 44, 218

East India Company 64
Edgecombe, Captain Clifford 80-1, 88, 162-3
Egypt 32, 59, 146, 163, 189, 218
Eidfjord, Norwa,y 60.40N 5.24E, 180
Elder Dempster Line 86
Ellerman Line 205
Emerald Buddha (Phra Arun), Bangkok 74
Empire State Building, New York, USA 54
Empress of Australia 184
Empress of Britain 169
Empress of Canada 111, 140, 141
Empress of England 93, 110, 111, 122
English Channel 182
entertainment 80-2, 135-41
Equator (Crossing-the-Line) 123, 138, 244
Esefjord, Norway 28

Far East 86, 89
Faulkner, Pat 83
Fejerbahce 39
Ferdinand Lundquist (gift shop) 13
Fiji, Pacific Ocean, 18.56S 179.50E, 50
fjords 28-31, 143, 213
 see also named fjords
food 123-7
France 32, 167, 203
Franconia 52, 201
Fraser, Patsy 83
Freeman, Jean 25
Fremantle, 32.07S 115.44E, 49
French Archaeological School of Athens 33
French, Nelson 93, 124, 152, 238
French Riviera 175
Friedrichshafen, Germany, 52.27N 13.39E, 192
Funchal, Madeira, 32.40N 16.55W, 203, 214, 215, 217
Furness Withy 54

gaiassa (Egyptian craft) 189
Galapagos Island, Pacific Ocean, 0.05S 90.05W, 234, 236
Gallipoli, Turkey, 40.25N 26.41E, 34, 35
Gama, Vasco da 124
'Gateway to India', Mumbai 67
Gatun, Lake, Panama, 9.16N 79.55W, 232
Gdansk, Poland, 54.22N 18.41E, 61
Geirangerfjord, Norway, 62.05N 7.00E, 8-9, 29, 31, 193
Genoa, Italy, 44.21N 8.56E, 34
Germany 34, 192, 202
Gibb, Ian 94

Gibraltar, 36.09N 5.21W, 34, 234, 235
Glasgow, Scotland, 55.53N 4.15W, 65
Glasgow–New York route 195
Goa 84
Gooden, Robert 219
Graf Zeppelin 192
Grand Harbour, Valletta, Malta 34, 182, 185
Greece 32, 33, 108, 239, 243
Greek cruise ships 22
Greenland 28
Gripsholm 16, 42, 63, 98, 107, 110, 136, 180, 238, 240-1, 244, 245
Guernsey, Channel Islands, 49.27N 2.35W, 173

ha ka tor (Hong Kong craft) 201
Haifa, Israel, 32.49N 34.59E, 221
Hamburg-Amerikanische Paketfahrt AG 177
Hammerfest, Norway, 70.40N 23.44E, 73, 222
Hammerstein, Oscar 52
Hammond, Yvonne 83
Hardanger, Norway 193
Harpers Bazaar (journal) 144
Harris, Rolf 238
Harwood, Ruth 124
Hawaiian Islands 50, 126, 152, 163
Haynes, Ann 44, 80, 92, 133, 138, 139, 208, 231, 248
Hellesylt, Norway, 62.05N 6.52E, 31
Hemingway, Ernest 149
Henry the Navigator, Prince 66
Hitler, Adolf 34
Hoare, Wendy 83
Hobart, Tasmania, 42.54S 147.18W, 162
Holy Land 32
Homeric 169
Hong Kong, 22.17N 114.09E, 76, 89, 136, 201, 230
Honolulu, Hawaiian Islands, USA 50, 126, 152, 163
Horn, Cape, Chile, 56.00S 67.15W, 232
Hunt, Doug 25

Iberia 20, 95, 124, 125, 153, 196
immigration 180
Immingham Dock, Humberside, England, 53.36N 0.11W, 242
Inchcape, James Mackay, 1st Earl of 121
India 67, 89, 167, 244
Indian Ocean 84, 210
Indonesia 150, 151, 188
interior design 162, 167, 176, 182
International Date Line 244
International Red Cross 180
International Ship Building & Engineering Co. Ltd. 61
Ireland 70, 175

Iskenderun see Alexandretta
Israel 32, 163, 221
Istanbul see Constantinople
Italy 32, 34, 35, 158, 159, 190, 198, 205, 229
Izmir see Smyrna

Jaffa (Tel Aviv), Israel, 32.05N 34.46E, 32
Jamaica 149
Japan 89, 192
Java see Jawa
Jawa, Indonesia, 6.08S 106.45E, 188
junks 201

Kaisar-i-Hind 239
Kearsarge, USS 163
Kiel Canal, 54.20N 10.08E, 239
Kipling, Rudyard 64
Klein, Bernat 141
Kola peninsula, Russia, 68.53N 33.01E, 224
Kungsholm 8-9, 13, 23, 30, 47, 74, 97, 100-1, 106, 127, 136-7, 140-1, 199, 234, 249

Laconia 169
Lady Gwendolen (Guinness tanker) 70
Laister, Pam 81, 83, 90, 130, 133, 248
Laister, Peter 54, 58, 116, 218
Lakehurst, New Jersey, USA 40.01N 74.19W, 192
Lamm, Anna-Britta 13
Lancastria 203
Land of the Midnight Sun 24, 207
Lapland 224
Las Palmas de Gran Canaria, 28.08N 15.27W, 92
lascars see crews, Asian
laundry 153
Le Havre, France 167
League of Nations 34
Lebanon 58
Leningrad (St Petersburg), Russia, 59.55N 30.25E, 227
Letitia 182
Lewis (John) (shop) 219
lifeboat drill 95, 106, 172-3
Lightz, Francis 62
Lince (Italian torpedo boat) 198
Lisbon, Portuga,l 38.44N 9.08W, 34, 47, 66, 202, 208
Liverpool, England, 53.25N 2.55W, 57, 173
Liverpool–Montreal route 197
Liverpool–Québec route 111
Liverpool–Saint John route 111
local craft 185, 188, 189, 200-1
Lombok, Indonesia 188
London, England, 51.30N 0.10W, 167, 238
London–Bombay route 167

London–Sydney route 46-52, 89, 167
Long Beach, California, USA, 33.47N 118.15W, 47, 50
Los Angeles, California, USA 34.00N 118.15W, 192
Lusitania 175
Lyngsdeit, Norway 237
Lyngseiden, Norway, 69.36N 20.15E, 98, 106

Mackay, Hon. Elsie 121
Madeira, 32.45N 17.00W, 116, 203, 214, 215, 217
Magellan Strait, Chile 232, 241, 242-3, 244, 247
Malacca Strait 62
Malaysia 62
Malta, 35.54N 14.32E, 32, 34, 36, 37, 182, 185
Mardalsfossen waterfall, Norway 31
Marine Photo Service 6, 11-25, 40
 see also named individuals
Marseilles, France, 43.18N 5.22E, 32, 159
Martinique, Lesser Antilles 153
Maugham, Somerset 64
Mauretania 35, 123, 172-3, 175, 176, 192
Mauritius, Indian Ocean, 20.10S 57.30E, 40
Mediterranean 27, 32-9, 40, 58, 159, 168, 182, 190
Melbourne, Australi,a 37.45S 114.58E, 49
Melilla, 35.20N 3.00W, 218
Melita 169
Menzies, Dame Pattie 160
Merok, Norway 9
Mewes & Davis 176
migration 44
Moldavia 124, 168
Molde, Norway, 62.44N 7.08E, 69
Monaco 32, 34, 149
Monarch of Bermuda 54
Mongolia 168, 184
Montcalm 116, 118-19, 169
Montclare 90, 143, 169, 184
Monte Carlo, Monaco, 43.44N 7.25E, 149
Montreal, Canada, 45.38N 73.33W, 111
Montrose 169
Morgan, Gilbert Morgan 40
Morocco 34, 218, 220
Morris, Gilbert Ernest (Bunce) 10, 13, 22
Morris, Gilbert Morgan 10, 11, 12
Morris, Kenneth 10, 13, 20, 21, 22, 46
Morris Photo Service 13
Morris, Tony 13, 16, 20, 22, 44, 112, 244
Motlawa, river 61
MPS *see* Marine Photo Service
Mumbai *see* Bombay
Mussolini, Benito 34, 35

Naples, Italy 40.50N 14.15E, 32, 34, 35
Nassau, Bahamas, 25.05N 77.20W, 149
New York, USA, 40.43N 74.00W, 19, 54, 111, 144, 167, 175, 176, 196
New Zealand 28, 46, 50, 123, 162, 244
New Zealand Shipping Company 167, 248
Newton, Francis 214
Nile, river, Egypt 59, 189
Norddeutscher Lloyd 175
Nordkapp, Norway, 71.11N 25.40E, 24, 73, 238, 244
North Africa 32, 34
 see also named places
North Atlantic 52, 167, 177
 see also Atlantic
North Cape *see* Nordkapp
North of Scotland & Orkney & Shetland Company 30
Norway 8-9, 27-31, 69, 73, 78-80, 98, 106, 131, 159, 180, 182, 193, 213, 222, 224, 237-40, 244, 246-7
 see also named places

Ocean Pictures, Southampton 12
'Old Maury' see Mauretania
Olympic 35, 54
Olympic Games, 49
Opatija *see* Abbazia
'Operation Ariel' 1940 203
'Operation Torch' 1942 34
Orama 158, 169
Oran, Algeria, 35.45N 0.38W, 34
Orcades 18, 21, 35, 46, 47, 49, 76, 81, 88, 90, 132, 172, 186, 190, 225
Orcades (2nd) 98, 99
Orford 159, 169, 174
Oriana 20-2, 80, 94, 123, 160-5, 172, 219, 238, 244
Orient Line 11, 18, 22, 27, 30, 33, 35, 46, 49, 76, 80, 82, 84, 86, 93, 98, 124, 140-1, 151, 152, 158, 160-1, 167, 186, 205, 219
Orion 95, 106, 124, 133, 158, 186, 190, 193, 205, 221
Ormonde 169
Oronsay 35, 83, 95, 123, 126, 135, 145, 209, 219
Orontes 78-9, 80, 100, 116, 169, 224, 242
Orsova 35
oruwa (Singalese craft) 188
Oslo, Norway, 59.56N 10.45E, 31
Otranto 88, 92

P&O 11, 12, 27, 32, 33, 34, 35, 58, 67, 76, 82, 84, 86, 89, 94, 116, 121, 123, 124, 129, 135, 136, 140, 151, 160, 167, 169, 190, 196, 221, 230, 239

P&O-Orient Lines 21, 76, 80, 160, 238
Pacific 50, 152, 160
Padrão dos Descrobrimentos (Monument to the Discoveries), Lisbon 66
Palermo, Italy, 38.08N 13.23E, 158
Palma, Portugal, 38.29N 8.36W, 34
Panama Canal 47, 97, 160, 163, 165, 232, 233, 239
Papua New Guinea 230
Penang, Malaysia, 5.30N 100.28E, 62
Peninsular & Oriental Steam Navigation Company *see* P&O
Peto, Harold 123
Pettit, Geoff 14, 23, 24, 46, 74, 136, 160, 219, 234
Phelps, Miss 214
'Plough Tavern' (*Oriana*) 160
Plymouth, Devon, England, 50.23N 4.10W, 167
Pointe-Noire, Congo, 4.46S 11.53E, 115
Port Elizabeth, South Africa, 33.58S 25.36E, 44
Port Moresby, Papua New Guinea, 9.30S 147.07E, 230
Port Said, Egypt, 31.17N 32.18E, 32, 146, 218
Porter, Cole 52
Portugal 66, 202, 208
Preobrzhensky, Mikhail 60
Prime Meridian 244
prohibition 167

Québec, Canada, 46.50N 71.15W, 111
Queen of Bermuda 54
Queen Elizabeth (Cunard) 176
Queen Elizabeth, HMS 185
Queen Mary 54, 103, 158, 176, 196, 219, 242
Queen Mary 2 103
Queenstown (Cóbh), Ireland, 51.51N 8.17W, 175

Radford, Bernard 31, 73, 127, 208
Raffles, Sir Stamford 64
Rarotonga, Cook Islands, 21.15S 159.45W, 137
Rawalpindi 59, 80, 132
Reid, William 217
Rhodes, Greece, 36.26N 28.14E, 32
Rio de Janeiro, Brazil, 22.53S 43.17W, 63
Roberts, Captain R.W. 83
Robertson stretcher 95
Rodgers, Richard 52
Rome, Italy, 41.53N 12.30E, 32
Romsdalsfjorden, Norway, 62.37N 7.24E, 69
Royal Canadian Air Force 240
Royal Liver Building, Liverpool 57
Royal Mail Line 129
Royal Mail Sports on Board (brochure) 129, 130
Royal Oak, HMS 185
Russia 224, 227
Russian cruise ships 13, 22

Saffery, H. 83
St Helena, South Atlantic Ocean, 15.58S,
 5.43W 231
Saint John, New Brunswick, Canada, 45.16N
 66.03W, 111
St Lawrence River, Canada 107
St Lucia, Windward Isles, West Indies, 14.01N
 60.59W, 83, 101
St Nazaire, France, 47.17N 2.12W, 203
St Nicholas Church, Tallinn 60
St Petersburg *see* Leningrad
St Rognavald 30
Sámi people, Norway 224
sampans 201, 230
San Francisco, California, USA, 37.45N
 122.27W, 160, 162, 192, 238
San Juan, Puerto Rico, 18.29N 66.08W, 226
Santorini (Thira), Greece, 36.24N 25.27E, 108
Sarkies brothers 64
Saunders, John 25
Savage, Paul 24
Scandinavia 184, 242
 see also individual countries
Schiaparelli, Elsa 45
Schlesien (German battleship) 185
Scotland 28, 30, 65, 176
Sep (Polish submarine) 202
Setterberg, Irine 13
Seven Sisters waterfall, Geirangerfjord,
 Norway 29, 31
Shanghai, China, 31.13N 121.25E, 230
Shaw, George Bernard 217
The Shetland Journal (Arthur Anderson) 27
ships' cats 103
Sicily 32
signalling 82
Singapore, 1.06N 103.54E, 64, 65
Six Day War, 1967 163
Smyrna (Izmir), Turkey, 38.25N 27.10E, 32
Smythe, H. Warrington 189
Sogn og Fjordane, Norway, 58.05N 7.40E, 213
Sognefjord, Norway 28, 213, 239
South Africa 40-5, 86, 197, 218, 244
South America 35, 40, 197
 see also named countries
Southampton, England, 50.55N 1.25W, 162,
 163, 173, 174, 177, 238
Southampton–South Africa route 40-5
souvenirs 214-19
Spain 32, 197, 218
Spitsbergen, Svalbard, Norway 240, 246, 247
sports 129-33
Starling, Edith 59, 132, 140
'steerage' 167
Stockloser, Joe 160

storms 208-11
Strait of Magellan, Chile 232, 241, 242-3, 244,
 247
Strait of Malacca 62
Strathaird 169, 179, 205
Strathallan 35, 169, 179, 190
Stratheden 169, 179, 190
Strathmore 169, 179, 190
Strathnaver 116, 124, 136, 169, 179, 205
Stromboli, Lipari island, Italy, 38.48N 15.15E,
 229
Suez, Egypt, 29.59N 32.33E, 59
Suez Canal 163, 239
Svartisen, Norway, 66.40N 13.56E, 30, 234
Svåsand, Hardanger, Norway 193
Swatow, Kwangtung, China, 23.23N 116.39E,
 201
Swedish America Line 13, 14, 30, 42, 98,
 112, 136, 168, 169, 180, 199, 218
Sydney, New South Wales, Australia, 33.55S
 151.10E, 13, 48, 49, 50, 52, 89, 151, 160,
 162, 167, 244
Sydney Opera House 48

Table Mountain, Cape Town 43
Tahiti, Society Islands, 17.32S 149.34W, 104
Tallinn, Estonia, 59.22N 24.48E, 60
Tangier, Morocco, 35.48N 5.50W, 34
Taranto, Italy, 40.28N 17.15E, 198
Tel Aviv *see* Jaffa
Telmo, Cottinelli 66
Thackeray, William Makepeace 32
Thailand 74
Thira *see* Santorini
Thomas, W. Aubrey 57
Tierra del Fuego 232
Tilbury, Essex, England, 51.28N 0.23E, 46,
 49, 51, 169, 179
Timothy, Elizabeth 83
Tinos, Greece, 37.33N 25.08E, 243
Titmarsh, Michael Angelo *see* Thackeray,
 William Makepeace
Tobago, West Indies, 11.15N 60.40W, 224
Tokyo, Japan, 35.40N 139.45E, 192
Transvaal Castle 92, 138-9
Trieste, Italy, 45.39N 13.47E, 32, 190
Trinidad, West Indies 47
Tripoli, Libya, 32.58N 13.12E, 32
troopships 159, 203
Tunis, Tunisia, 36.50N 10.13E, 32
Tunisia 32, 108
Turkey 32, 34, 35, 38-9, 98, 99, 106, 221, 225
Tutankhamun 32
Tyrrhenia see Lancastria

U-14 202
U-172 98, 186
Uganda 18
Ultor, HMS 198
uniforms 80, 85
Union Steam Ship Company 40
Union-Castle Line 11, 19, 35, 40, 44, 54, 58,
 80, 81, 82, 86, 92, 116, 133, 135, 136, 167,
 215, 218, 244
United Nations 40
United States 35, 86, 180
Utzon, Jørn 48

Vadheim, Norway, 61.12N 5.50E, 78-9, 80
Valletta, Malta, 35.54N 14.32E, 34, 36, 37,
 182, 185
Vancouver, Canada, 49.13N 123.06W, 47,
 50, 160, 162, 238
Venice, Italy, 45.26N 12.20E, 32, 35, 159,
 190, 198, 205
ventilation 179
Verwoerd, Hendrik 40
Vest-Norges Flyveselskap (West Norwegian
 Airlines) 193
Viceroy of India 58, 67, 105, 108, 121, 123,
 129, 131, 151, 168, 184, 228, 239, 247
Voltaire 219

Waikiki Beach, Honolulu 152
Wales, Edward, Prince of 131
Wall Street crash 168
Walvis Bay, 22.59S 14.31E, 44
Wat Arun, Bangkok 74
Waterline Collection 6, 24
Waterloo, London 238
Wedgwood (china manufacturers) 219
Wellington, New Zealand, 41.17S 174.47E, 162
Wellington (tug) 174
West Indies 47, 83, 101, 160, 162, 176, 180,
 182, 224
Westminster, Loelia, Duchess of 131
'White Sisters' (P&O) 35, 169, 179
White Star Line 168, 169
 see also Cunard White Star
Wilhelmshaven, Germany, 53.32N 8.07E, 202
Winterbourne, Keith 18, 110, 130, 135-6,
 155, 163, 244
Wittet, George 67
Woodward, Frank 46, 47
World War I 35, 173
World War II 34, 35, 60, 156, 176, 202, 203

Yates, Clair 83

Picture credits

All images reproduced in this book are © National Maritime Museum, London, with the exception of the following:
© Tony Morris for photographs on pages 10, 16–20 (right).
© Geoff Pettit for photographs on pages 23–25.

Images in this book may be ordered from the Picture Library, National Maritime Museum, Greenwich, London, SE10 9NF (tel: 020 8312 6600). Please quote the reference number listed below.

Introduction
Page 8–9 P83842
Page 20 (left) P89240

Chapter 1
Page 26–27 P90522
Page 29 P93182
Page 30 P95546
Page 33 P91446
Page 35 P91658
Page 36 P93000
Page 37 P97877
Page 38–39 P90876
Page 41 P91550
Page 42 P86847.CN
Page 43 P96646.CN
Page 45 P91068
Page 48 P99280
Page 49 P89182
Page 51 P95718
Page 52–53 P95602
Page 54 P93803 (top), P93808 (bottom)
Page 55 P93816
Page 56 P91541
Page 57 P92801
Page 58 P90716
Page 59 P90209 (top), P90998 (bottom)
Page 60 P95630 (top), P91414 (bottom)
Page 61 P91425
Page 62 P94250
Page 63 P94660
Page 64 P95135
Page 65 P95141
Page 66 P97667.CN
Page 67 P96540.CN
Page 68–69 P90103
Page 70–71 P96854.CN
Page 72 P90795
Page 73 P92055 (top), P92106 (bottom)
Page 74 P90549
Page 75 P91258
Page 76–77 P97274

Chapter 2
Page 78–79 P84680
Page 81 P89131
Page 83 P94787 (top), P89616 (bottom)
Page 85 P85233
Page 87 P85787
Page 89 P85680
Page 91 P84031
Page 93 P85912
Page 95 P84355
Page 96–97 P94193
Page 98 P97722
Page 99 P84134
Page 100 P84613
Page 101 P94757
Page 102 P85423
Page 103 P85433
Page 104 P83480
Page 105 P85348
Page 106 P88247.CN
Page 107 P98834.CN
Page 108 P90849
Page 109 P95088
Page 110 P86556.CN
Page 111 P85852.CN (bottom), P85956.CN (top)
Page 112–113 P90225
Page 114 P90227
Page 115 P90148
Page 116 P95973
Page 117 P85126

Chapter 3
Page 118–119 P84009
Page 120–121 P85235
Page 122 P85951.CN
Page 125 P87296
Page 127 P88819.CN
Page 128 P90104
Page 131 P85291
Page 132 P85330 (top), P89132 (bottom)
Page 133 P84370
Page 134 P85764
Page 137 P88873.CN

Page 139 P84530
Page 140 P85858.CN (top), P88392.CN (bottom)
Page 141 P85862.CN (top), P96771 (bottom)
Page 142–143 P84012
Page 144 P90627
Page 145 P89572
Page 146–147 P94393
Page 148 P92436
Page 149 P93757 (top), P93446 (bottom)
Page 150 P90541
Page 151 P95596
Page 152 P97351
Page 153 P93102 (top), P87286 (bottom)
Page 154–155 P90637

Chapter 4
Page 156–157 P83410
Page 158 P84088
Page 159 P84165
Page 161 P89266.CN
Page 164–165 P89255
Page 166 P83505
Page 171 P84094
Page 172–173 P83962
Page 174 P95227
Page 178–179 P85058
Page 181 P91596
Page 182–183 P93003
Page 184 P84018
Page 185 P92968 (top), P84925 (bottom)
Page 186 P84138
Page 187 P84103
Page 188 P91230 (top), P92479 (bottom)
Page 189 P93837
Page 190 P85032
Page 191 P85031
Page 192 P83769
Page 193 P84444
Page 194–195 P83459
Page 196 P98174

Page 197 P83627
Page 198 P83949
Page 199 P87927
Page 200 P92302
Page 201 P92291
Page 202 P85217A
Page 203 P83911
Page 204–205 P95995

Chapter 5
Page 206–207 P90372
Page 209 P89603
Page 212–213 P95167
Page 215 P92939
Page 216–217 P92901
Page 220 P91189
Page 221 P84328
Page 222 P92090
Page 223 P92160
Page 224 P84551 (top), P93920 (bottom)
Page 225 P90175
Page 226 P99112
Page 227 P92730 (top), P94938 (bottom)
Page 228 P90749
Page 229 P95493
Page 230 P95123 (top), P94373 (bottom)
Page 231 P94728
Page 232 P94155 (left), P94194 (right)
Page 233 P98553
Page 234 P95510
Page 235 P97041
Page 236 P96977
Page 237 P97723
Page 239 P92520
Page 240–241 P98223.CN
Page 242 P92381 (top), P92376 (bottom)
Page 243 P95721
Page 247 P83828
Page 248 P95486
Page 249 P95277